D1074100

Looking Glass Labs

Meghan Berg

WE ARE GODS IN THE CHRYSALIS

MEGHAN BOODY

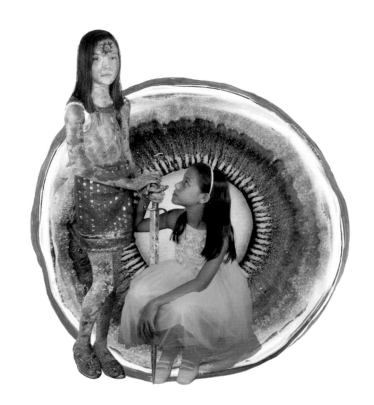

ESSAYS BY KATIE ROIPHE AND SUE SCOTT

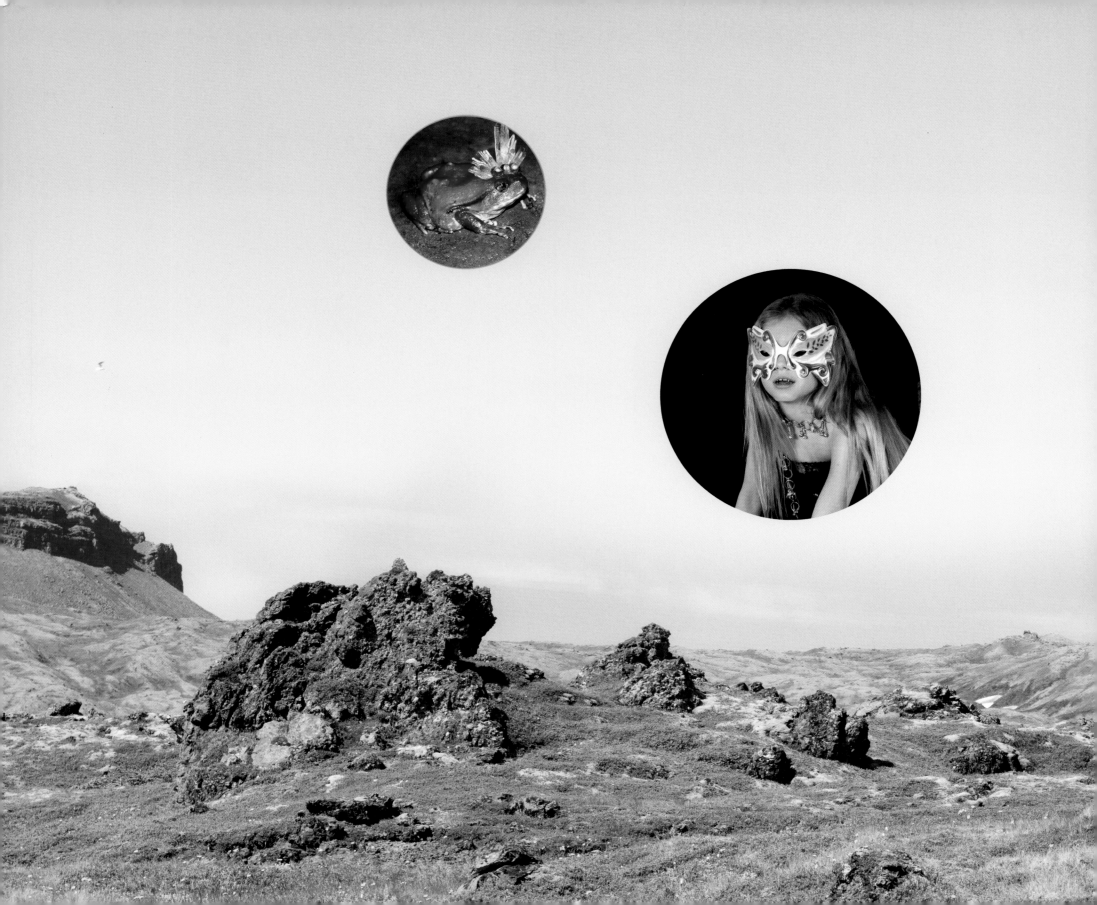

BEGONE

FROM THESE PAGES ANY DOUBTERS OF HIGHER DIMENSIONS
WHERE ETHEREAL BEINGS REIGN!

===

THIS BOOK IS FOR INTREPID ADVENTURERS OF THE SOUL,
FOOLHARDY TRAVELERS RIDDLED WITH WANDERLUST AND
THE THIRST FOR THE BEYOND. WE CALL OUT TO ALL THOSE
INEXTRICABLY LURED INTO THE PASSAGES OF THE MIND
BODY LABYRINTH. TO ALL MINERS OF THE SECRET LIFE
SOURCE AND STAR POWER HIDDEN IN OUR DEPTHS, WE SAY:

ENTER!

LOOKING GLASS LABS WELCOMES YOU TO THE REALM OF POSSIBILITY

Meghan Boody

We Are Gods in the Chrysalis

All photographs © 2015 Meghan Boody

© 2015 Kerber Verlag, Bielefeld/Berlin and authors

Copyedited by Ryan Newbanks

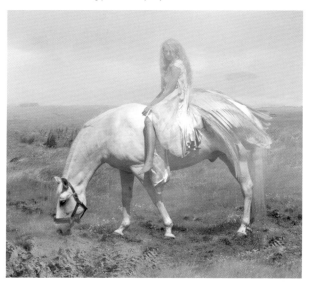

The Deutsche Nationalbibliothek lists this publication in the
Deutsche Nationalbibliografie; detailed bibliographic data are
available on the Internet at http://dnb.d-nb.de.

Printed and published by: Kerber Verlag, Bielefeld

Windelsbleicher Str. 166–170

33659 Bielefeld Germany

Tel. +49 (0) 5 21/9 50 08-10

Fax +49 (0) 5 21/9 50 08-88

info@kerberverlag.com

Kerber, US Distribution

D.A.P., Distributed Art Publishers, Inc.

155 Sixth Avenue, 2nd Floor

New York, NY 10013

Tel. +1 (212) 627-1999

Fax +1 (212) 627-9484

ISBN 978-3-7356-0100-1

www.kerberverlag.com

Printed in Germany

All rights reserved. No part of this publication may be reproduced, translated, stored in
a retrieval system or transmitted in any form or by any means, electronic, mechanical,
photocopying or recording or otherwise, without the prior permission of the publisher.

Figure Credits

xv: Royal Photographic Society / National Media Museum / Science & Society
Picture Library. xvi: Courtesy of Julie Heffernan and P.P.O.W Gallery, New York.
xvii: © Gregory Crewdson. Courtesy Gagosian Gallery. xviii: Copyright 1952, 1980
Ruth Orkin. Used with special permission of the Ruth Orkin Photo Archive. xix
(left): Kobal Collection. xix (right): ©1997 Matthew Barney Photo: Michael James
O'Brien Courtesy Gladstone Gallery, New York and Brussels

(opposite) *The Ugly Duckling,* 2006

(frontispiece) *Psyche, Queen of Beasts,* 2011

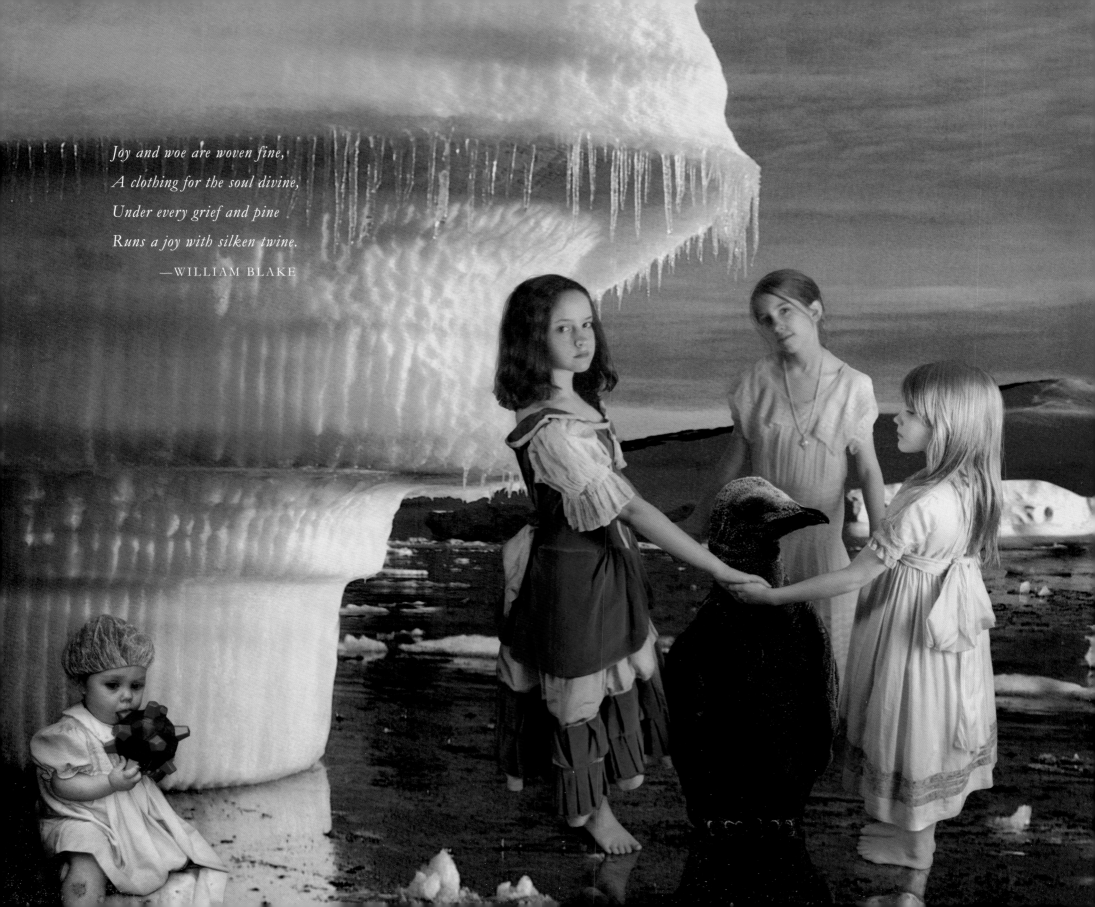

Joy and woe are woven fine,
A clothing for the soul divine,
Under every grief and pine
Runs a joy with silken twine.
—WILLIAM BLAKE

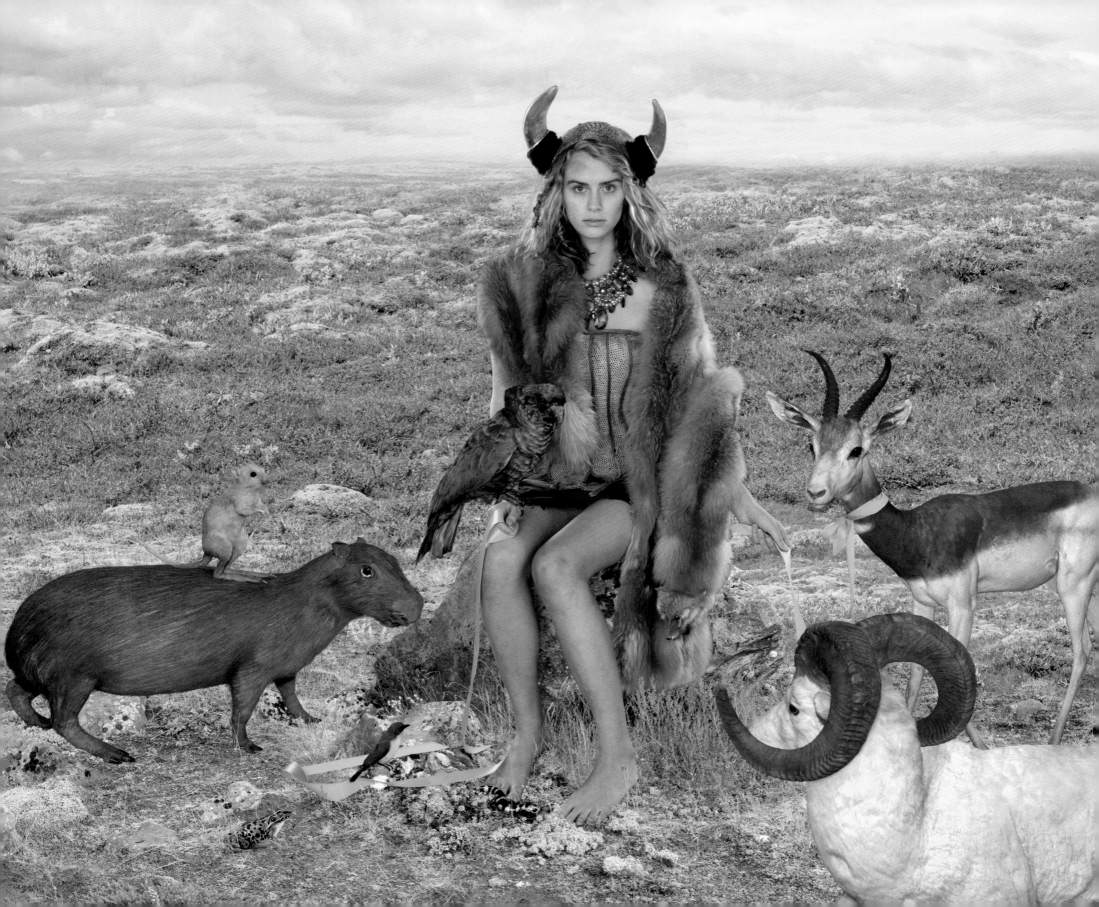

CONTENTS

PLATES

WITH COMMENTARY BY CATHERINE MICHELE ADAMS

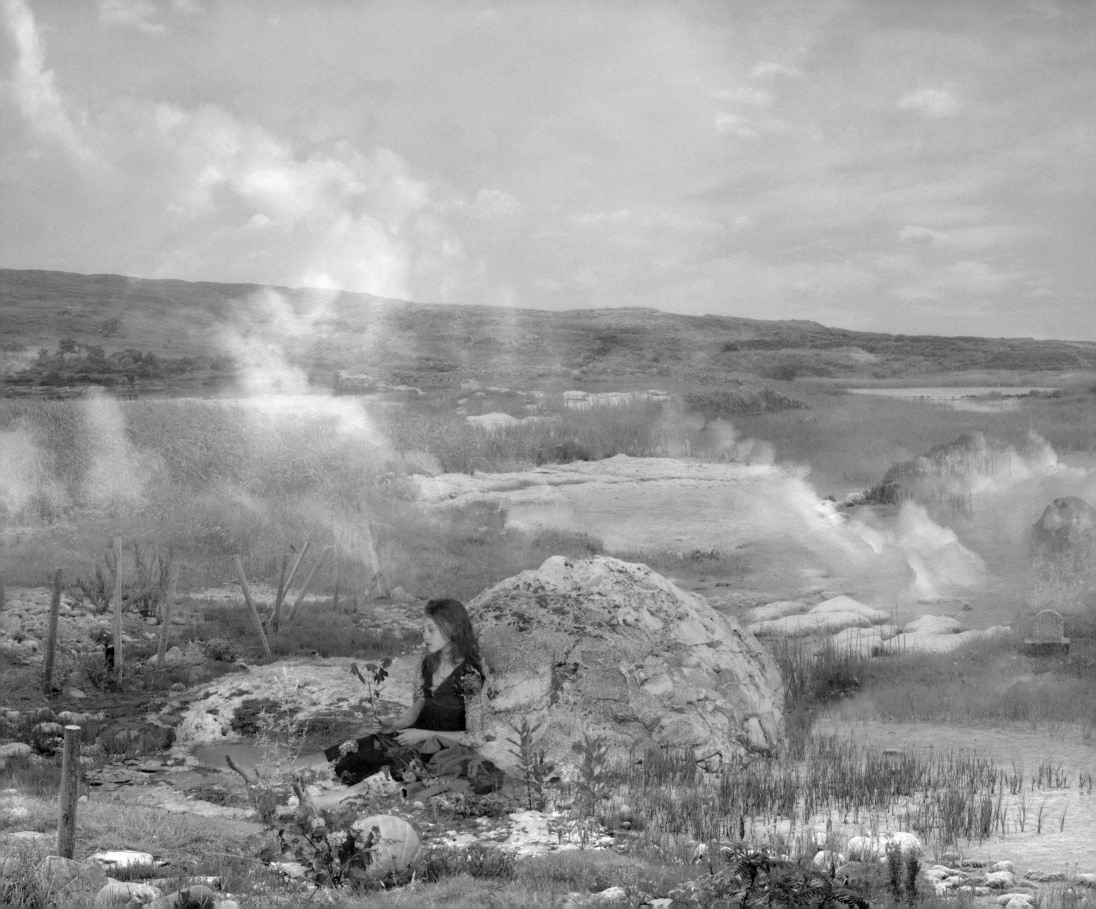

STATEMENT BY THE ARTIST

"Find her, free her, love her." – CLARISSA PINKOLA ESTÉS

AS I FIND MY WAY IN THE WORLD, I create phantom women and girls who undergo parallel investigations of the self. These inner expeditions take place in cosmic coming-of-age narratives told through images and objects, the playgrounds where my subjects crawl out of their cocoons, unfurl, and blossom. They often begin their wanderings lost and alone, Bambies blinded by headlights and babes in the woods. They stumble into predicaments and compromising situations, stymied by labyrinths, sinkholes, and unsavory characters. Male/female power plays, the desire for rescue, the quest for true love, and ultimately the search for the self, these fraught scenarios are the prisms through which my heroines view their world, searching far and wide for the crumbs littered along the path. Equal parts Dr. Freud and Dr. Frankenstein, fragments of the psyche are collected and reassembled in new combinations with new capabilities. Moments of illumination and even happy endings appear as urchins morph into Amazonian creatures of female prowess, capable of vanquishing their foes and seizing their hearts' desires.

ADVENTURES UNDERGROUND

BY KATIE ROIPHE

I. FEAR

MY FIRST FEELING in the presence of Meghan Boody's work is fear. The work seems to be looking at, examining me, which is not the way it's supposed to go.

Take Psyche tumbling into a cavelike underworld, her Alice in Wonderland dress replaced by spangly gypsy clothes, discovering she has grown a tail while her masked twin lies on the ground, watching, surrounded by garbage, a broken bicycle, a chicken.

The images feel familiar but just out of reach, like dreams I have forgotten but not entirely shaken off. I am disturbed by them but I am not exactly sure why. My impulse is to take the giant pieces off the walls and bring them home where I can look at them by myself in a room.

I once wrote a novel about a girl in Victorian England who had been in a confusing situation with an older man: "That was the pain, the wrenching of who you were into who you will be. The tearing apart of one being into another. The force and violence of that change was making her cry." When I wrote those lines I did not feel I had any relation to them. I was trying to conjure my character's feelings, but they had nothing to do with me.

When I left Meghan's studio I went home and waited until everyone was asleep and climbed under the covers to stare at *Psyche and Smut* and *The Lighthouse Project* and *Glass Worlds* on my laptop in the dark. It's hard to explain what happened next. If I were inside one of Meghan's lavish, mythological tableaux, a portal would have opened and ragged acolytes would be dancing around me with giant frogs and concubines; in my tin-ceilinged bedroom in Brooklyn, some old feelings returned to me.

There was a night I couldn't stop crying. I cried on the Persian rug by the fire in the much older man's apartment, in the street, in the taxi home, in my bed. The man, who I loved and trusted, had told me that he had sexual feelings for me.

In the years that followed I developed a cool narrative about this man. It had become a sort of cocktail party conversation story, a story in which I am, by implication, some version of a sophisticated gamine.

The raw fear I felt was totally lost to me. The mourning which was overwhelming, drowning me: I had lost that.

I found the passages in my journals where I described having sex with the man and was surprised to see that I had blacked them out with a marker. Who was the girl who had crossed out those passages? She couldn't bear to read them. She had refused to go into a bedroom with him because anything that happened on a living room couch didn't count.

Meghan refers once to her work as "a call to adventure." I wonder if this could be the adventure she is talking about: the former selves are unloosed suddenly, they are unfixed. Who knows what will happen? They are running wild. One of them may grow a tail.

This is what I am trying to say about how the art was looking at me.

Figure 1. The artist at age eight

2. VIOLENT TRANSFORMATIONS

Metamorphosis is everywhere, overwhelming, dizzying: the girl whose skin turns into the mottled skin of a frog, the iridescent frogs eggs; it spills out of the work onto the frames, which are carved with larva multiplying, tadpoles, fossils; this is evolution on speed, it's like a science lab of becoming something else.

Meghan's work is unusually attuned to subterranean moments of violent change. When everything you love is at risk, everything you know might be wrong, every structure you have slips away. There is a vividness, a searing intensity to these moments. You are torn out of your old self, and the world is demanding that you replace it with a new one.

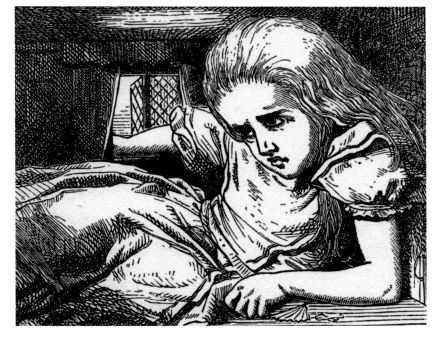

Meghan puts it this way: "When you go through these heart-wrenching experiences you have to reinvent yourself. People don't normally change unless they are pushed to the precipice of disaster. I am thankful I've had these experiences because they connect me to other people and give me a cut to quick spirituality that grows in the place of the discarded deadwood. There is also a resoluteness that comes out of the depths, out of necessity, of not caring what other people think."

What does it mean to see life as a series of violent transformations? To be viscerally alert to those harrowing moments when you burn yourself down and build yourself up again. Many people will not recognize this narrative. They live more blithely, or change comes more slowly and peaceably, or they anesthetize themselves, or they don't get into situations where they risk losing everything.

Mostly we drape these times with terms like "growing up" or "recovery" or "a hard time" and the strangeness and otherworldliness and beauty and breathtaking loss are tamed by memory, played down.

And yet secret stories of radical transformation obsess us. I remember seeing the great grouchy Tenniel drawing in *Alice's Adventures in Wonderland* where she drinks the potion and grows enormous, and bends her head cramped into the house (fig. 2). This is how bizarre and sudden and out of control it felt, the total disorientation of one's body changing. When the caterpillar asks Alice who she is she says: "I hardly know sir just at present – at least I know who I was when I woke up this morning, but I think I must have been changed several times since then."

The isolation of those moments of violent transformation is shocking. Meghan's images are an evocation of this: no one is as vividly out of place as her Photoshopped people juxtaposed against icy tundras, desolate moors, moonscapes; the technique itself telegraphs the detachment from their surroundings, the precariousness of their existence in them.

Even Meghan's loft in New York is testimony to radical transformation. There is nothing unadorned, bare, plain; everything feels conjured, palm trees, carved Chinese wooden daybed, her girl in a box with mice. Here is the Victorian impulse to decorate, to pattern, to embellish, to make extraordinary, to escape function.

I wonder why I experience this place as so restful or relaxing. It's counterintuitive in such a visually overloaded or patterned space to feel so calm. I think it is the feeling of possibility, abundance, the sense that ideas and fantasy are manifest. The fears and anxieties of the world are kept at bay. In some way this loft is so completely imagined, so thoroughly realized, in every corner, that it feels transporting. You have, whatever you are running from, escaped.

Does one actually get stronger after violent transformations? Is the exhaustion and pain of them redeemed, is there something ravishing and exhilarating in them? I've always thought so.

Another way to look at this: in Meghan Boody's kind of fairy tale is there a happy ending?

There are exuberant works, many of which she saves and harbors for her bedroom, her inner sanctum. Psyche kneels before the beast who has turned into a centaur, with doves circling his head, the acolytes stand over a cauldron, a gypsy caravan in the background. Psyche and Smut finally fused under a sixties spacecraft, with starbursts of light and butterflies. The Beast and Psyche dancing with the acolytes in a wild party by a fire.

The walls and ceilings of this room are silver. The bed has carved parrots on the bed posts. It may be that at night they fly off.

3. DARK ANGELS

"Why do we get seduced by the dark angel? There is a romance with the edge," Meghan is saying. "There is something exciting about throwing yourself into a perilous situation and making it extra-specially perilous to see if you can survive."

Her work interrogates and celebrates and satirizes a series of dark angels: Henry VIII, the Beast in *PsycheSuperStar*, the nameless man lurking behind *Electronic Warfare Suite*.

"A lot of it is about going to the very marrow of the person, and having mortal combat there. It's about possession and giving yourself so completely to someone that they own you. There is a beauty and a trust to that. A relinquishment of your own will. The question is for how long. Can you reclaim yourself?"

The Beast she has conjured is both deeply attractive and deeply repellent, with his ridged boar's nose, his long fingernails, his matted black hair, his louche bohemian clothes, his sullen slouch.

Psyche is imprisoned by him, but with the help of the tousled acolytes she escapes through an elaborate metal hole in the ivy-covered wall. As she is halfway through the hole, he stands over her, bare chest draped with chains, pulling her tail, which bleeds. She is in garters and satin underwear. A monk's childish wooden bed is behind her, spattered with paint that looks like blood.

Afterward she lies bandaged and bleeding and naked in a dark, leafy sanctuary. She lies in the position of a doll that has been thrown on the ground. How to read this image? She is escaped, discarded. There is a hospital feel to the scene, she is healing or about to heal.

This is how it feels leaving a dark angel.

Meghan herself has some experience with dark angels, out of which she built *The Electronic Warfare Suite*. Glowing blue knobs open small metal doors, cut from Cor-Ten steel plates, which are

labeled with military terms: "Ground Zero," "General Dynamics," "Reconnaissance," "Scramble Response," "Project Babylon," "Desertion," "Requiem." Beneath them are glowing yellow photographs of smiling faces or curled up naked bodies or people flirting or cows or dogs superimposed on grids. The military terms impose their aura on lovely or innocent moments; the loss pervades, metal and radiance converge.

When her marriage was dissolving, Meghan was working on her haunting, comic series *Henry's Wives*. The last wild piece is darkly triumphant: the beheaded wives gather in a sun-dappled garden to watch a blue-spotted creature, half gecko, half sea slug, drowning in the water, frogs eggs or golden apples in his mouth, one of the wives has her head fused to a bird, and a burning child stands on a table.

Here is another way to look at Meghan's kind of happy ending: those transcendent times you somehow manage to channel hardship into creativity. The writer John Updike talks about the process of transforming the worst periods of your life into art as turning pain into honey.

"For me working is the ultimate panacea," Meghan says. "I am completely absorbed and happy and everything feels available to me. Nothing else matters. I have to rouse myself out of that state. My poor son. It's like, what about dinner?"

4. MAPS

We eat salads out of glass pie dishes. We are talking about the force that propels both of us toward self-revelation in our work, the drive to uncover, to reveal, to display. Other people will criticize or gossip about this drive in both of us.

Meghan: I want to come clean. I want to examine what I've done. I feel compelled to expose myself in a certain way that I feel ambivalent about.

Me: I have that too. I don't know why I want to write about certain personal things, but I can't resist even though I always think of resisting.

Meghan: It's terrifying in a way. I sometimes think, are my emotions going to be controllable around this? The fear is really about your place in the world. Will I lose power? If I admit weakness or lacuna or great pits of sadness.

Me: That's definitely my fear. But maybe you *gain* power? When I wrote my last book, which was called *In Praise of Messy Lives*, I felt like I was seeking out an invisible community of messy life people.

Meghan: I feel like exploring difficult moments is actually allowing me access to a force outside of myself. Even though I feel alone in them, by stripping away all vanity and all surface, you tunnel into a reservoir of being, a common place. I think ideally it's like the quote from *Women Who Run with the Wolves*, "Art is a map for those who follow after us."

After I leave her studio I try to write an e-mail about how much I connected to her work. I find the email tricky to write because the connection is so strong and I don't know her. I put in a line, "thought on the way home: I wish I'd known you at Brearley!" Brearley is the Upper East Side girls school we both went to, a few years apart. I thought as I wrote it that this was a strange thing to say, but I had a powerful fantasy of meeting her walking around the halls, a blond girl with wary eyes, a mouse tucked in her pocket, seeing even then, other worlds. The twelve-year-old me was looking for the twelve-year-old her. Anyway, I found her. *Art is a map for those who follow after us.*

OUTSIDE OF TIME

BY SUE SCOTT

WHEN MEGHAN BOODY FIRST INVITED ME to her studio, almost two decades ago, I was completely fascinated by her sculpture *Deluxe Suicide Service*, 1996. This working pinball machine was encased in concrete on a hydraulic stretcher and retrofitted as a reliquary to keep its inhabitant – a photographic image of a young woman – in a suspended state. Were we in the future looking back or was she looking out from the future? The sculpture-game hybrid lit up and bells rang as it was played, leading one to speculate about the correlation between the goal of the game – preventing the metal ball from going down the hole – and the fate of the young girl trapped below. There simply was nothing like it being done at the time.

Over the years, I've watched Boody's work evolve and change, the product of a fertile if not a little bizarre imagination. Compare the pinball machine with her *Mice and Me* made twenty years later. A casket-like structure of stainless steel and chickenwire, the work holds a lifelike sculpture of the artist as a young girl, reclining in the grass, an adolescent Snow White tended to by live white and grey mice. Though one may feel squeamish about, even repulsed by, the scene of a young girl sharing a cage with rodents, the creatures are, after all, the minions of magic in fairy tales. Who is to say she won't wake up one day? Freud called this the uncanny – the simultaneous attraction and repulsion experienced around something that is strangely familiar, but not quite right – an effect that Boody produces throughout her work with enormous power.

Boody's early sculptures look like remnants from an archeological dig. Reliquaries, tombs, and derelict image banks, the contraptions serve as elaborate housings for her photographs. Over time, the photographs grew and took over, pushing the sculptural element to the edge of the image – which became, in essence, frames. Encrusted with mythic creatures, embedded with eyeballs and wrapped in silk, her frames seem sentient, as if imbued with protective spirits. Like a window or a portal to another world, they provide the anchor for the complication of her vision.

I've come to think of Boody as the Wes Anderson of the art world. Not that her work resembles Anderson's aesthetic; instead, she shares a whimsical approach to storytelling whose veneer of childlike naiveté belies a conceptual sophistication and concern with the difficult lessons of adulthood. Like Anderson, she occupies a place in the art world that is both insider and outlier. As a photographer and sculptor, she freely engages in fantasy and narrative, creating work that recalls another time, acknowledges art-historical precedent and yet is squarely situated in the present. She embraces narrative – albeit an elliptical one – in an art world that views narrative with suspicion.

What stories does Boody tell and why? The narrative-driven photographic work to which she has mainly devoted herself in the past twenty years is a mash-up of classic myths, remnants of stories that have been part of the collective unconscious for centuries: Bluebeard, Beauty and the Beast, Persephone, Psyche and Cupid, and Hansel and Gretel. She is particularly drawn to tales that offer models of behavior as well as scenarios of transformation. Can art inspire deep psychological change and, if so, what would it look like? Boody's heroic tableaux and derelict objects wonder aloud about such possibilities. The title of this book, *We Are Gods in the Chrysalis*, offers an answer.

Boody's work unlocks a door into her own inner shape-shifting. Each series addresses a different phase of her psychic evolution, serving as pictorial guides during periods of personal crisis. The markings of

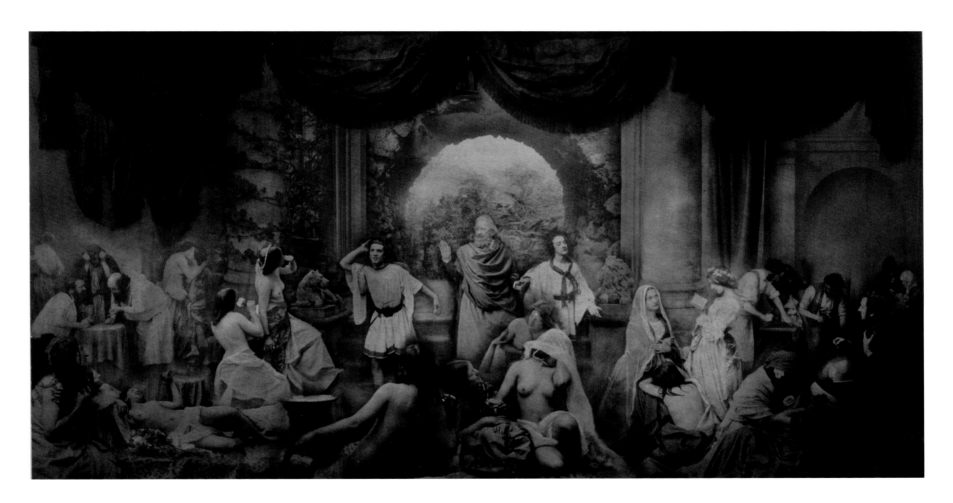

transformation, birthings and corpses appear throughout her work, along with womblike spaces, ovum, and fetal ooze. Women incubate and then emerge. Ultimately, the potent symbol of the chrysalis surfaces as the thread that holds the oeuvre together. As her heroines become more-powerful selves, Boody's hope is that "viewers will hear the fairy tale knock on the door of their own psyches."

Although her proclivities toward art were apparent from an early age, Boody studied philosophy and French at Georgetown University, intending to be a writer. After graduation, she enrolled at Parsons in Paris to study fashion design, where she took a photography class that would change the direction of her life. She quickly discovered a love for and ease with the medium, shifting her focus from fashion and writing.

Figure 1. Oscar Gustav Rejlander, *The Two Ways of Life*, 1857. Carbon print, 16 1/8 x 31 in. (41 x 79 cm)

During this time, Boody was exposed to the work of Oscar Gustav Rejlander (1813–1875) and Henry Peach Robinson (1830–1901), pioneer photographers who sought to upend the primacy of painting with this new discovery. They introduced her to the storytelling capacity of the medium that could be achieved by photomontage and double exposure. Boody was particularly struck by the believability that a photograph could invoke and, prompted by these masters of photographic manipulation, began to dismantle and recompose images based on her own narratives. Today, equipped with a mastery of Photoshop, Boody patches together hundreds of layers in each photograph to create convincing and wholly original environments.

Boody's work, much like Rejlander's, explores allegorical tales of human folly. They share an attraction to the tawdry side of life, the pull between good and evil. Rejlander's magnum opus, *The Two Ways of Life*, 1857 (fig. 1), reads like a grand history painting. In the center of the composition, a stately man presents two paths for life, one depraved and one pious. The work caused great controversy when it was first exhibited; the immoral side was hidden behind a curtain. Rejlander was accused of soliciting prostitutes to pose for him. Boody once followed a beautiful woman into her place of business, a local strip club, and asked if she could photograph her. The resulting series, *NY Doll*, 1996 (pp. 102–113), presents women engaged in compromising situations in hostile yet beautiful environments. It's interesting to

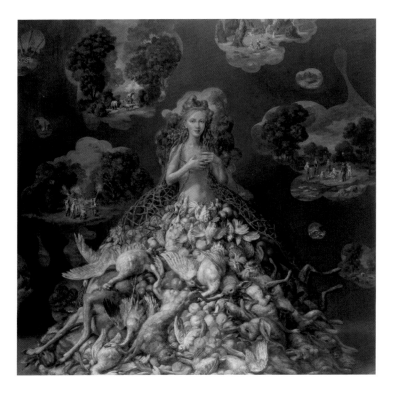

consider just how much the life circumstances of an artist's model jump-start the imagination, becoming the starting point for narratives about human behavior.

Boody's fascination with the painterly possibilities of photography comes from her love of Old Master painting. Compare *Psyche, Queen of Beasts*, 2011 (frontispiece), in which a beautiful young woman wearing a fox fur is surrounded by exotic and geographically discordant animals, with Julie Heffernan's contemporary painting *Self Portrait as Booty*, 2007 (fig. 2), where a woman faces the viewer, her cape a net and her skirt made up of the bounty of the hunt. Both artists employ themes and imagery from Old Master painting while deconstructing its visual content, each guided by her own personal manifesto and universal concerns. Many of Heffernan's works can be considered a form of self-portraiture; Boody rarely features her own likeness in her work, although most of her characters can easily be read as avatars.

It isn't surprising that when Boody stepped outside of myth to do a historical series, she chose Henry VIII's wives to explore female archetypes (pp. 88–101). In Boody's portraits, each wife is placed alongside larger-than-life symbols that make reference to her personality and reputation through universal iconography. Catherine of Aragon kneels by a giant pomegranate – which can represent both fertility (she had one daughter and at least five miscarriages) and the Underworld (Persephone ate six seeds from the fruit and was thus condemned to return to Hades each year). Anne Boleyn, who was vilified as a harlot, is depicted with a green apple, the forbidden fruit of knowledge. The

Figure 2. Julie Heffernan, *Self Portrait as Booty*, 2007. Oil on canvas, 68 1/2 x 65 in. (174 x 165.1 cm)

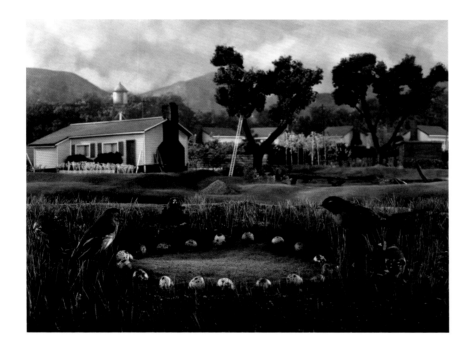

young Elizabeth stands next to Boleyn, the heir Henry dreams of, though he never imagined it would be a woman who would lead England to glory.

Perhaps this Elizabeth relates to the child on fire in *In a Garden So Greene*, 1998 (p. 100). Both are child avatars/deities, one historical and one mystical, inchoate figures of the powerful regimes to come. The seven images in this series directly relate to the seven phases of alchemy, this last piece being the Coniunctio, or grand synthesis, a theme that runs throughout Boody's work. Carl Jung wrote about opposites as an encounter between the alchemical King and Queen, *Sol* and *Luna*, but it can also manifest in darker forms, such as a loathsome dragon wrapped around a man in the throes of death. [1]

Boody hides symbols throughout the work. The Phoenix rising — the symbol of regeneration and rebirth — is a trope she uses in various forms. The burning house, a girl on fire, the white horse on the pyre, columns of smoke behind Catherine of Parr — connect the stories

in a visual manner while speaking to the unconscious power of the elements, the opposites about which Jung wrote.

Boody cites the early work of contemporary photographer Gregory Crewdson as another source of inspiration. Take, for example, his *Untitled*, 1992–97, which depicts a magical scene of birds involved in some kind of ritual, set against a backdrop of small-town America (fig. 3). Crewdson's scene is familiar yet fantastic. Like one of Boody's images, its composition appears purposefully unrealistic, wearing its artifice on its sleeve, while its narrative is forcefully implied but ambiguous. But unlike Crewdson, whose primary subject is the contemporary American landscape, Boody is more interested in mining the psyche through exploration of myth.

There are a few instances where Boody pays compositional homage to another artist. Such is the case of Ruth Orkin's iconic *American Girl in Italy*, 1951 (fig. 4). When Boody did the staging for the photograph entitled *Guard! What place is this?* (pp. 20–21), from the *Lighthouse Project*, she lifted the composition almost verbatim. This is Orkin's best-known work, an action shot capturing a young woman walking down a street through a throng of ogling men. As opposed to Cartier Bresson's decisive moment, Orkin's image is actually a recapture of a previous moment; after photographing the girl walking through the gauntlet of admirers, Orkin asked her to retrace her steps for another shot, while the men were asked not to look at the camera. This successful recreation of an emotionally charged moment intrigued Boody. Sometimes she photographs her subjects on location and sometimes she shoots her models individually and then transposes them into the picture later. The challenge is getting her models to convincingly engage and role-play "in the dark," in the absence of a set or other players.

All of Boody's mises en scène are hyper-staged. She serves as set director for each scene and, rather than using a storyboard, she works intuitively from a list of possible shots, which changes and evolves

Figure 3. Gregory Crewdson, *Untitled*, from the series *Natural Wonder*, 1992–97

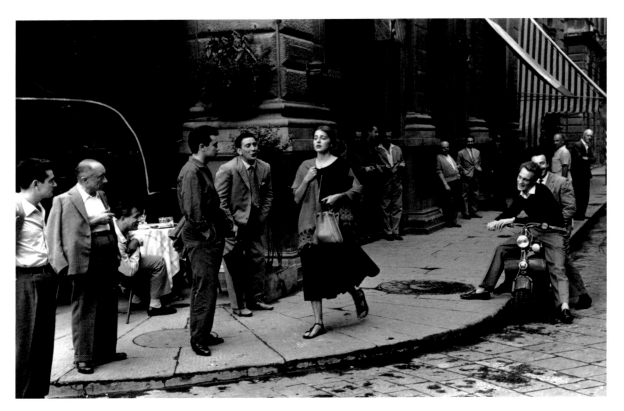

If adolescence is about the quest for identity, this pursuit must be even more complex for adoptees, some of whom fantasize about having exotic origins. The fantasy can be more appealing than the reality of life, especially during the challenges of the teen years. The journey of the innocent Psyche to the Underworld in *Psyche and Smut*, where she meets and is held captive by her doppelganger Smut and her circle, can be read as a quest to reunite contradictory selves. Through a series of tribulations, Psyche is reconciled with Smut, then triumphantly transformed into PsycheSuperStar, who must undergo her own trials toward individuation.

Making her art and telling these stories continues to be a source of revelation as well as resolution in her own life. Boody recently met her birth mother and perhaps the biggest surprise was that there was none; her mother lives a typical American Midwestern life. The only thing she knows of her father is that he is Lebanese/Norwegian, which has it's own aspect of mystery. Boody wonders if this daydream is better left intact.

during a shoot. She travels to sites of extreme nature like Iceland or the Burren in Ireland, solicits actors/models, and rents or fabricates period costumes. Scenes or objects that might be difficult if not impossible to photograph in situ – a rearing white horse, a colony of bats – come from found images.

Much of Boody's work arises from a desire to reconcile her origin with self. She knew she was adopted from a young age and this knowledge fueled much of her early fascinations as well as her art. As a little girl she was an avid reader, losing herself in fairy tales like *The Princess and the Goblin* and *The Red Fairy Book*. The books were beautifully illustrated and Boody was often as intrigued by the artwork as she was by the story. "Illustration is a dirty word in the art world," she acknowledges, "but I don't mind. My work does hearken back to these early childhood illustrations." [2]

"I did have this *Arabian Nights* fantasy about my background," said Boody, "a hope for the exotic. But, what I've realized over time is that because I was transplanted, I am this weird hybrid. I am the exotic element I was searching for."

How much do we remember of infancy? An acquaintance once told of her adopted daughter who awoke from a nightmare dreaming she had been abandoned in a park with animals. Her mother had never told her she had been left in the zoo when she was a few days old. Boody lived in a foster home for five weeks before she was adopted.

Figure 4. Ruth Orkin, *American Girl in Italy*, 1951

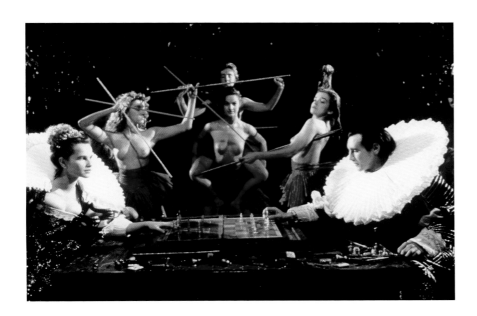

Boody's images also find resonance in the work of Matthew Barney, whose incredibly convoluted and inexplicable stories of narcissism possess a similar romanticism and an oblique approach to storytelling (fig. 6). Her reading of Barney's work may offer the best insight into her own. "The work is so dense and multilayered it's hard to parse specifics," she says. "But it becomes clearer if you let the story filter through you without trying to make sense of it. You have to intuit what he is doing. It's the same with my work – if you try to take it apart and analyze it, you won't get very far. But if you just let it fall over you like a dream, then you will begin to understand."

As a child, she dreamt about institutions where the kids form armies to fight the administration. She reenacts portions of this in the *Lighthouse Project*, where the authority figures are barely present. After several encounters in the institution, it is destroyed by fire and Boody's young heroine is once again orphaned (or freed) to wander the land alone.

Earlier I compared Boody with Wes Anderson and though she shares Anderson's romance with the feeling brought on by memory, her erudite and absurd examination of Old Master compositions has more in common with Peter Greenaway (fig. 5). Boody appreciates Greenaway's allegiance to the art of the past and the way he breathes new life into age-old allegories. Like Boody, he flirts with attraction and repulsion. Like Greenaway, Boody plays with overlays of personal marking and writing over her images.

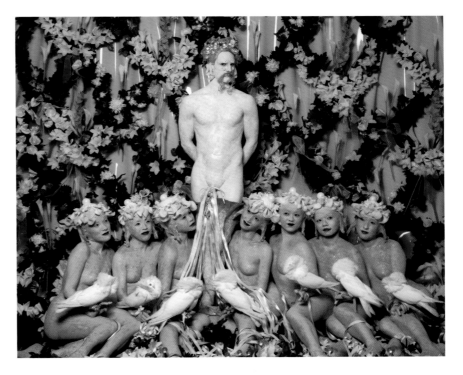

[1] Carl Jung, *Jung on Alchemy*, ed. Nathan Swartz-Salant (London: Routledge, 1995), 35.

[2] All quotes from the artist are from an interview with the author, March 2015.

Figure 5. Peter Greenaway, production photograph from *Prospero's Books*, 1991

Figure 6. Matthew Barney, CREMASTER 5, 1997 Production still

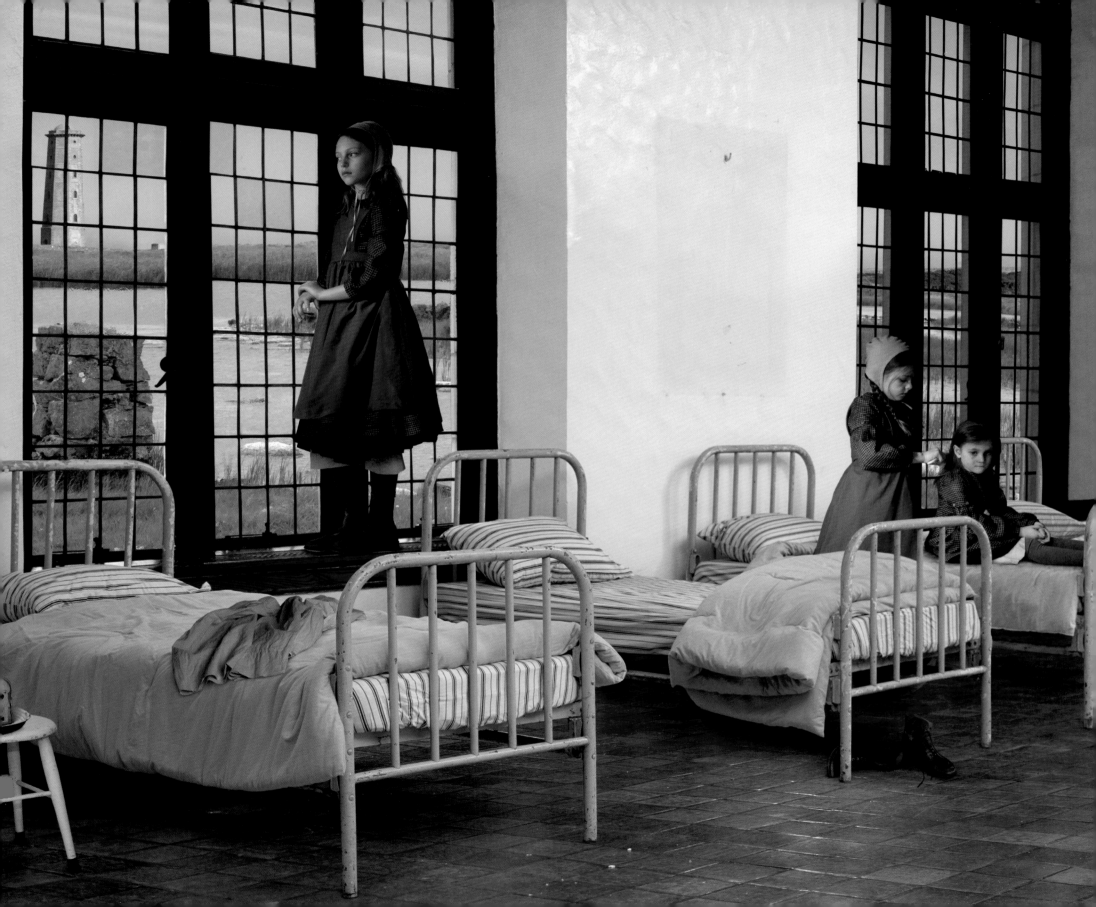

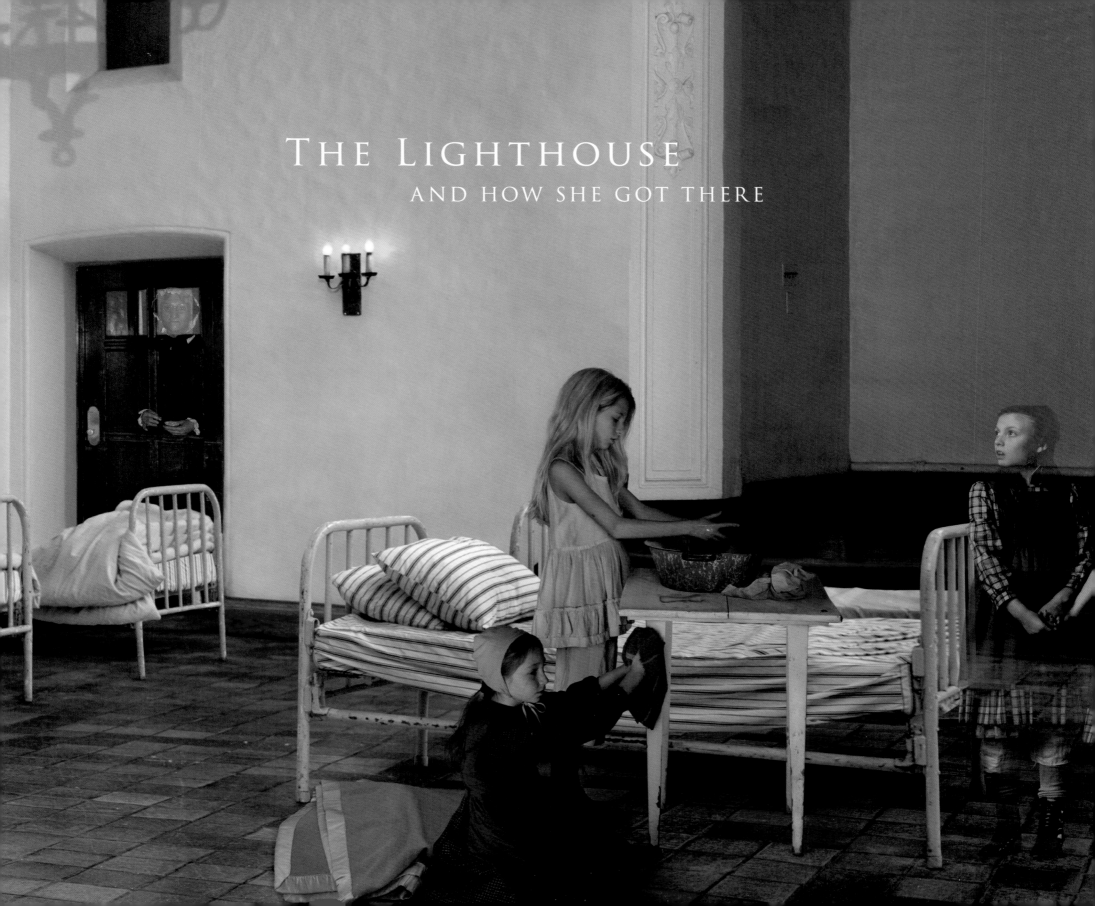

The Lighthouse
AND HOW SHE GOT THERE

THE LIGHTHOUSE PROJECT takes place in a 19th-century Anglo world of Dickensian institutions and vast moorlands where urchins and strays struggle to find their way. The series begins with the dormitory of an asylum, a group of young girls, and a far off lighthouse. After a catastrophic fire destroys the asylum, one lone survivor wanders through barren countryside where bogs threaten to swallow her whole and sheer cliffs impede her progress. The pictures are titled after the opening lines of Victorian novels and stories with orphan protagonists, from *Jane Eyre* to *Adam Bede* to *The Little Mermaid*, illuminating the experience of the girl star who narrowly escapes disaster and soldiers on.

Each photograph portrays a suspenseful moment in the shape-shifting narrative, which entangles the viewer with the fate of the orphaned child. Resonating with the glass eyeball embedded in the picture frame, the girl relentlessly pursues her search for an intact "I," doggedly picking up the pieces of her shattered self and gluing them back together and sweeping us along in the universal yearning for belonging and home.

Night is generally my time for walking, 2006

(previous) *There was no possibilty of taking a walk that day*, 2006

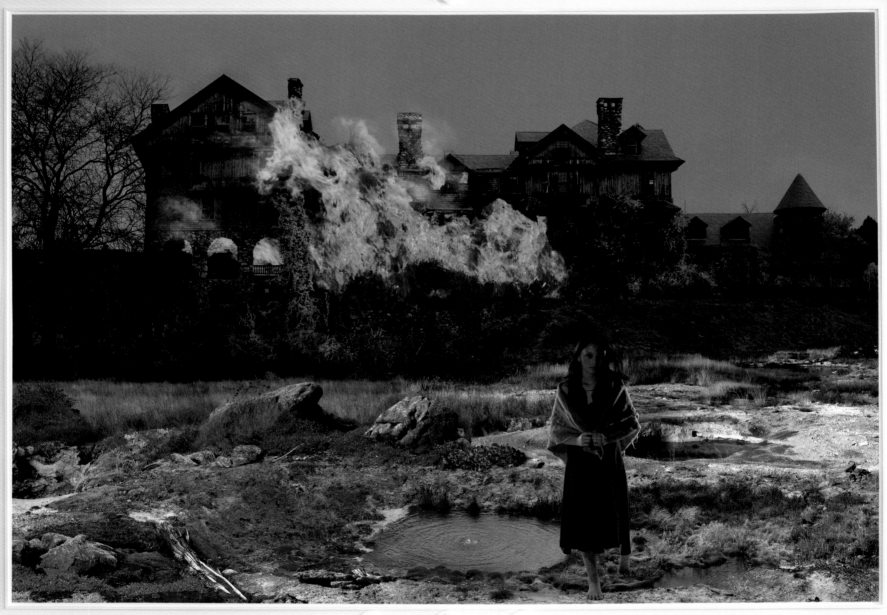

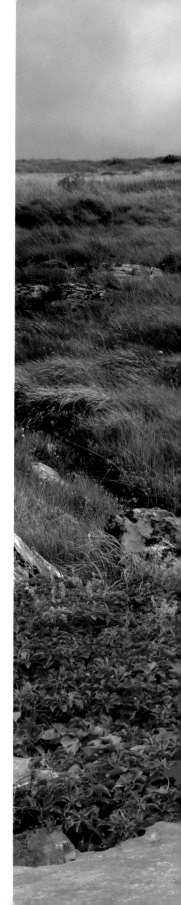

Whether I shall turn out to be the hero of my own life or whether this station shall be held by anyone else, this story must show, 2006

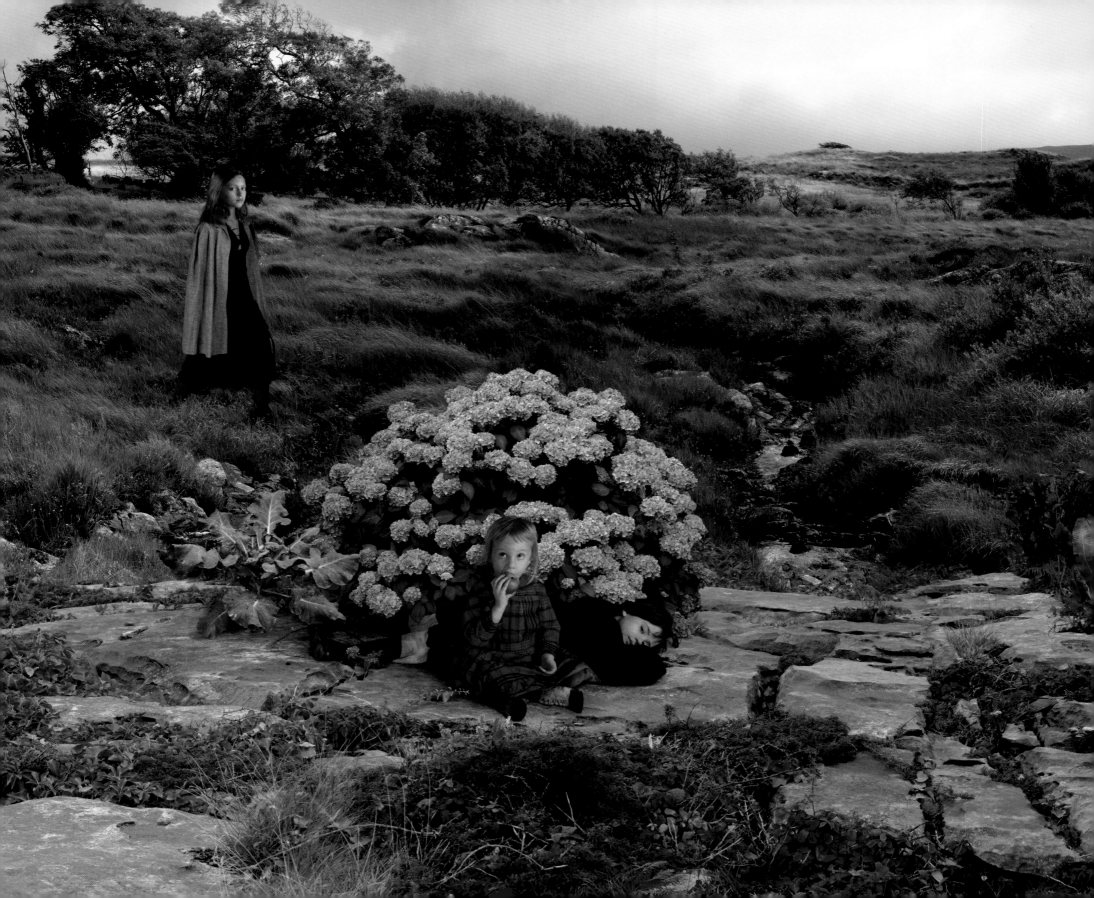

You will rejoice to hear that no disaster has accompanied the commencement of an enterprise which you have regarded with such evil forbodings, 2008

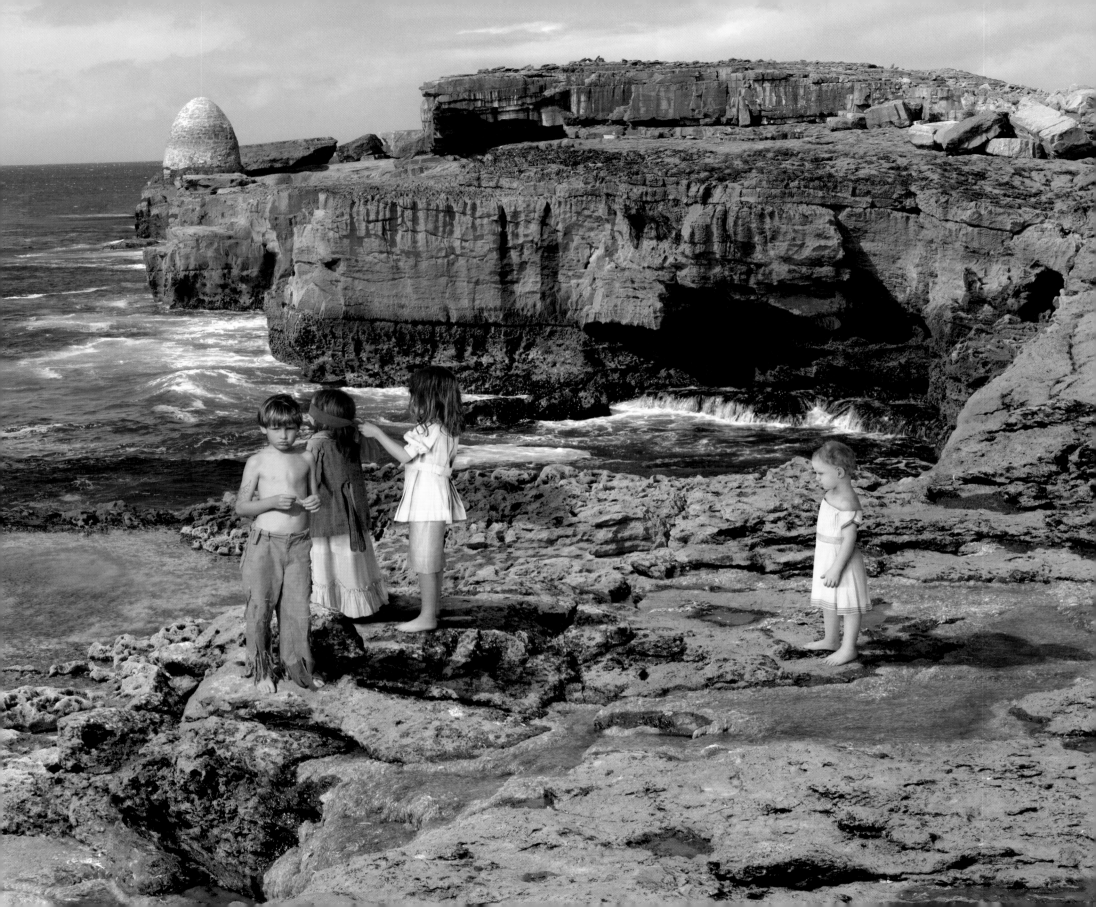

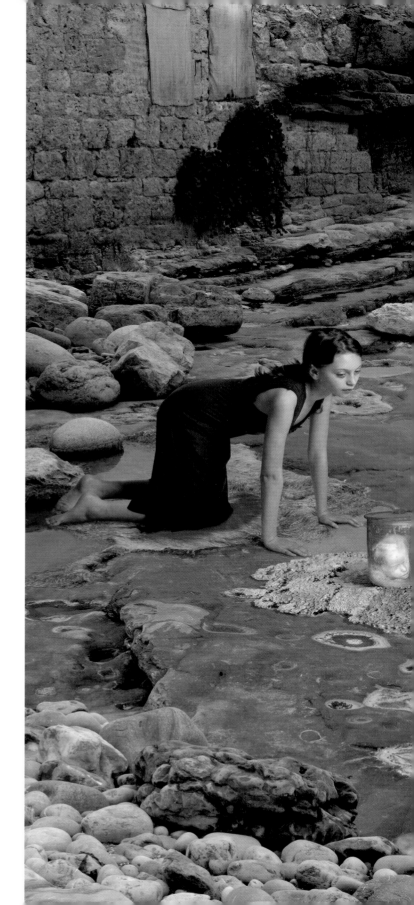

I am the native of a sea-surrounded nook, a cloud-enshadowed land..., 2007

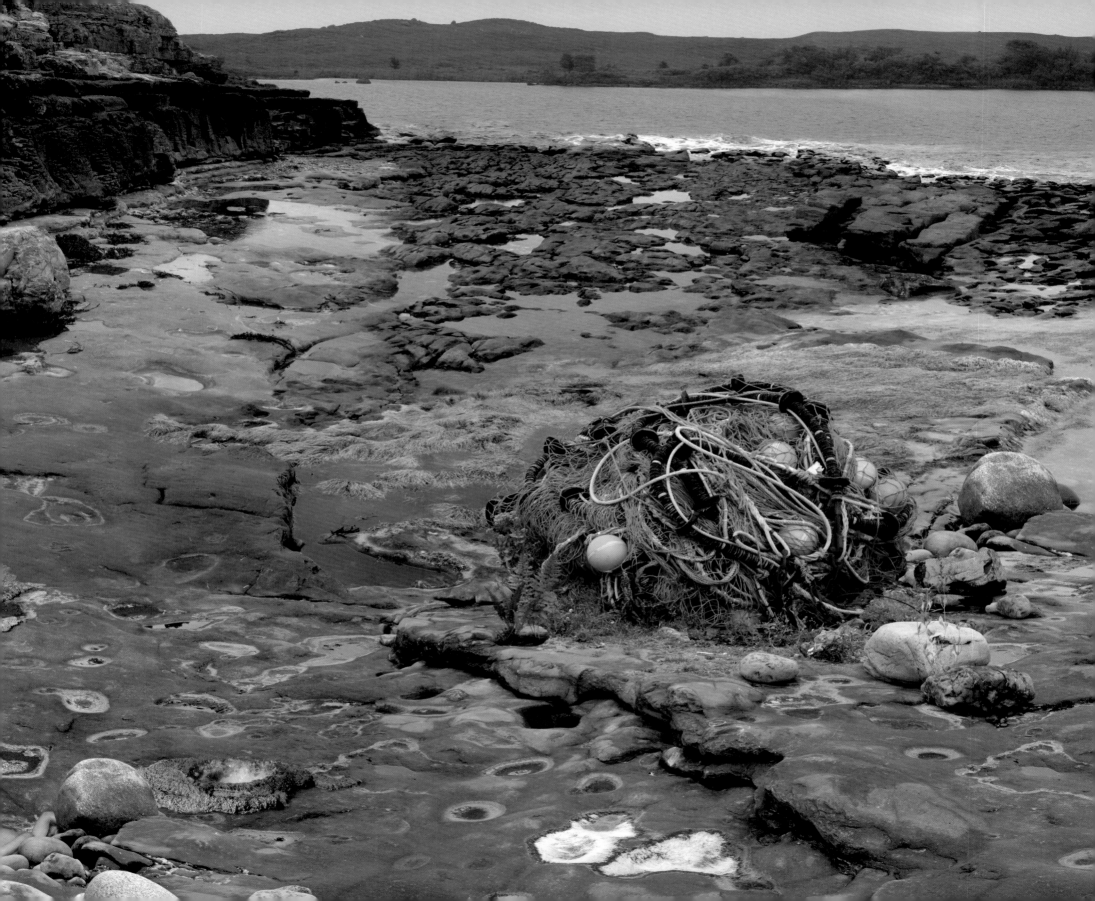

East o' the sun, West o' the Moon, 2006

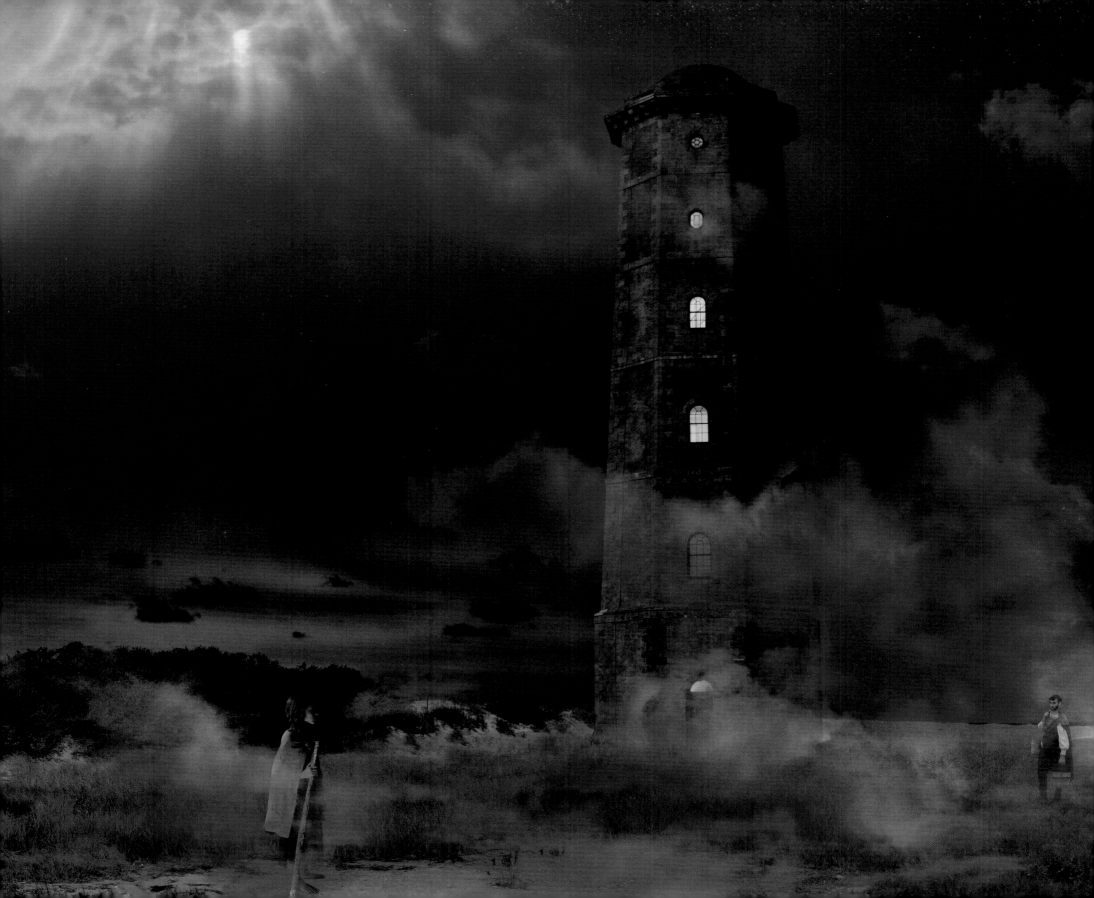

With a single drop of ink for a mirror, the sorcerer undertakes to reveal far-reaching visions of the past, 2010

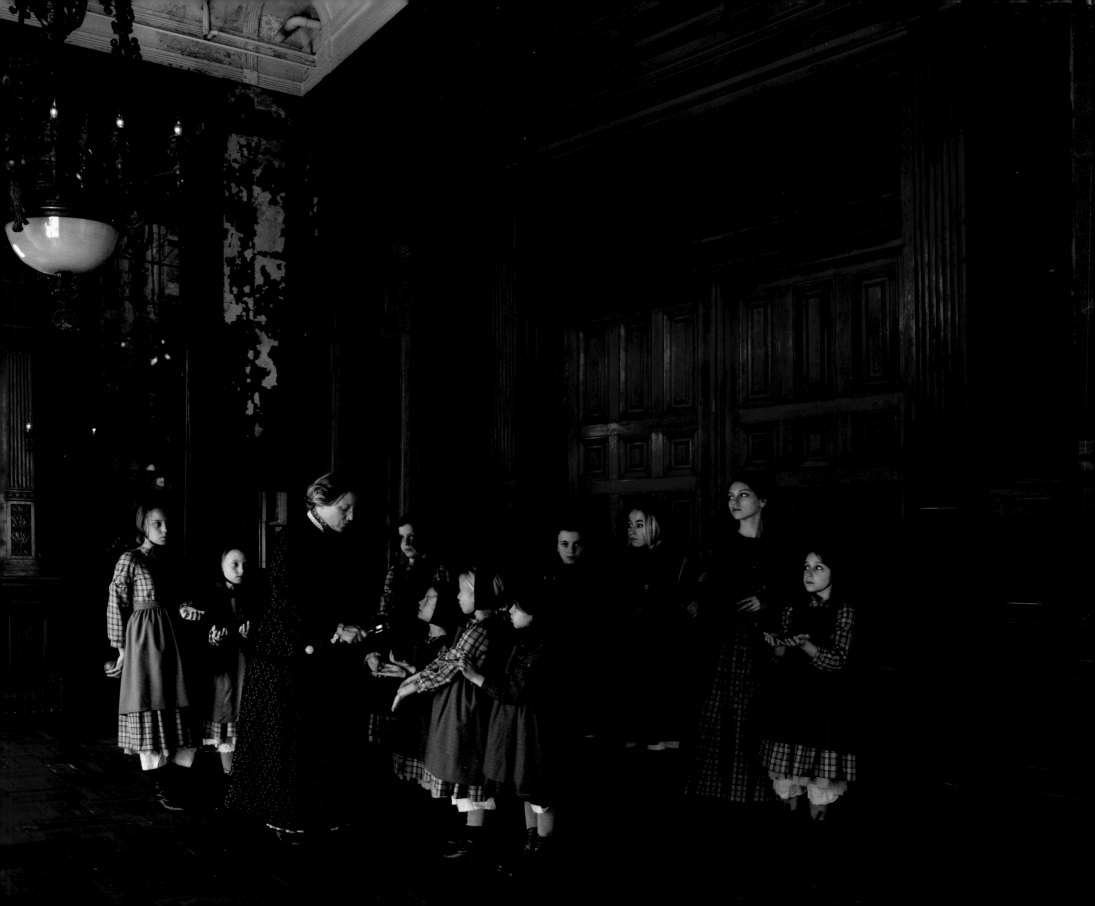

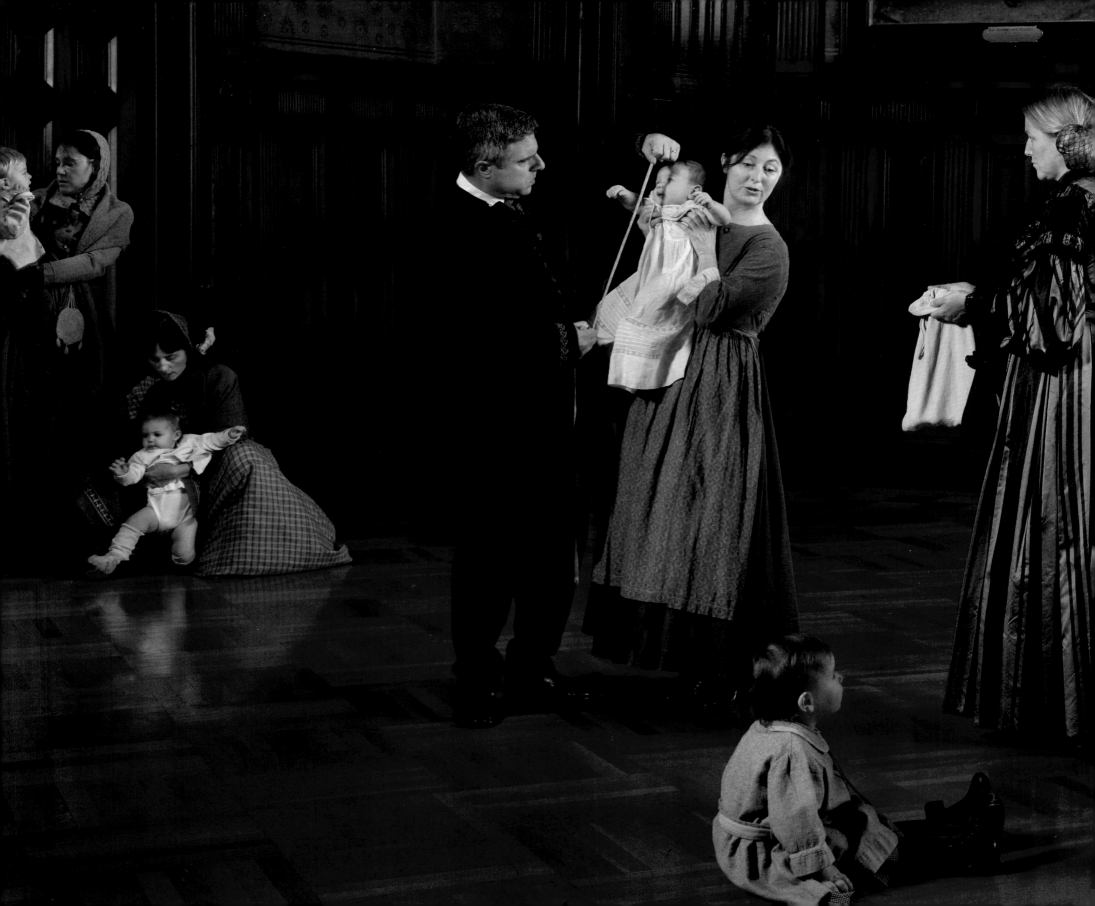

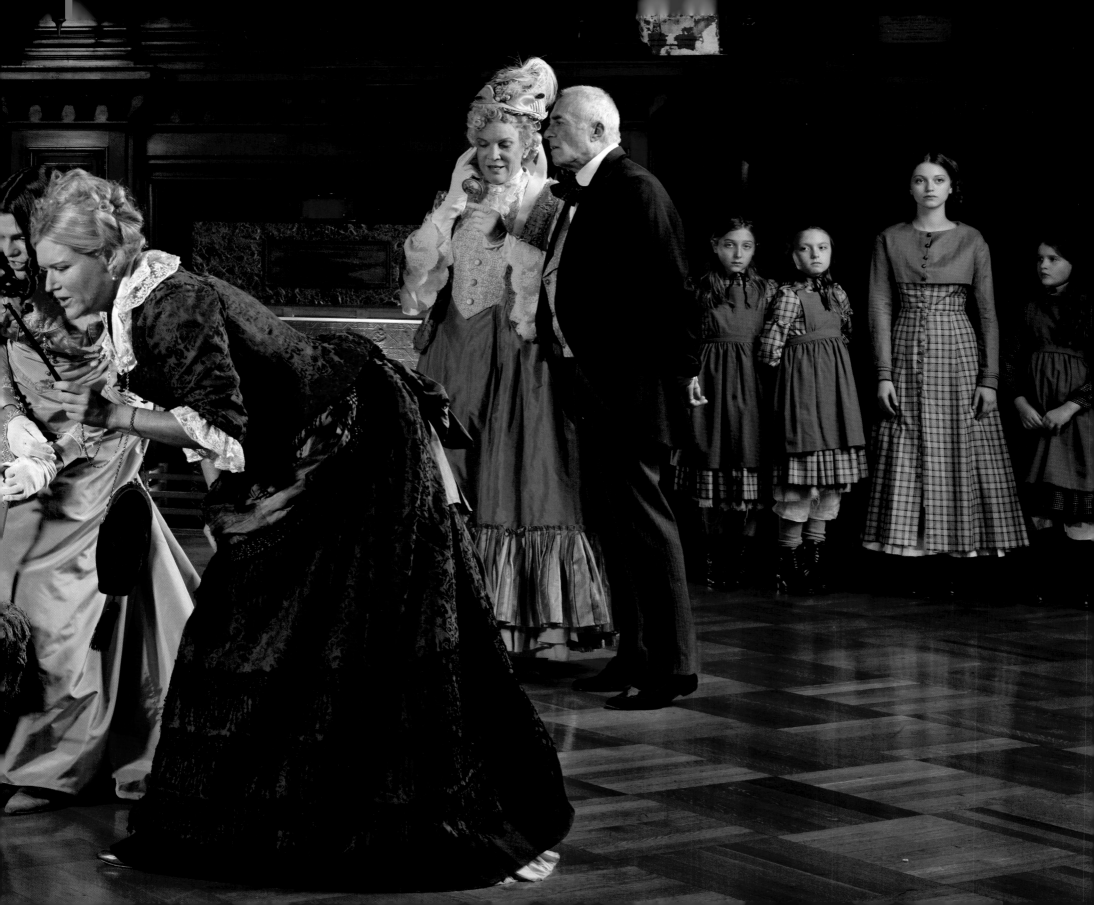

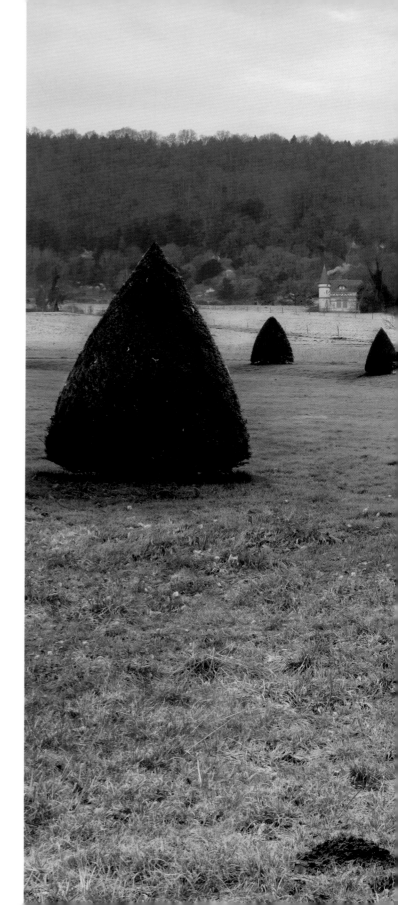

It was one of those exquisite days that come in winter,
in which it seems no longer the dead body, but the lovely ghost of summer, 2009

(previous) *All true histories contain instruction,* 2010

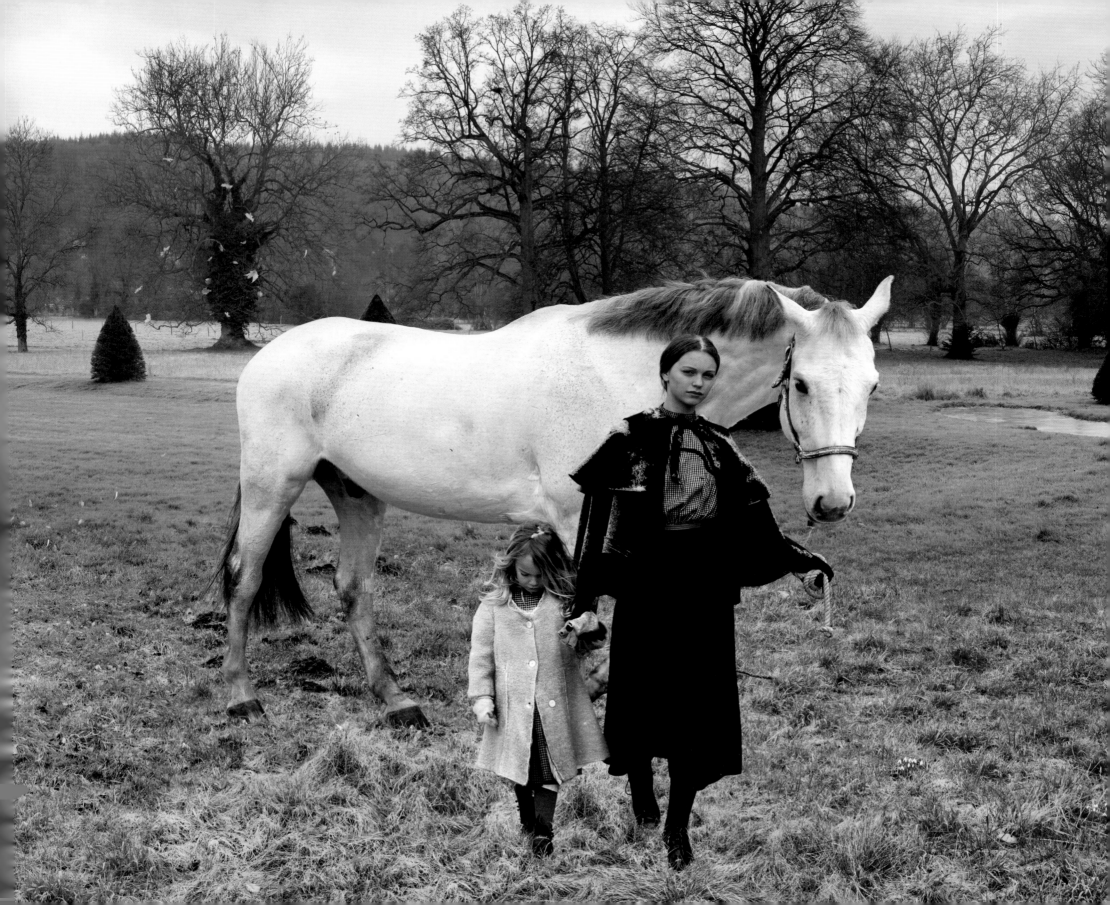

I was apprenticed to the sea when I was 12 years old and I have encountered a great deal of rough weather, 2009

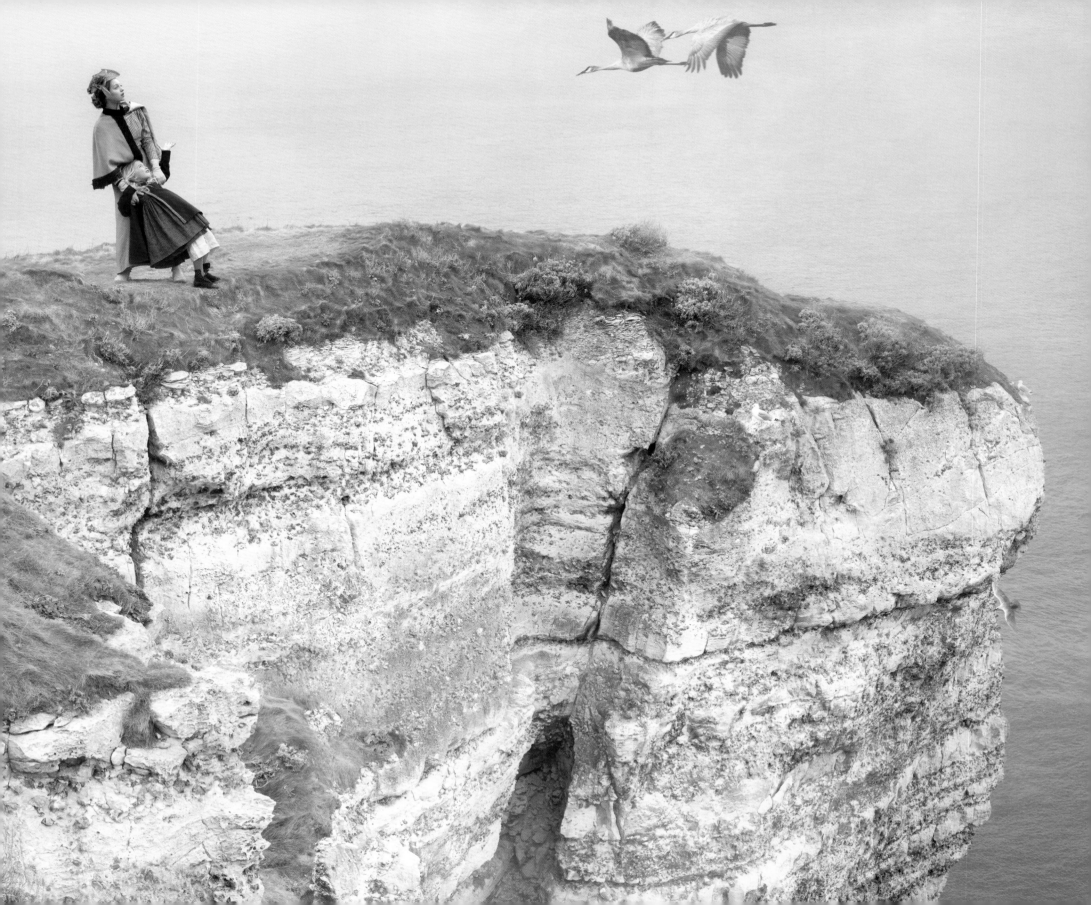

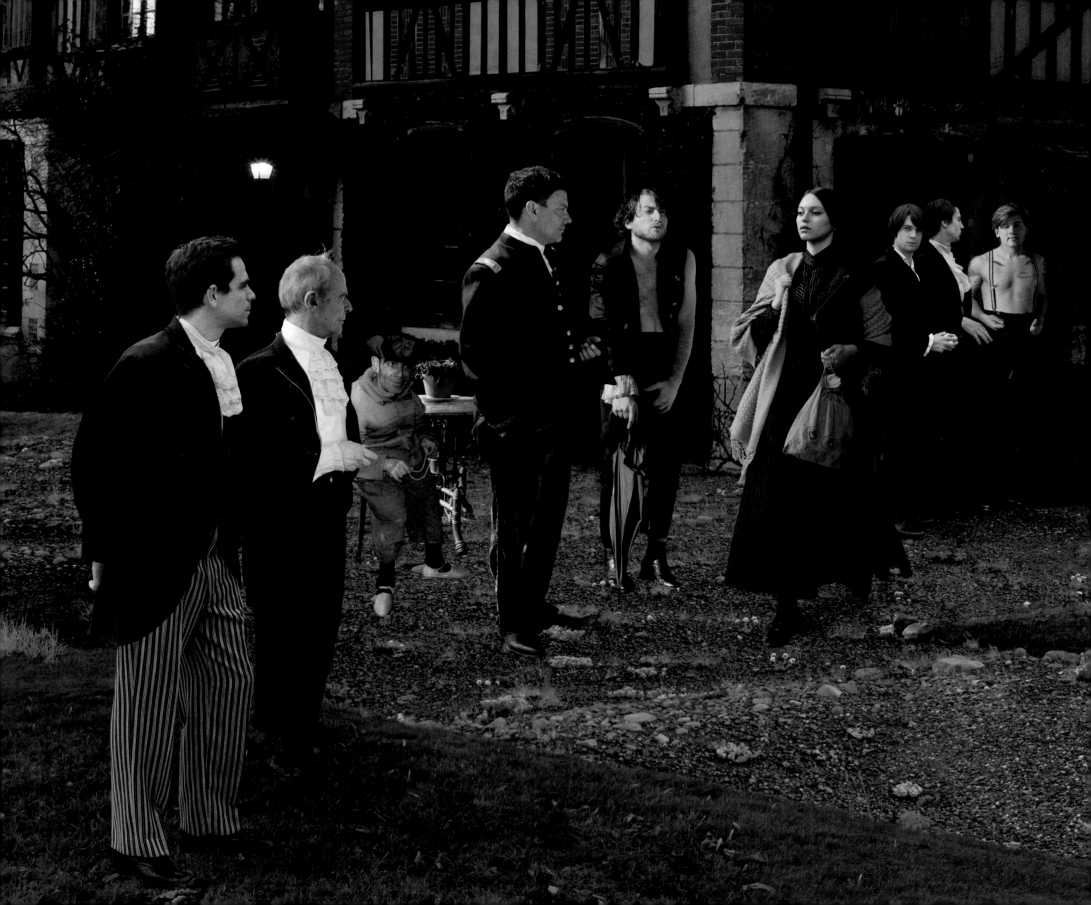

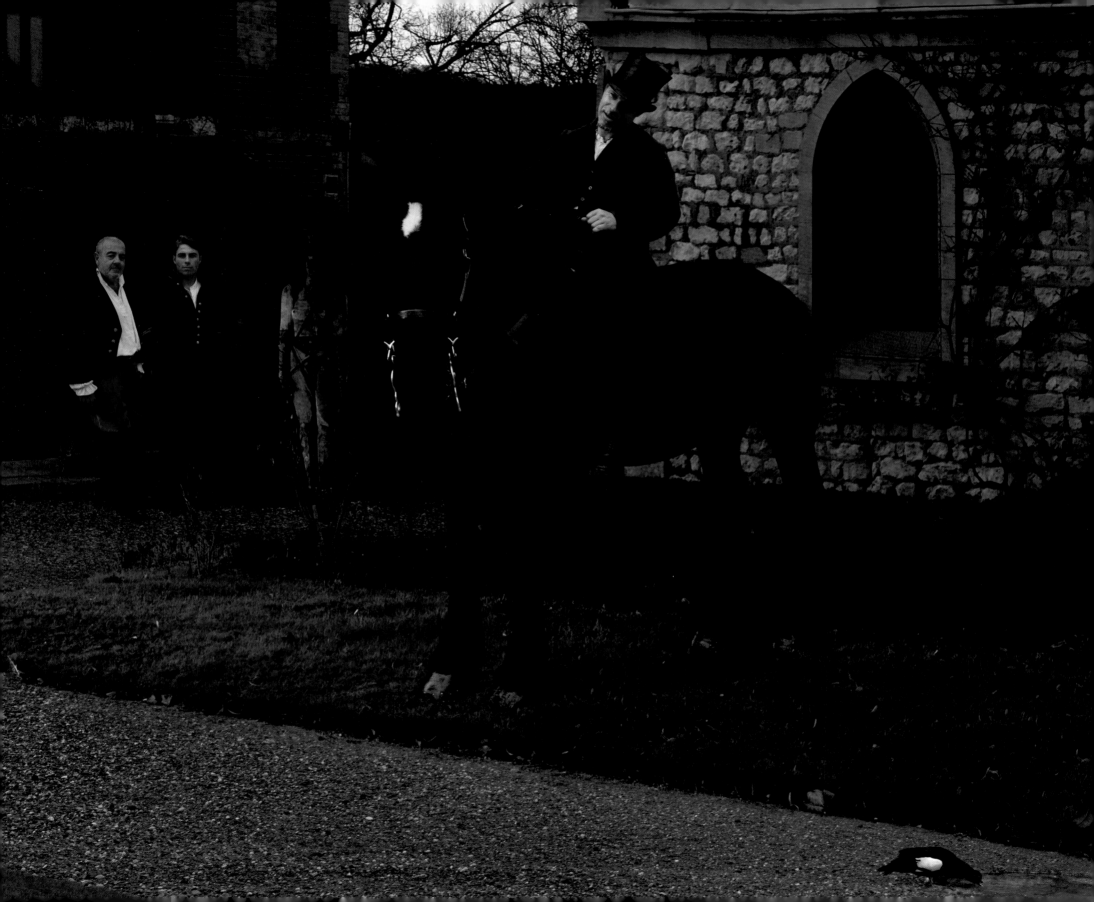

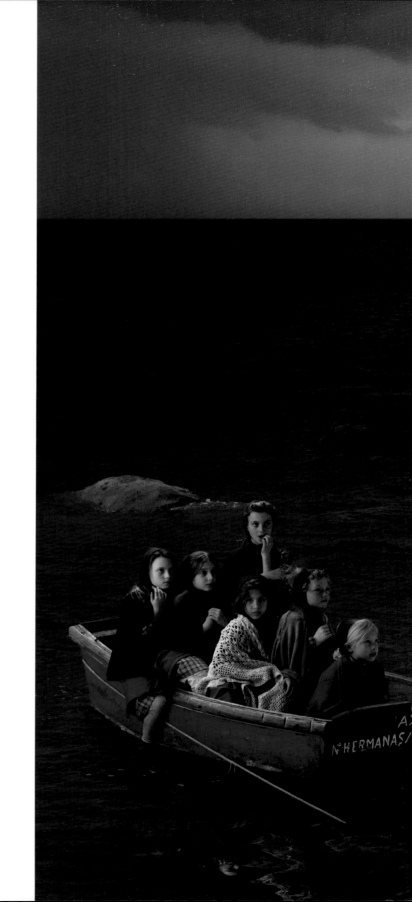

Far out at sea the water is as blue as the bluest cornflower, and as clear as the clearest crystal, but it is very deep..., 2009

22

(previous) *Guard! What place is this?*, 2009

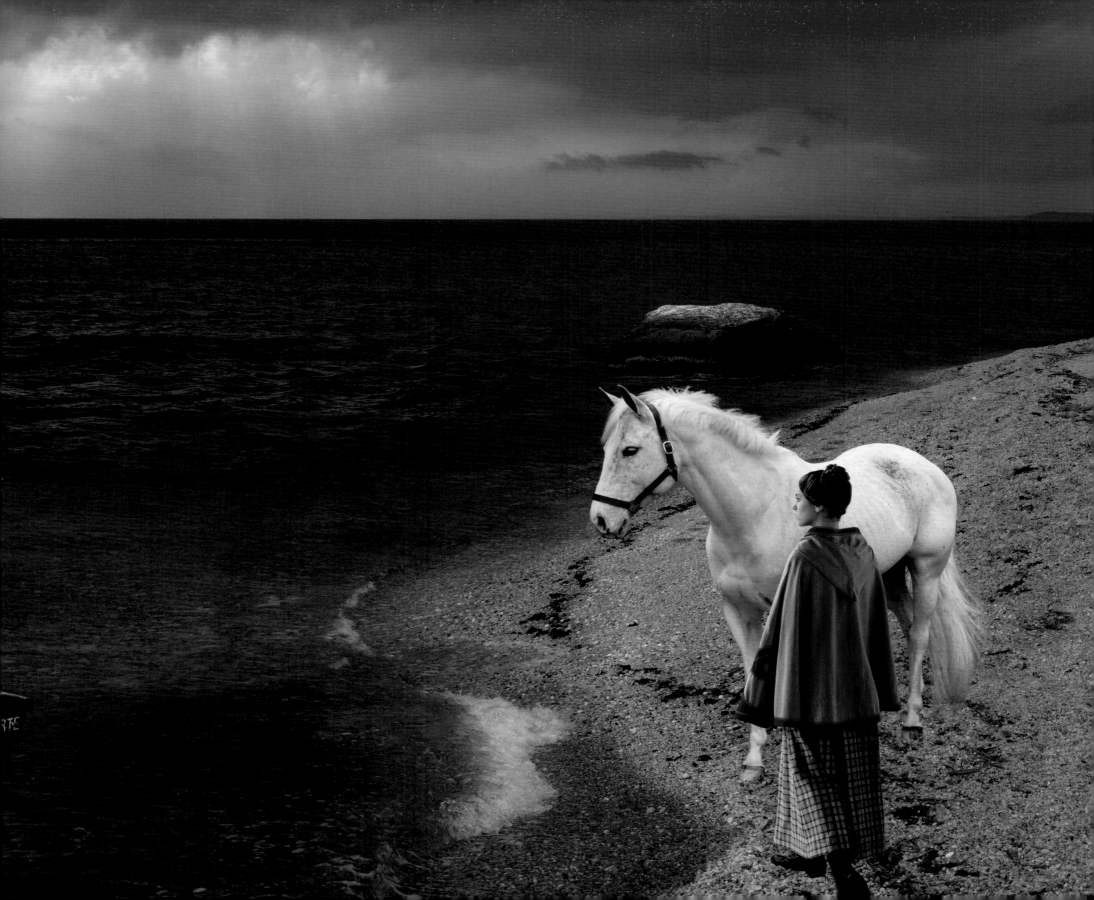

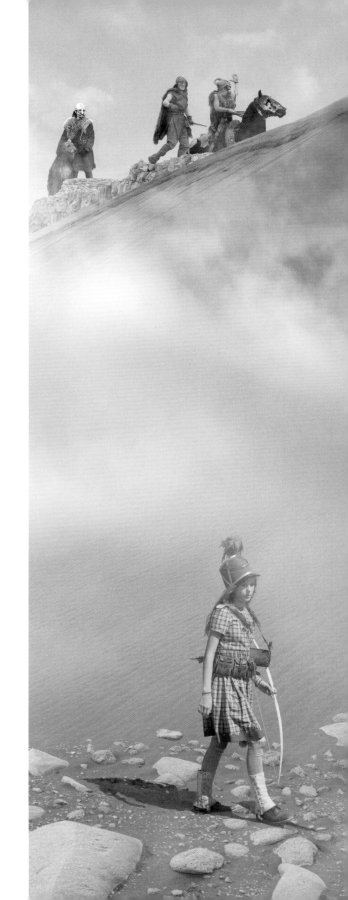

There were once four children who spent their holidays in a white house,
happily situated between a sandpit and a chaulkpit, 2011

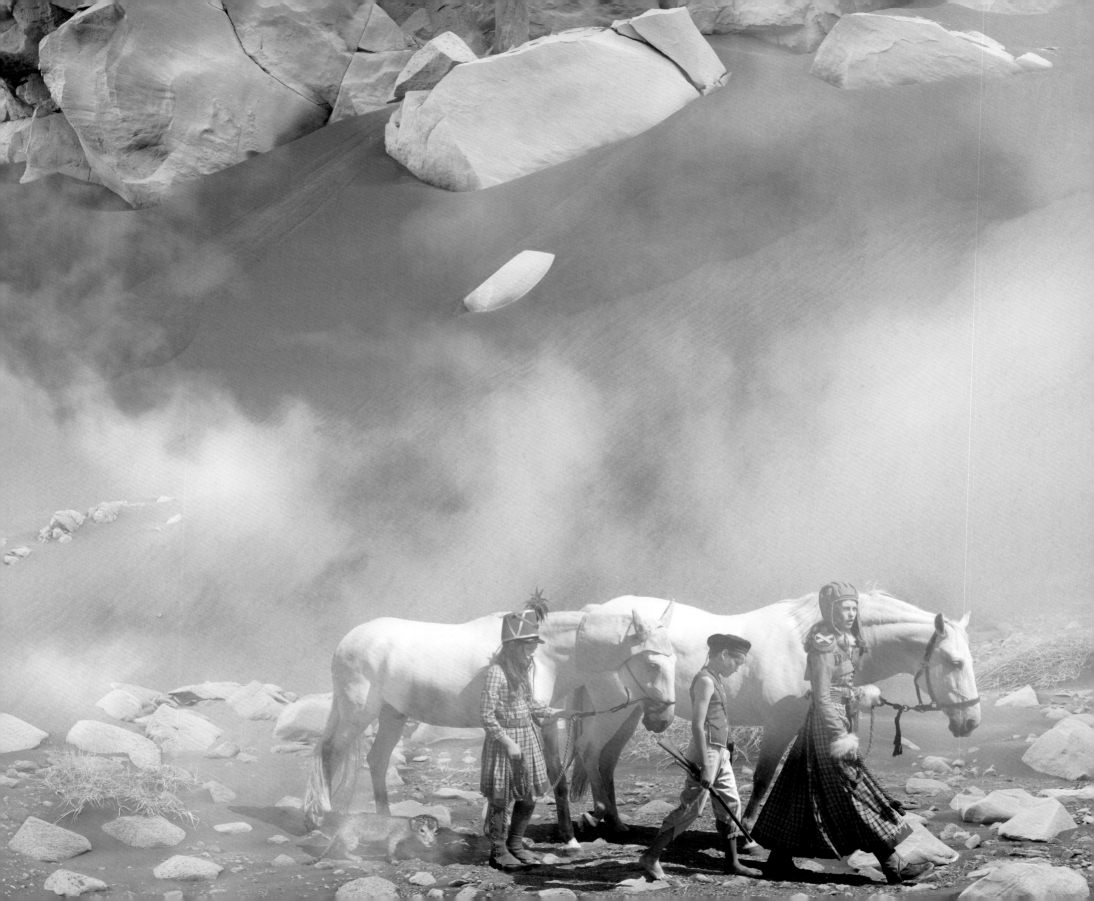

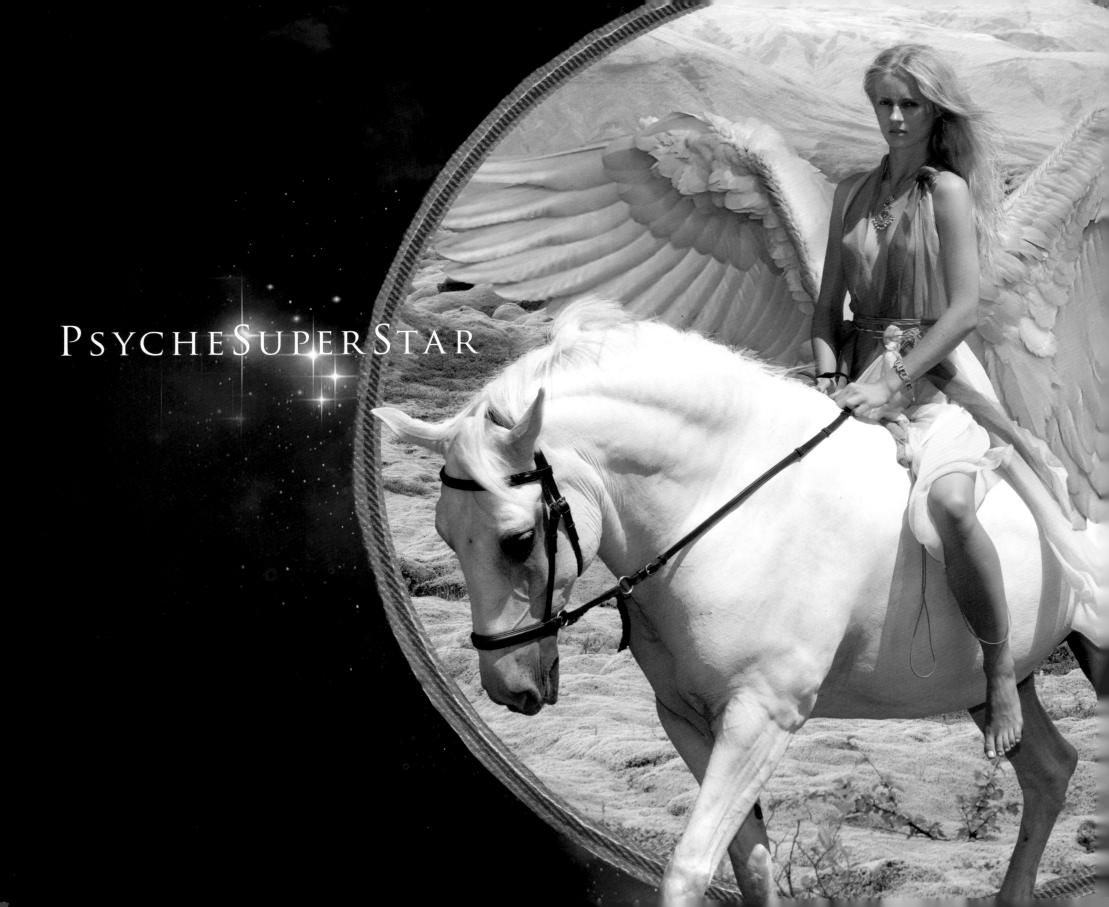

PSYCHESUPERSTAR is a cosmic coming-of-age tale of an adolescent girl's quest for selfhood and true love. This epic story, told in two photographic series, explores the emotional turmoil of a misfit girl in her privileged life and her journey to unchain herself in a fantastical underworld. A combination self-help primer, David Lynchian odyssey, and Judy-Blume-on-crack fairy tale, this psychologically driven "double feature" tracks the metamorphosis of a hapless child into the ultimate female heroine. She arises, PsycheSuperStar, slayer of her own dragons and pursuer of dreams.

THE FIRST SERIES, *Psyche and Smut*, follows wide-eyed and innocent Psyche as she falls into a subterranean realm ruled by frogs and concubines. There she becomes fatefully transformed by one of its fiercest inmates – her deviant twin sister, Smut. Psyche endures many trials of initiation as she grapples with her sister, all part of her journey toward her dark inner core. At one point, a cocoon forms around Psyche and she emerges from it with a rat's tail. At another, Smut reveals a grotesque deformity and Psyche flees in revulsion. In the end, the twins reunite, generating an energy field that fuses them into one. PsycheSuperStar is born, but she has yet to live up to her name.

Psyche's is not the only drama of the underworld, for other peculiar residents appear equally embroiled. Boody arranges their subplots and cameo appearances along the lower edge of each piece, like filmstrips, the predella of an altarpiece, or the factions of a chaotic mind in revolution.

Psyche AND Love

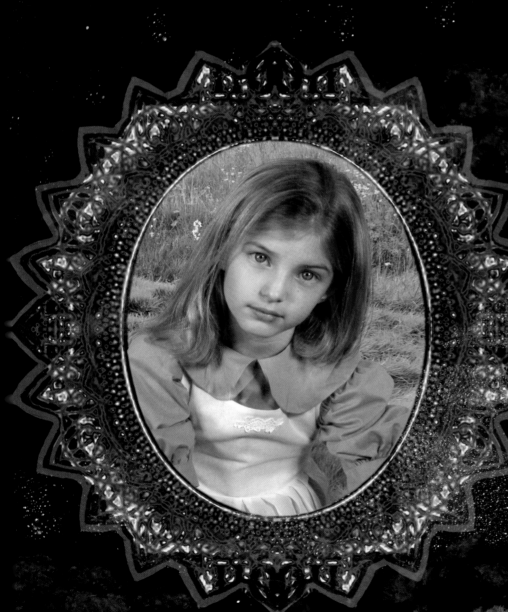

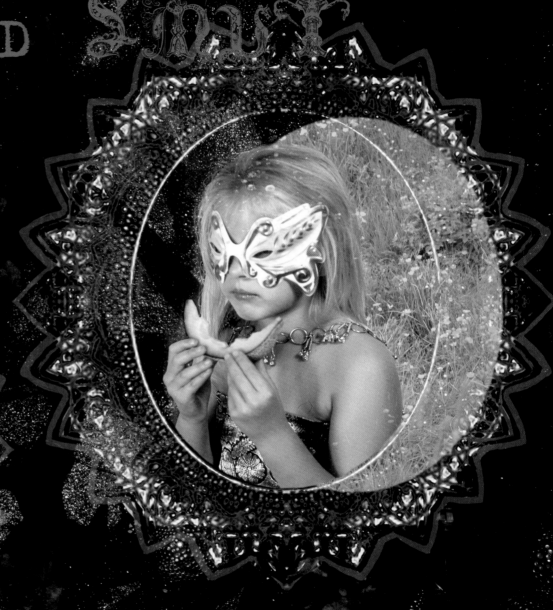

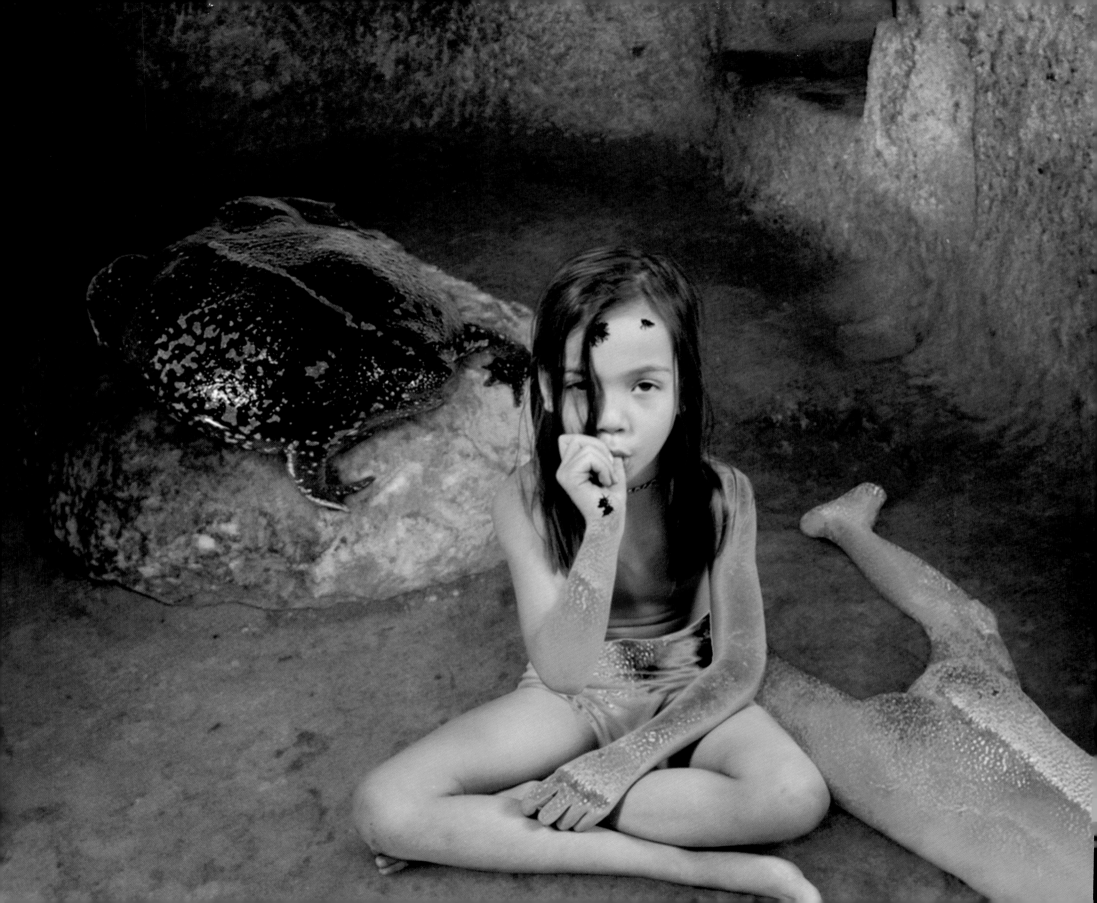

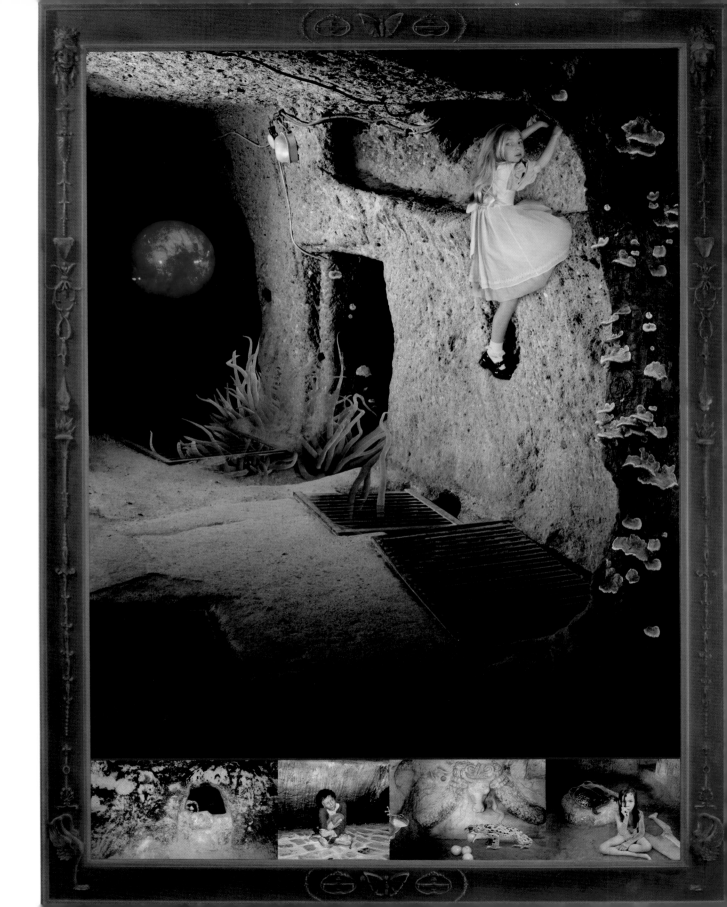

Psyche Enters, 2000

(opposite) *Psyche Enters*, detail, 2000

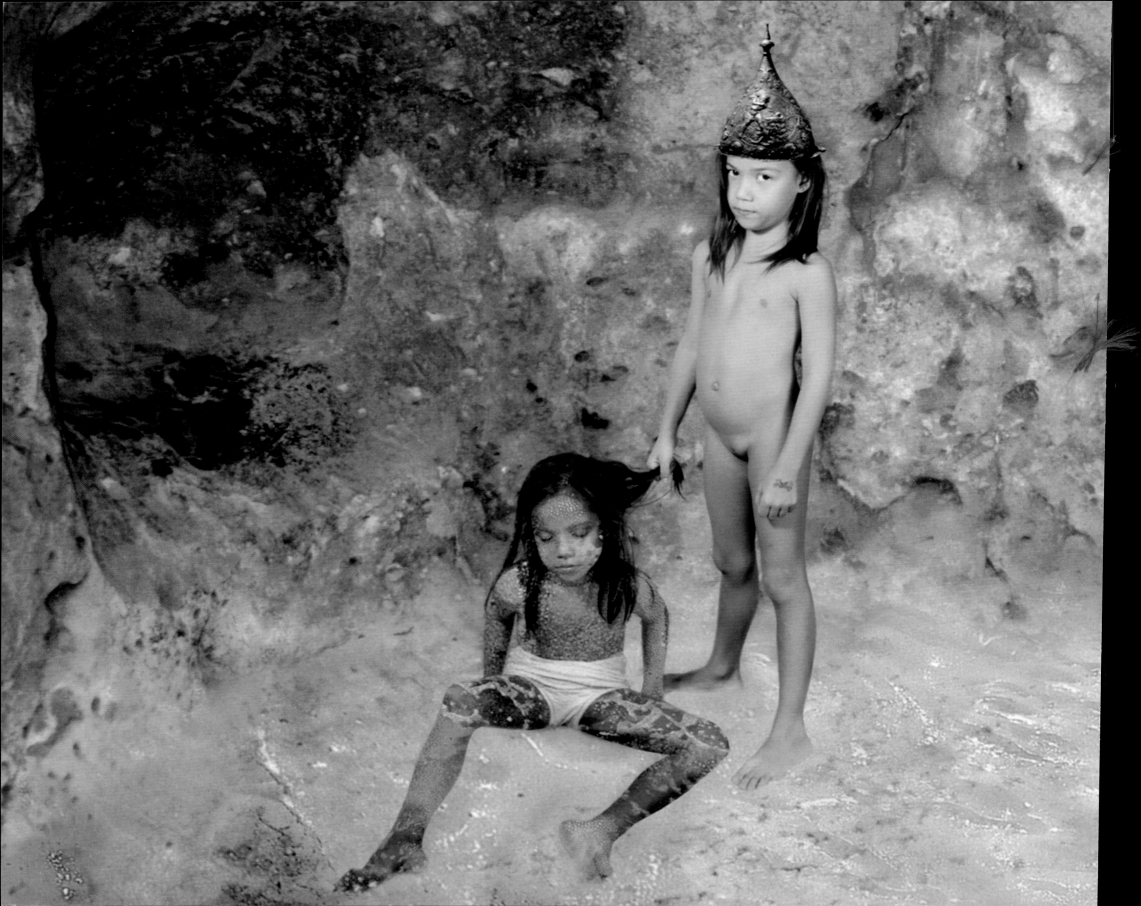

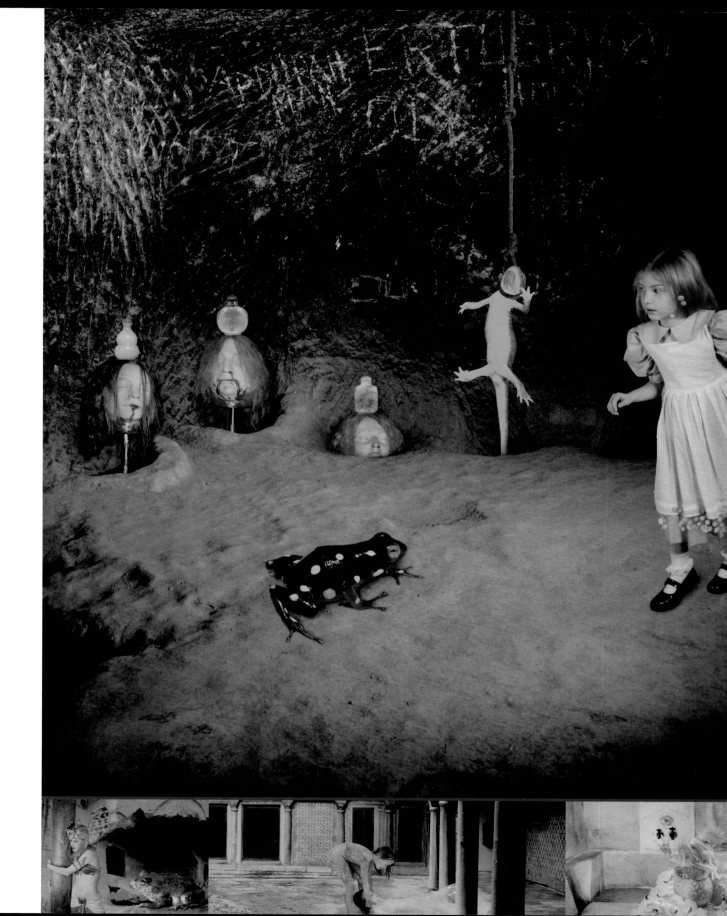

Psyche Sees, 2000

(opposite) *Psyche Wakes*, detail, 2000

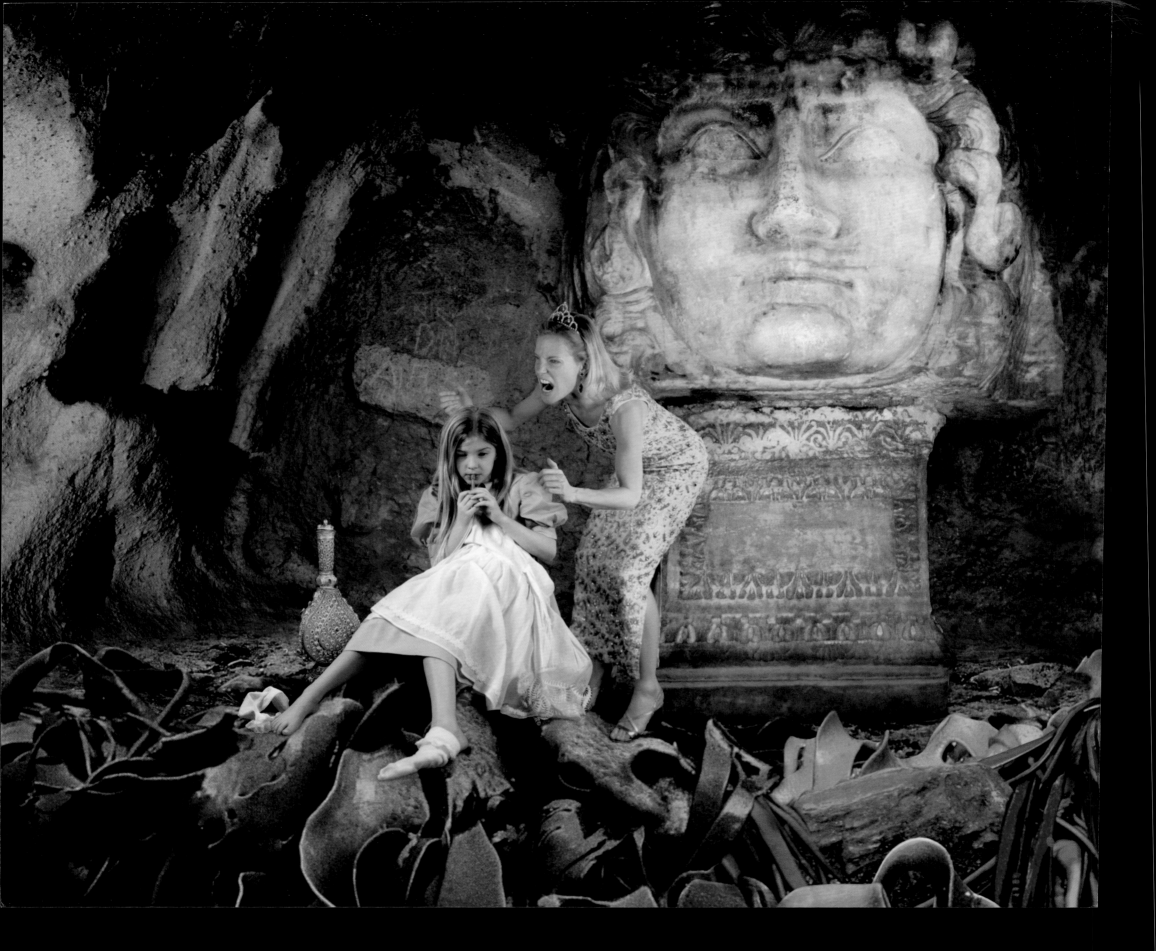

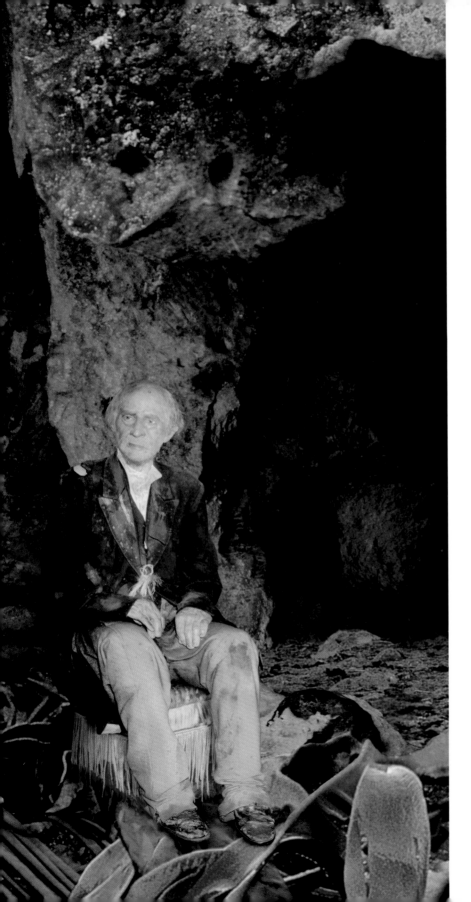

Psyche Smokes, detail, 1999 35

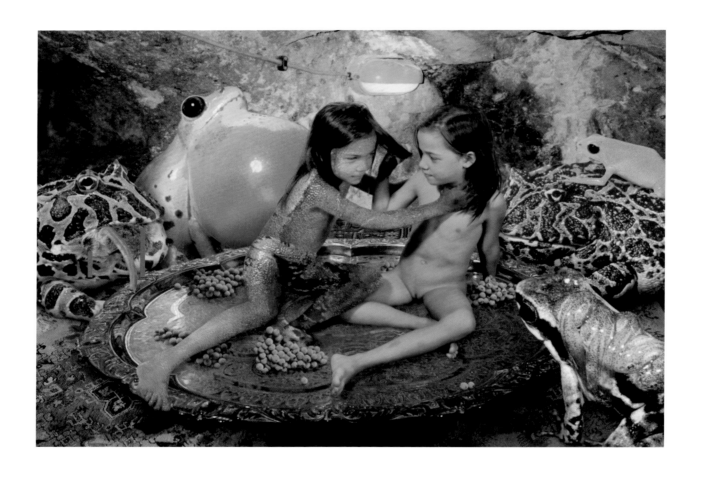

Psyche Sleeps, detail, 2000

(opposite) *Psyche Wakes*, detail, 2000

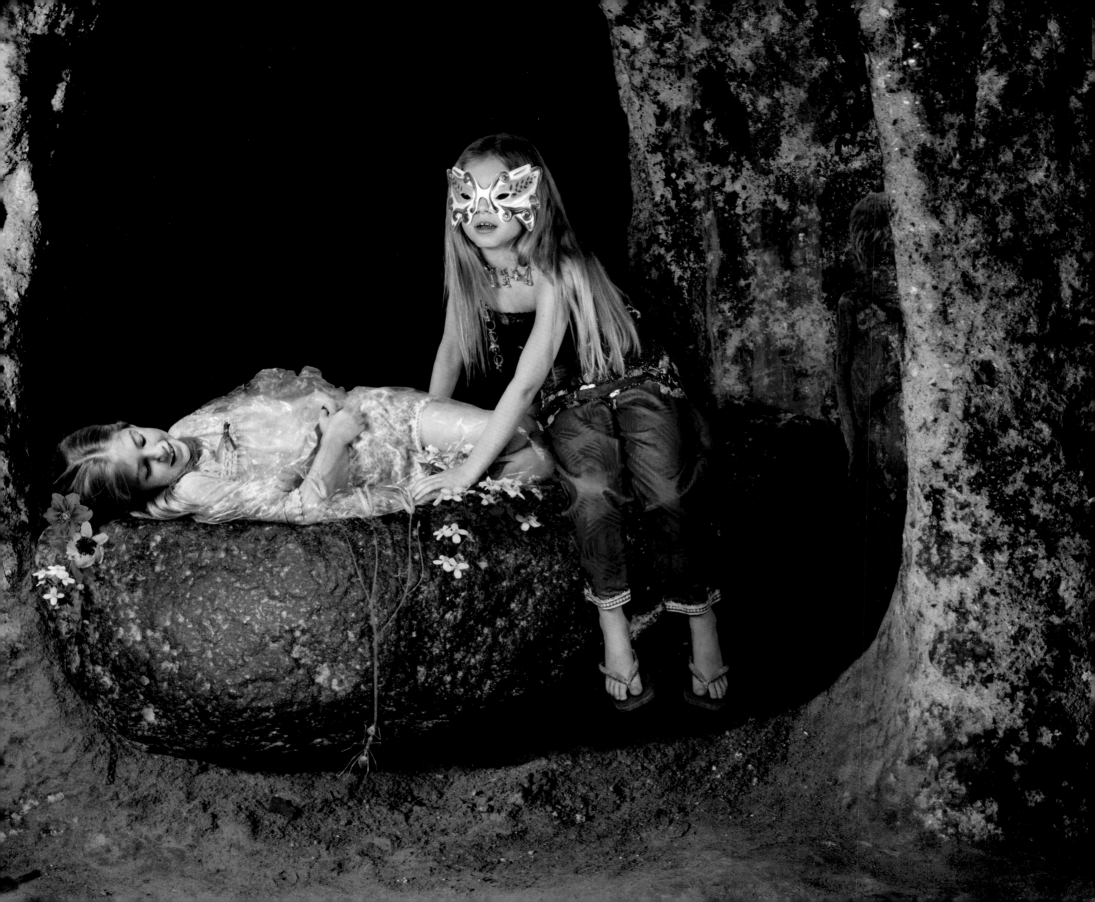

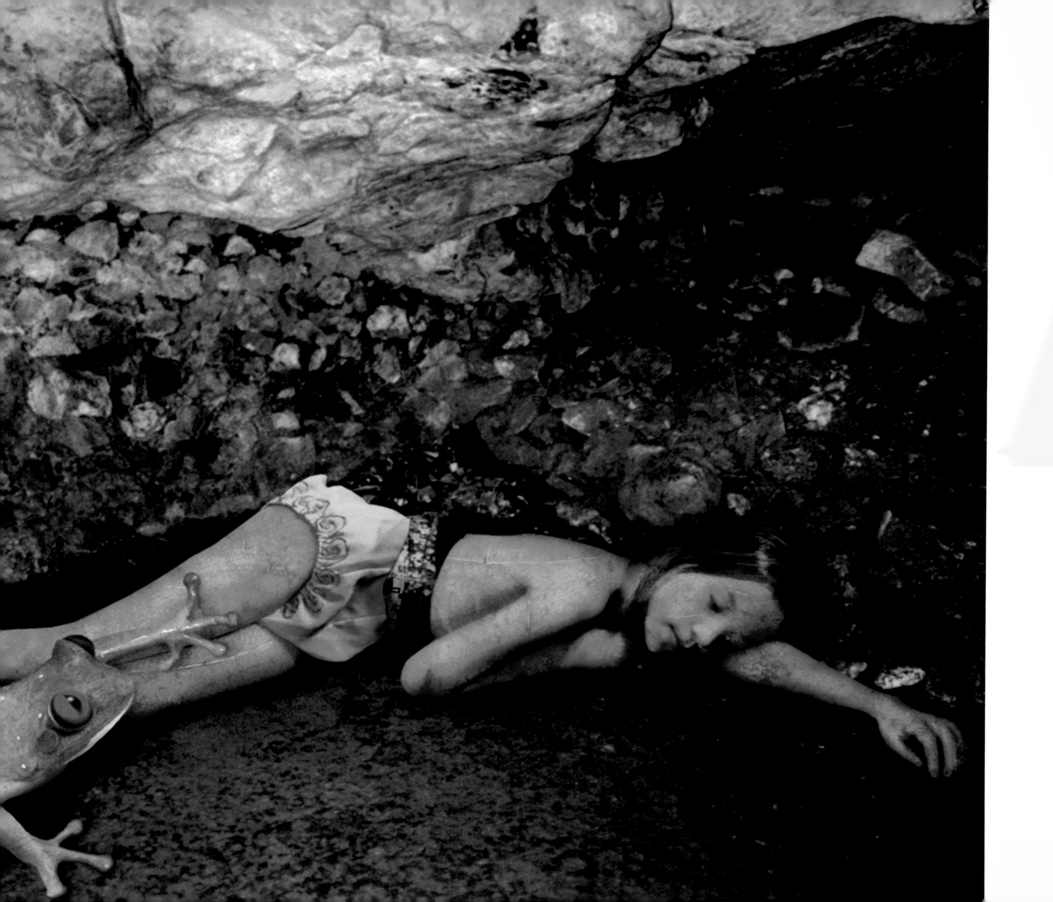

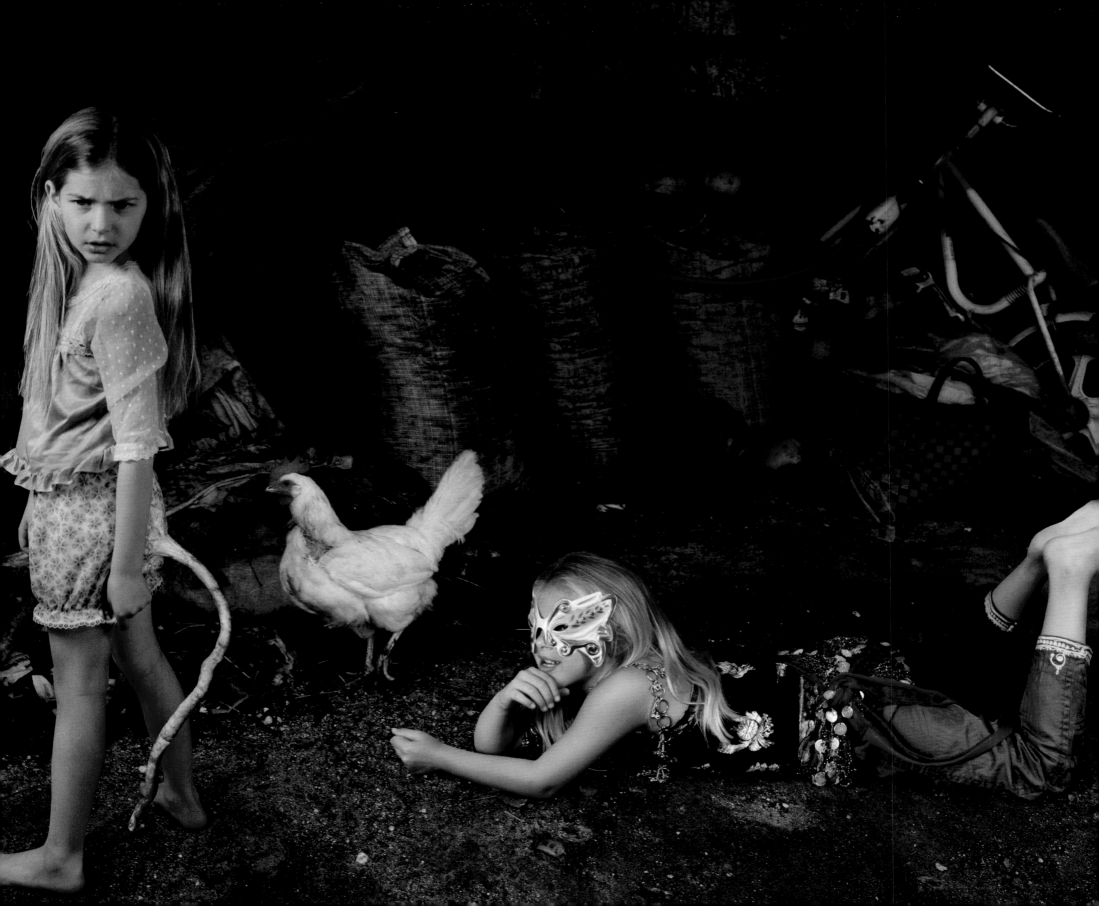

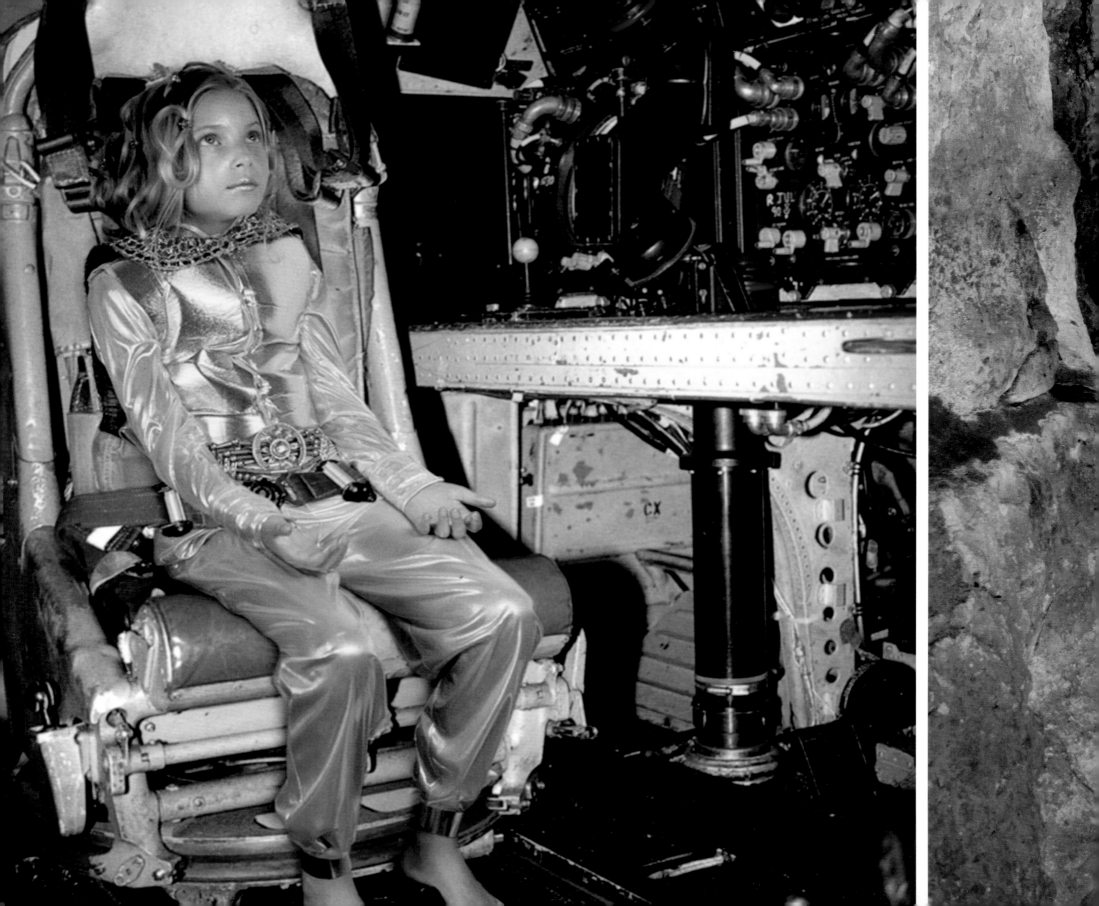

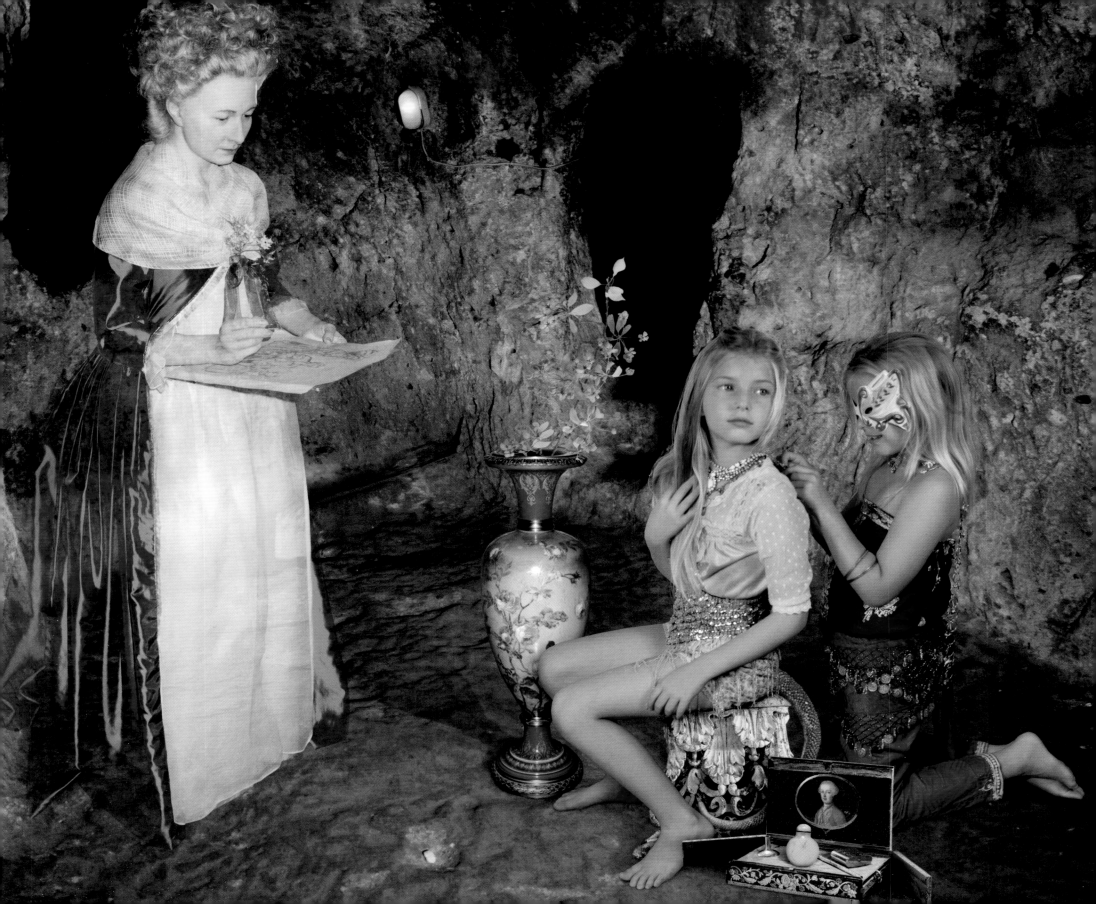

Psyche's Tail, detail, 2000

(opposite) *The Assesment of Smut*, detail, 2000

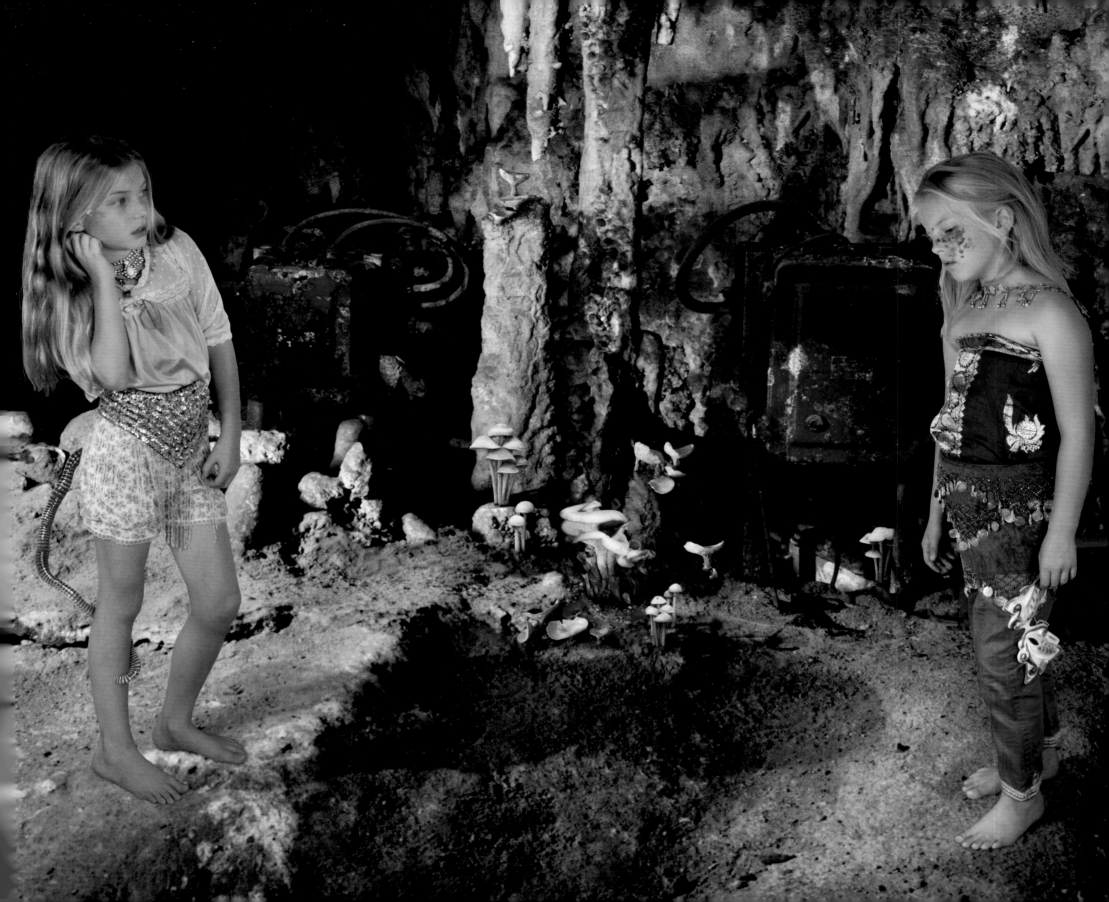

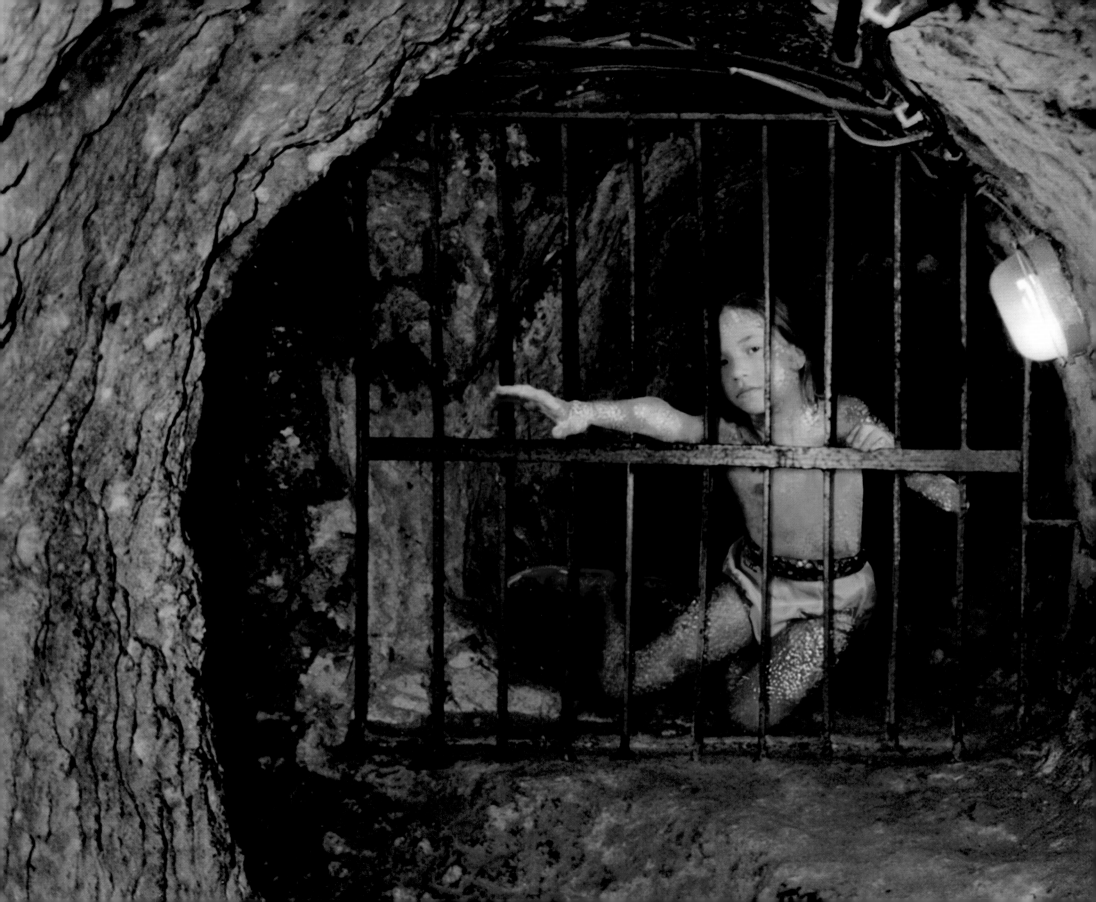

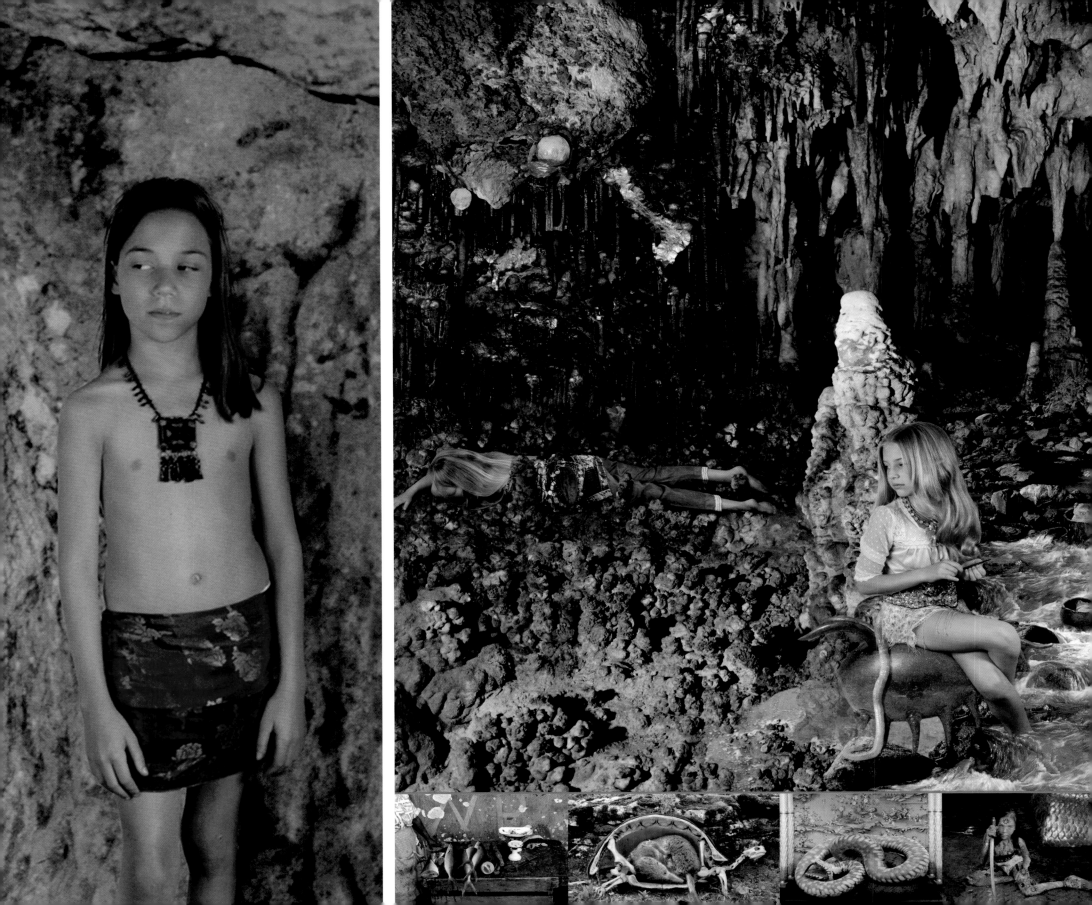

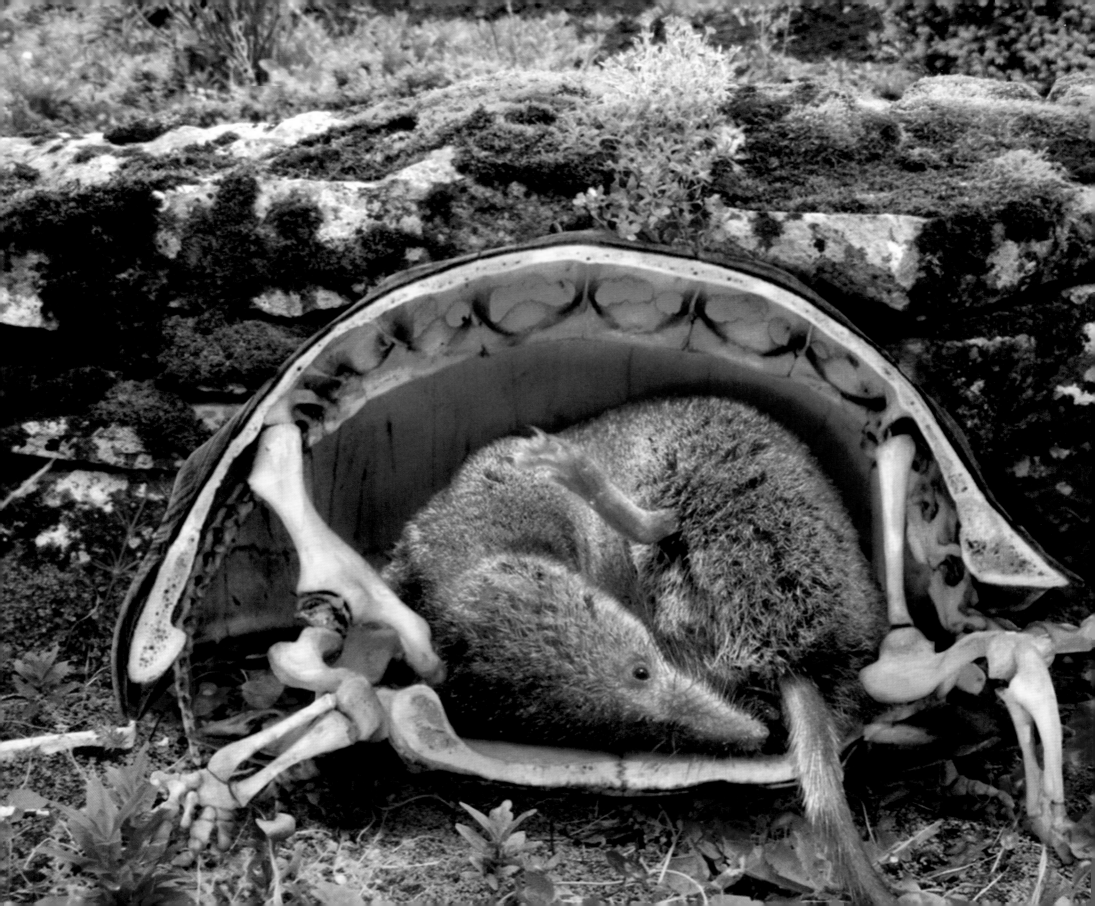

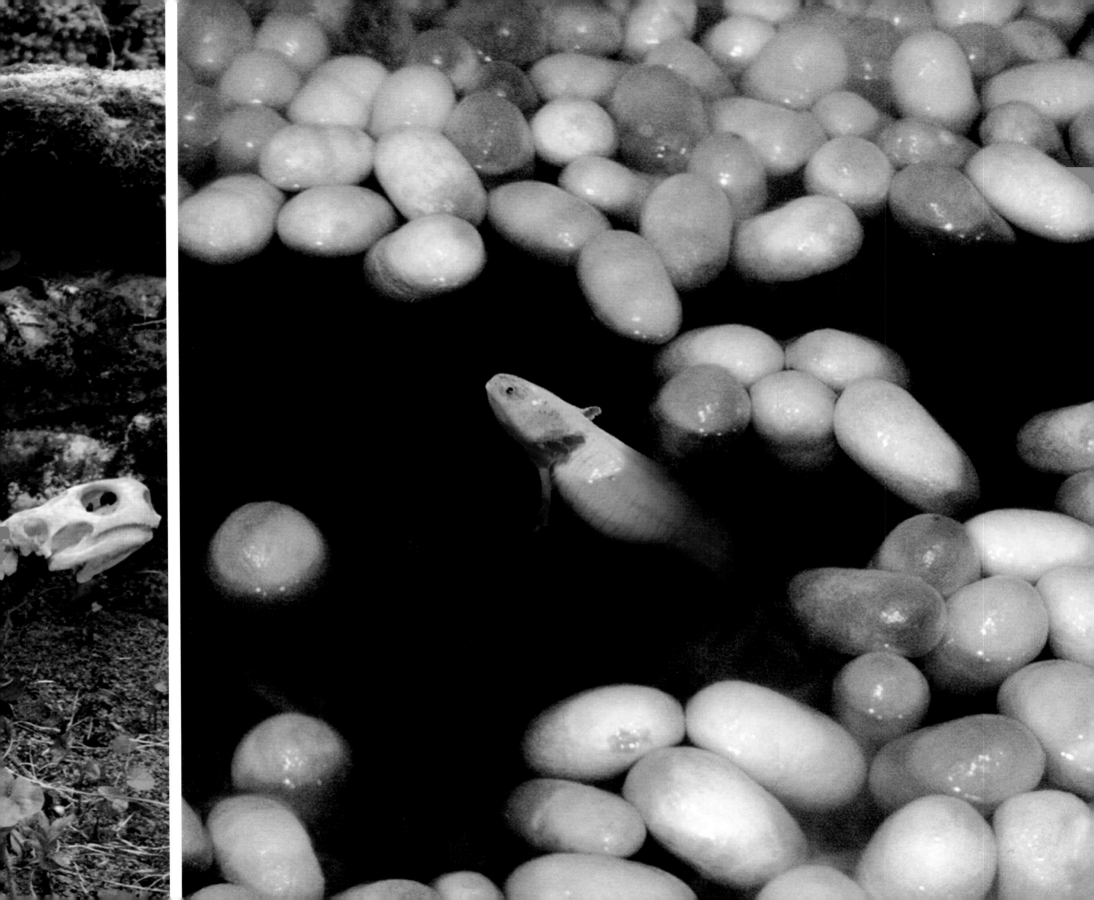

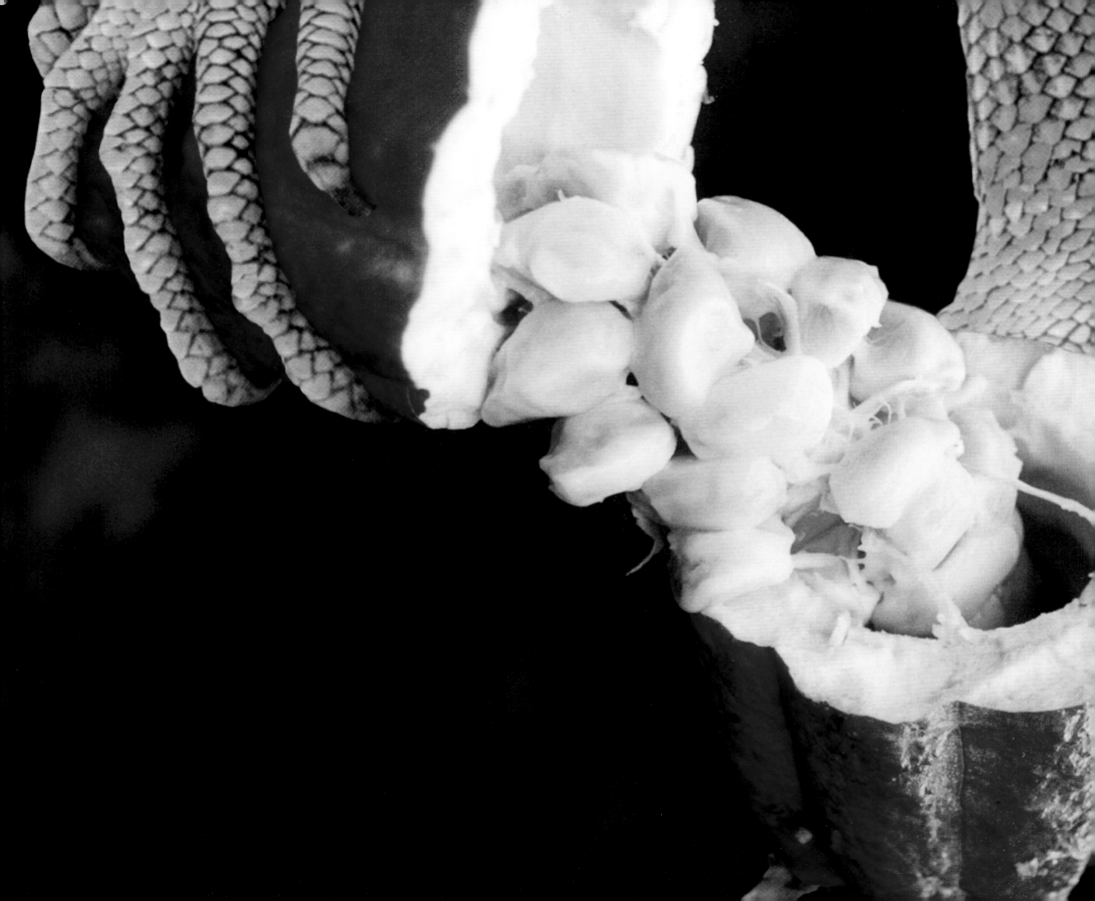

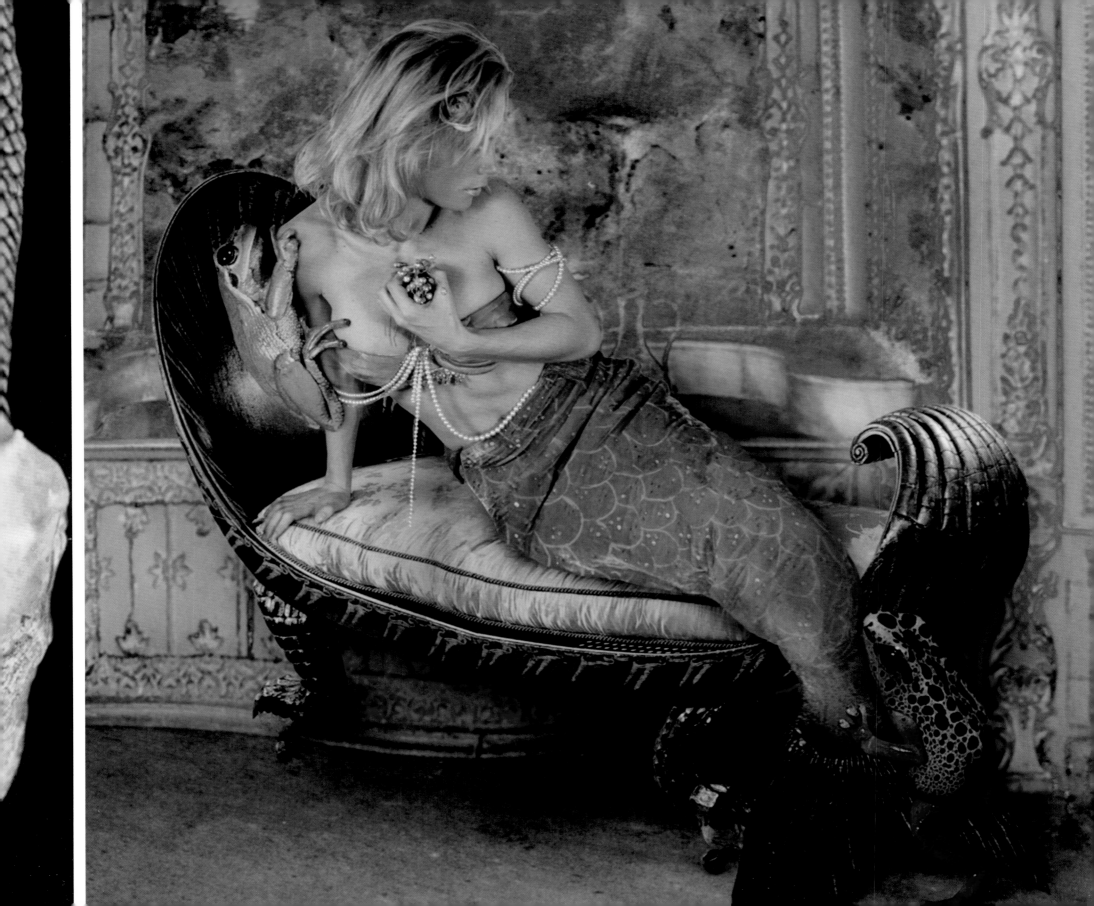

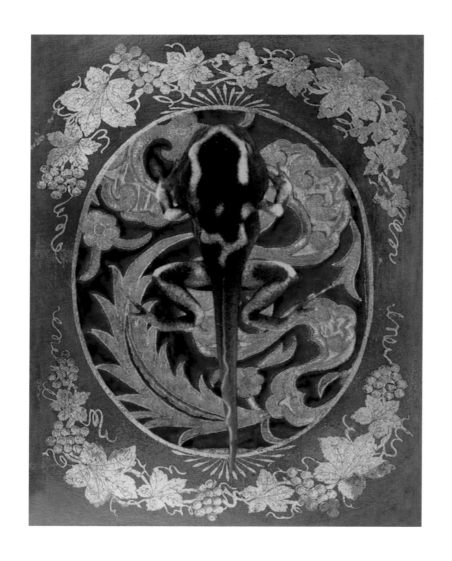

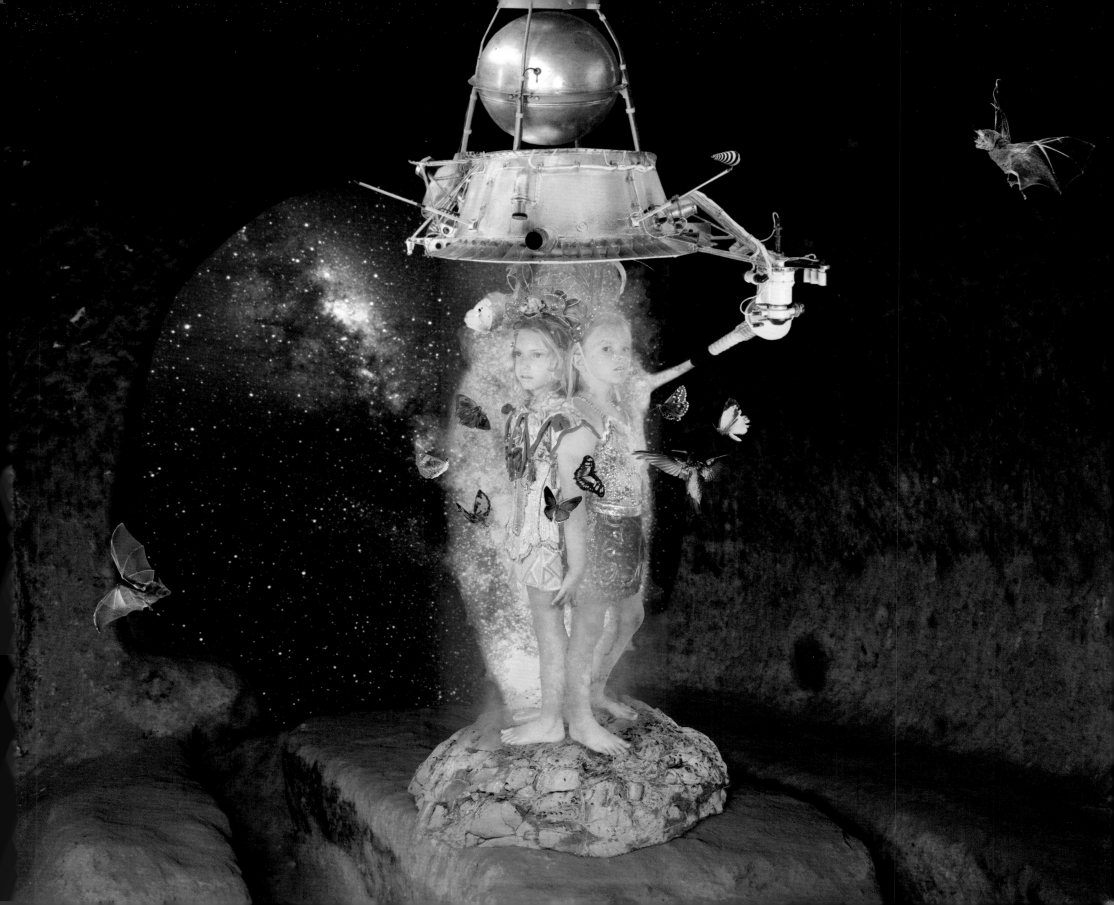

BOODY PICKS UP THE STORY TEN YEARS LATER with the subterranean romance *Psyche and the Beast*. A teenage *PsycheSuperStar* finds herself in thrall to the newest ruler of the Underworld, a ravishing werewolfian creature. Great success and tragedy befall this entwined pair as they struggle with the bindings of obsession and possession. Only at the explosive ending do we know whether the Beast can shed his skin and become worthy of Psyche's love.

Especially in this series is Boody inspired by the age-old power of storytelling, weaving familiar symbols (the winged white horse, the Beast, the imprisoned damsel) into her personal myth and leaving the viewer to fill in the narrative blanks between images. Endowing her tale with the trappings of a commercial industry geared to enthrall, Boody has selected the names of leading perfumes as titles for the series: *Magie Noire*, *Black Orchid*, *Wind Song*. These words of seduction serve as mating calls, attracting her viewer further into her land of enchantment, danger, and transcendence.

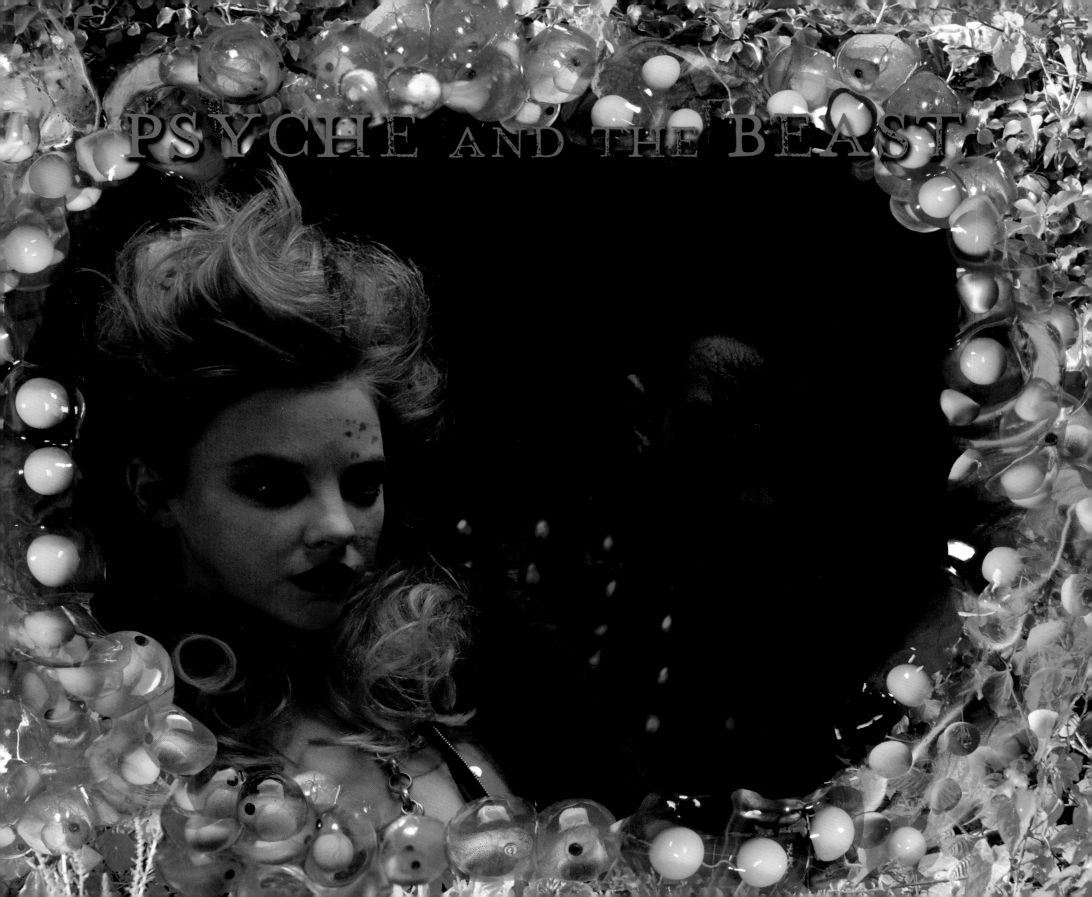

PSYCHE AND THE BEAST

54 *White Shoulders (The feeding of her private fire)*, 2012

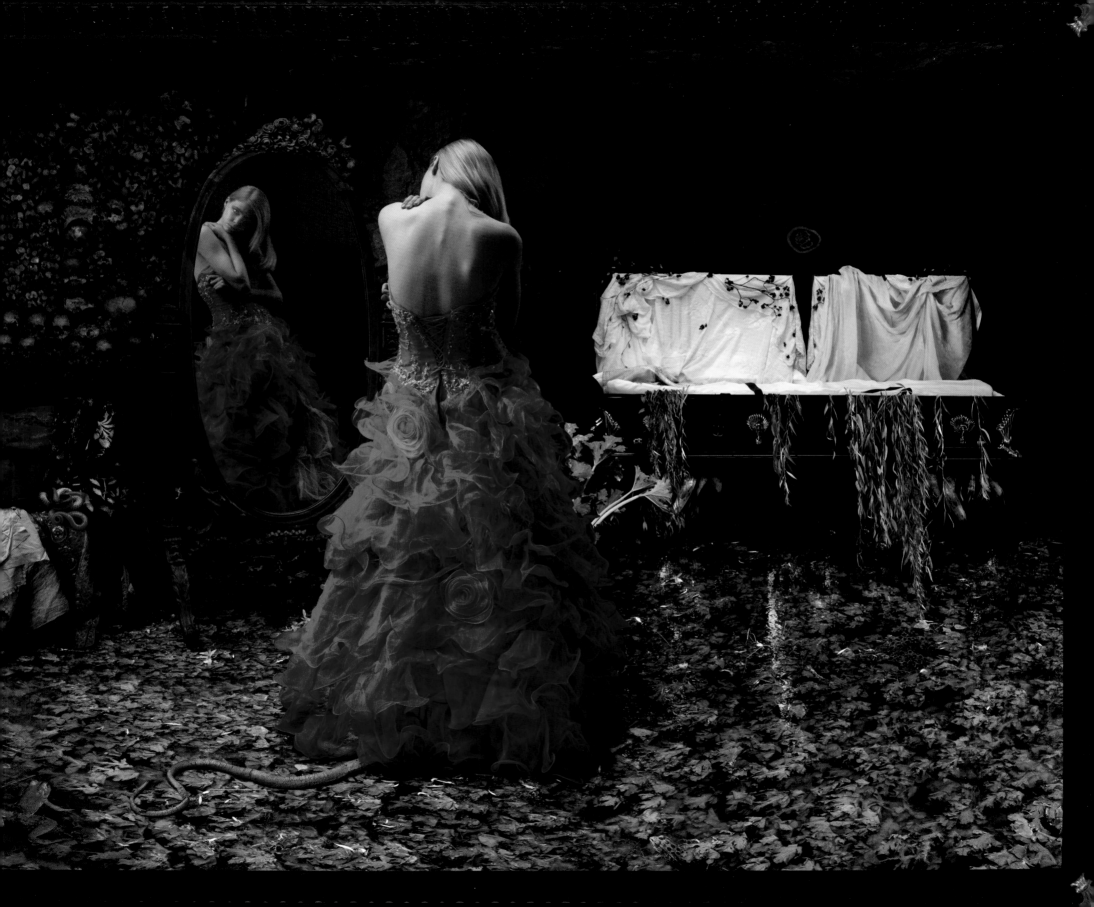

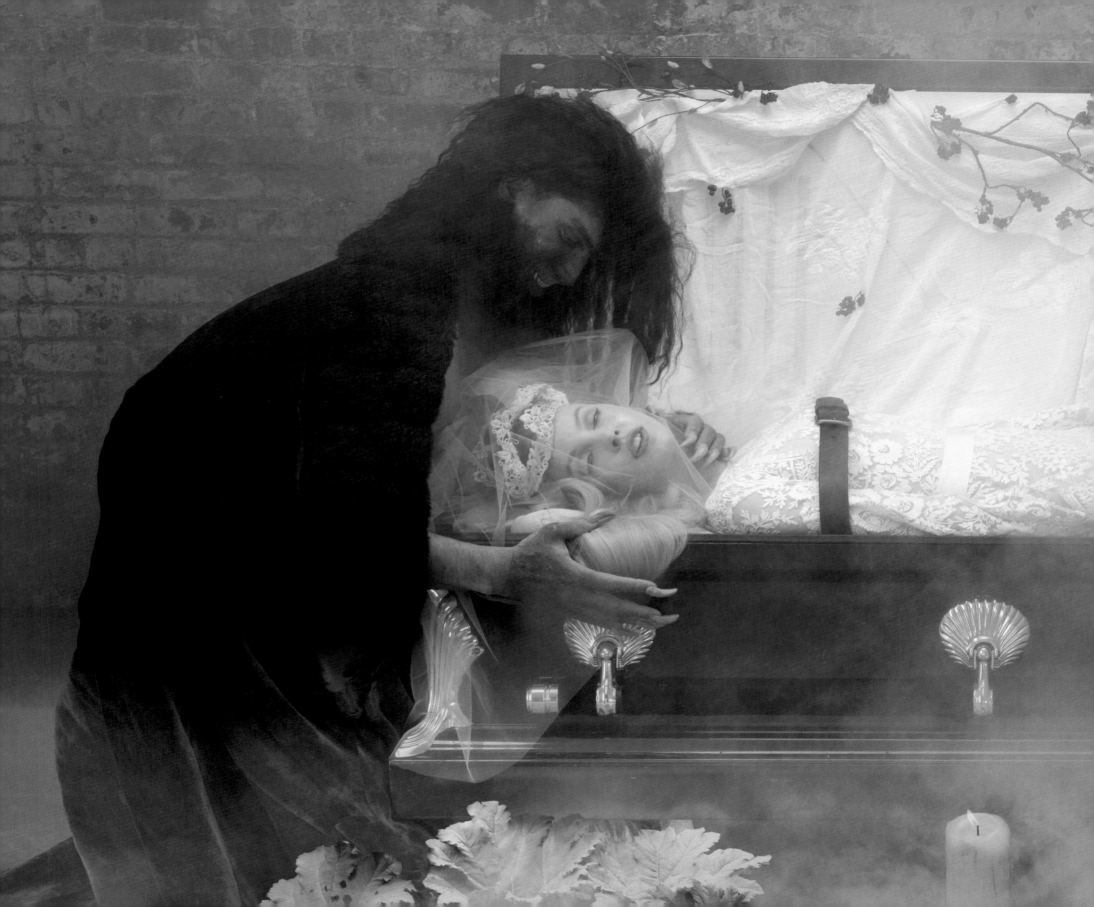

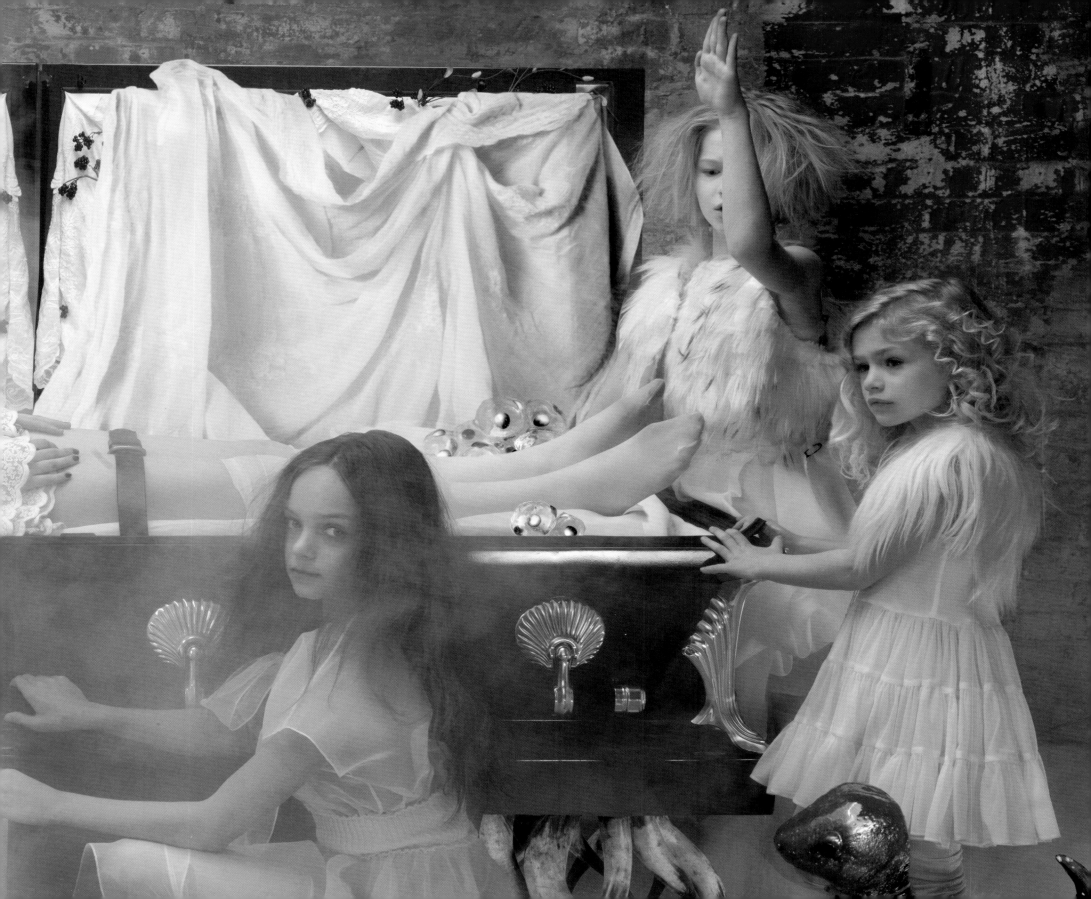

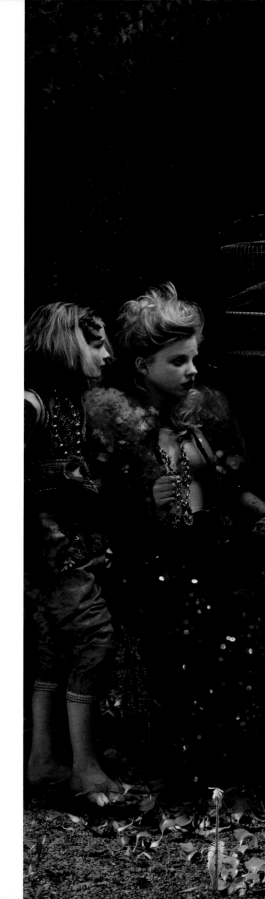

Magie Noire (Of her dainty flesh they did declare a common feast), 2012

(previous) *Angélique Encens (And all the Graces rockt her cradle being borne)*, 2012

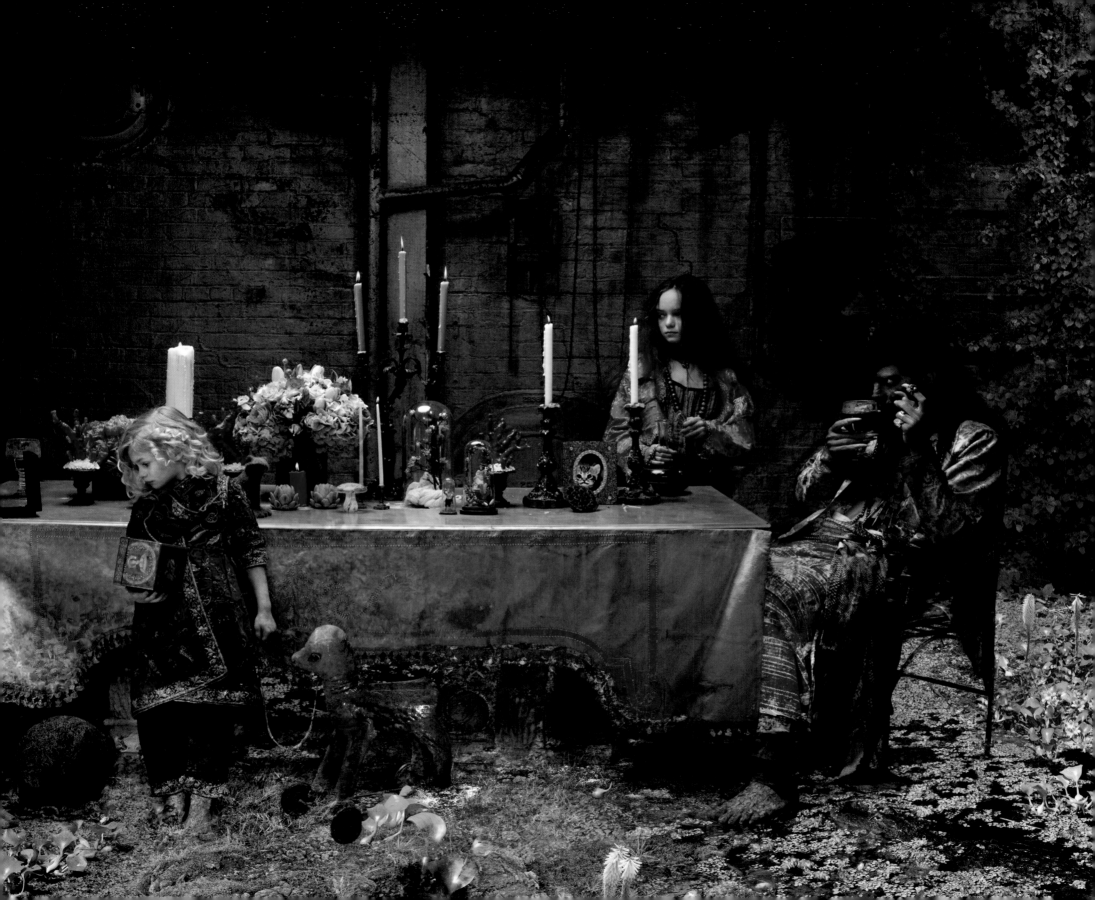

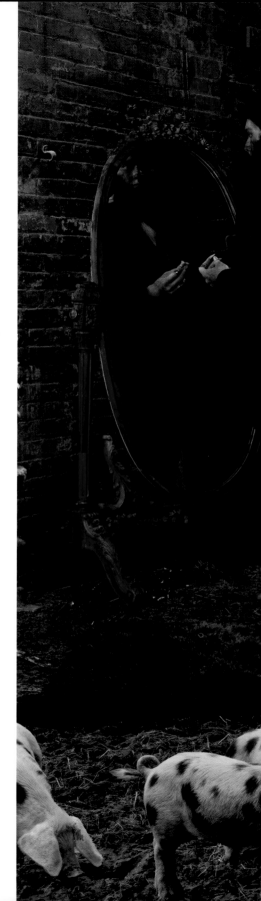

Folie de Minuit (And sitting high; for lowly she did hate), 2014

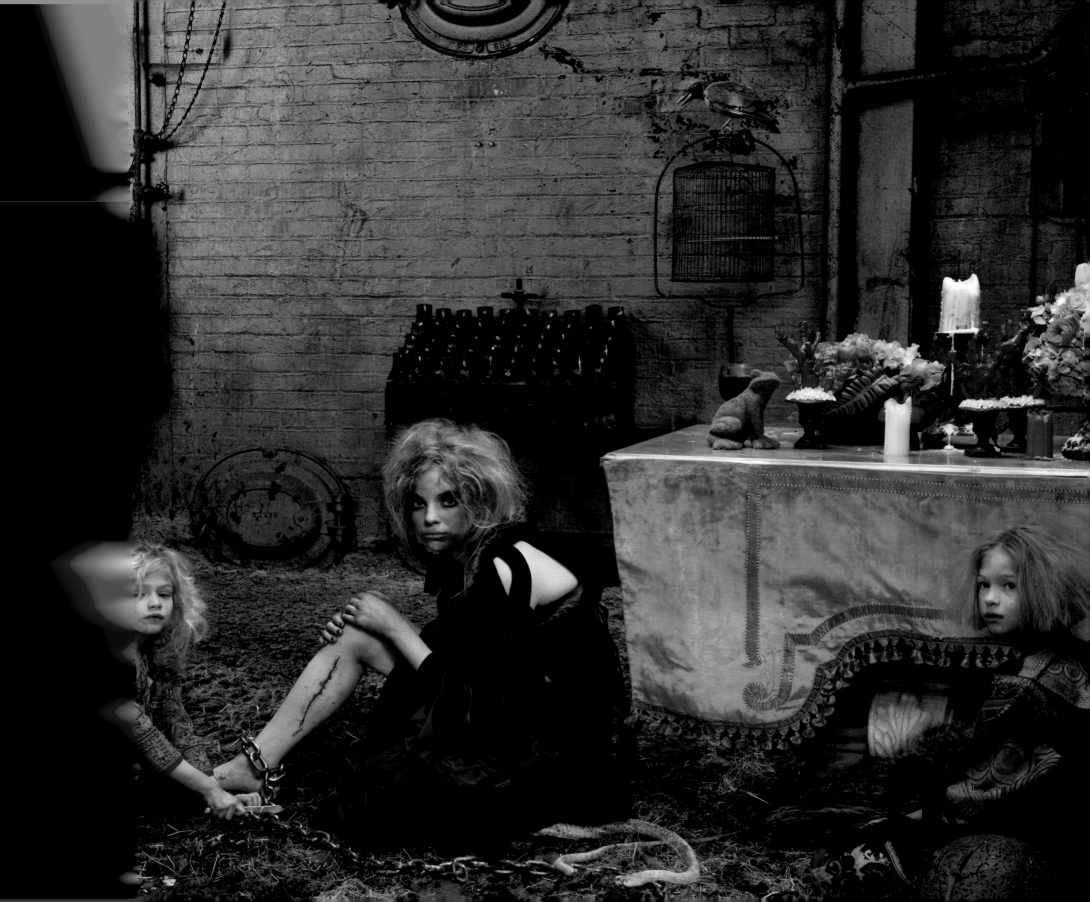

Minotaure (No usual fire, no usual rage), 2013

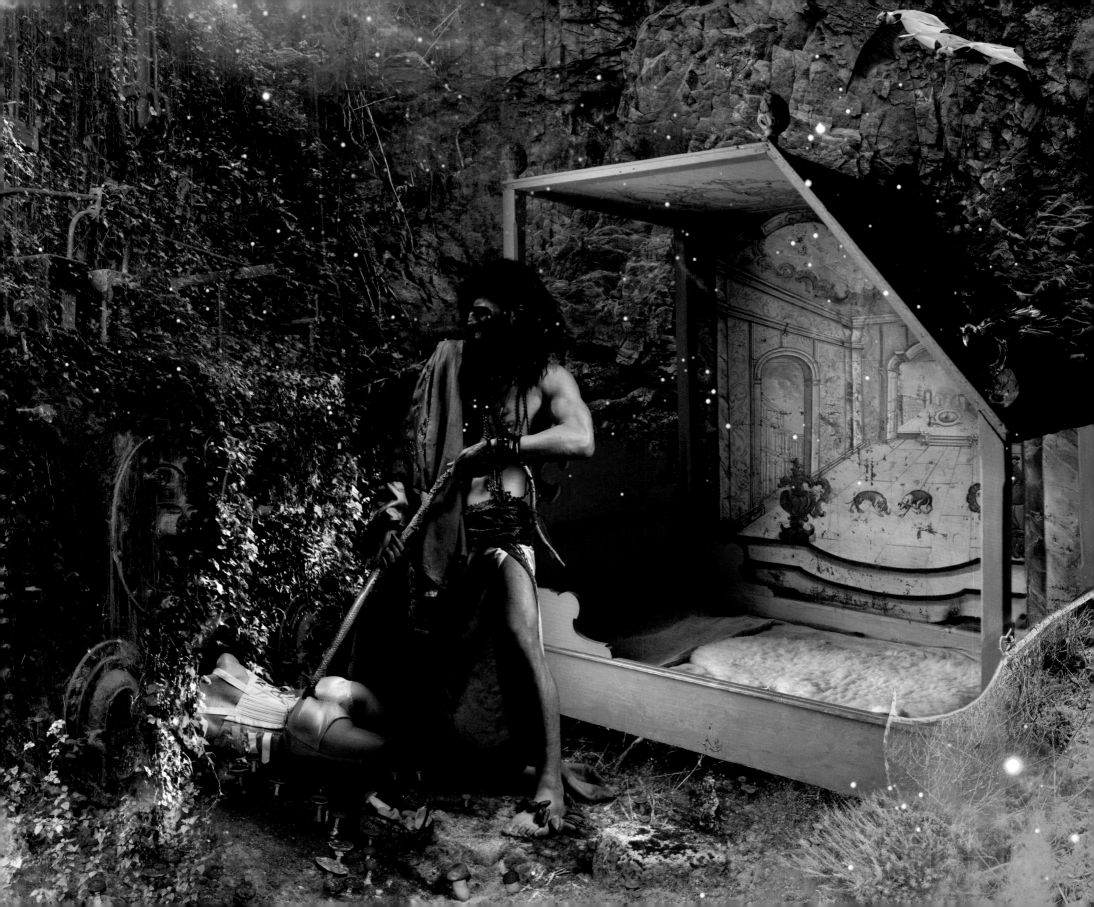

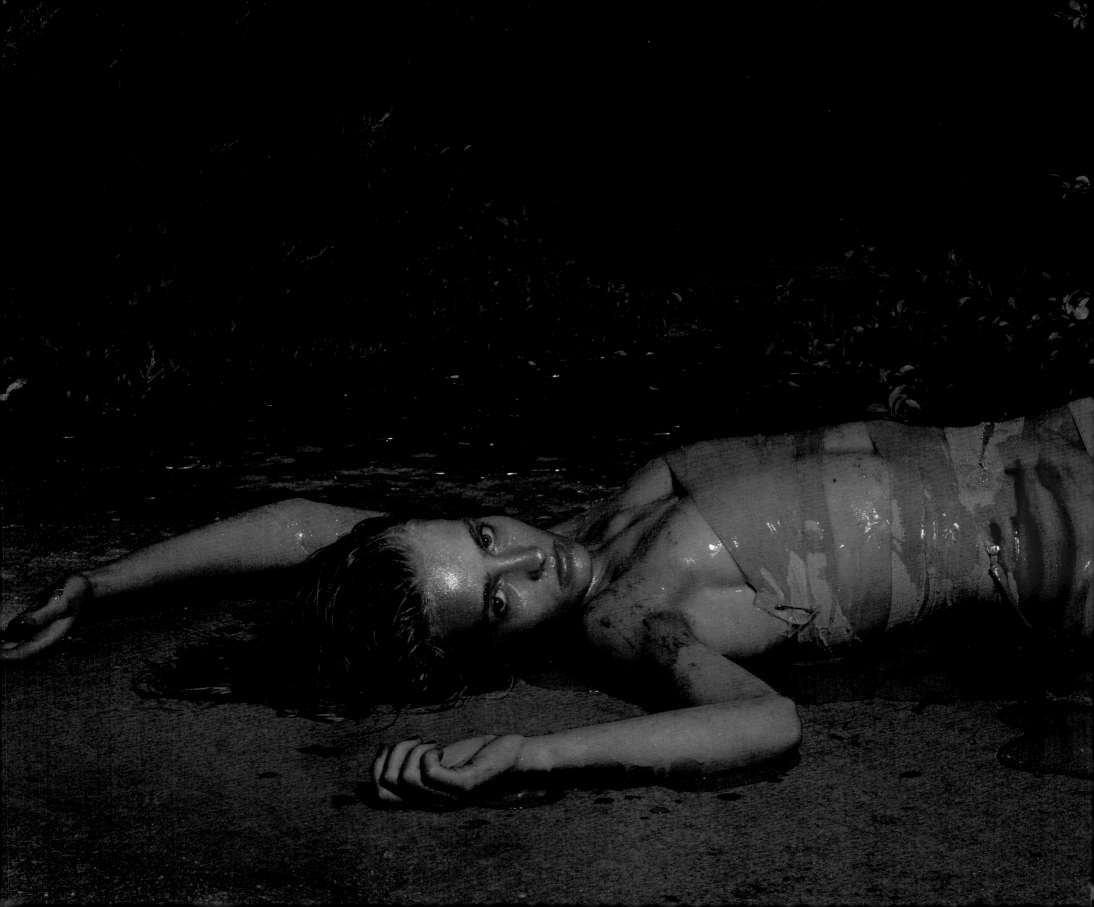

Flowerbomb (Of her love he was entirely seized), 2014

(previous) *Opening Night (But mine is not, quoth she, like others wound),* 2014

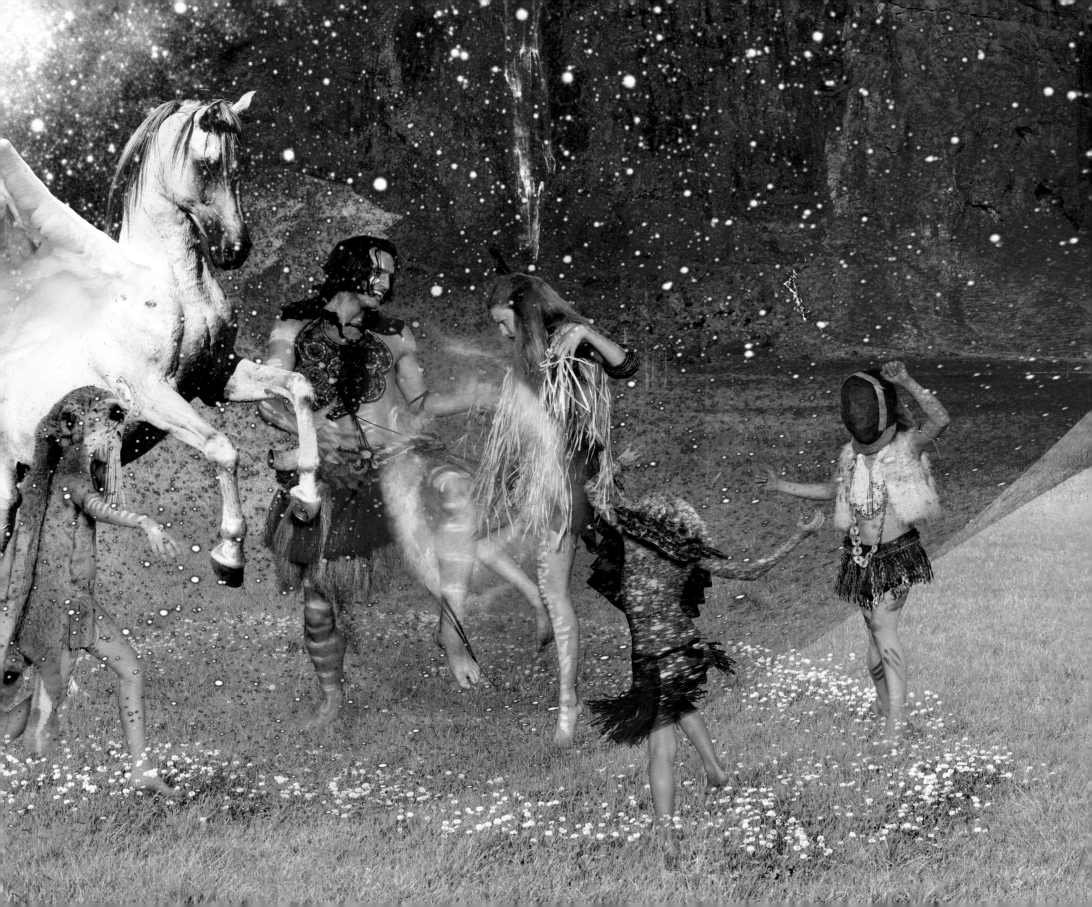

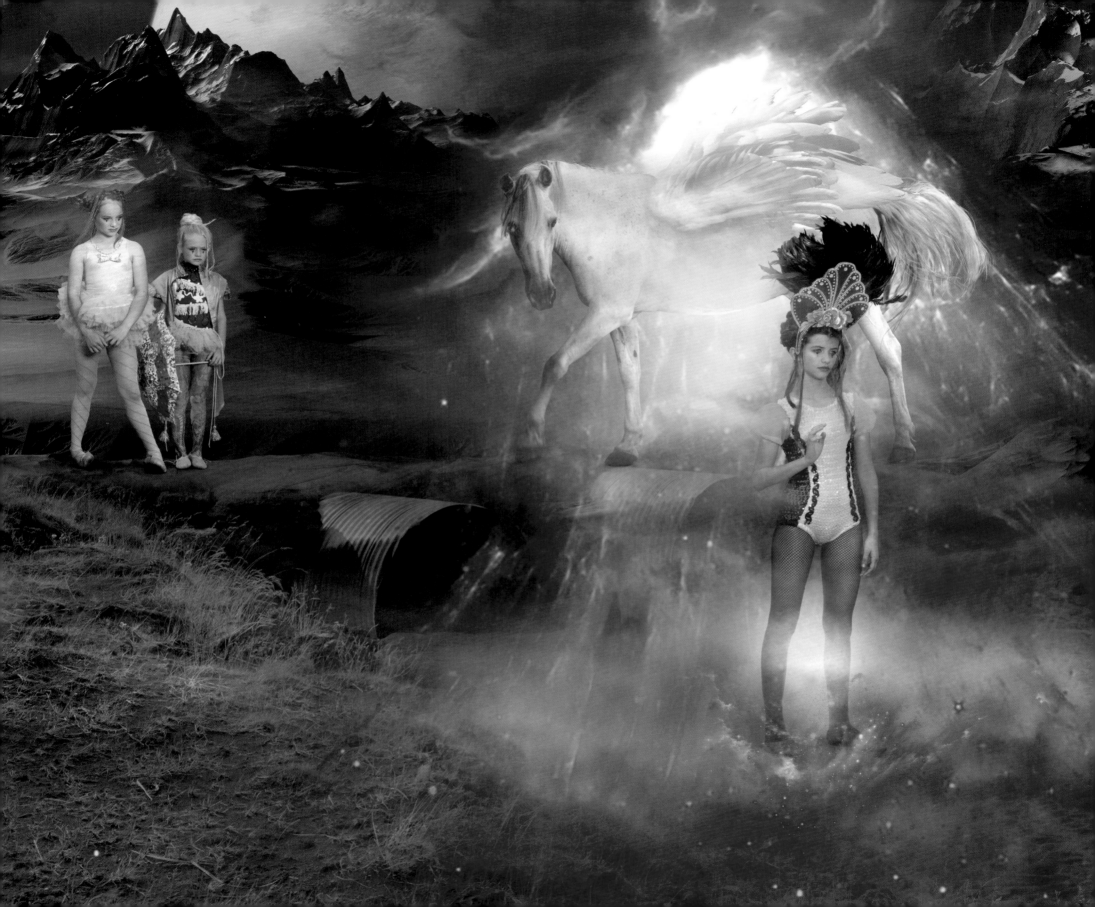

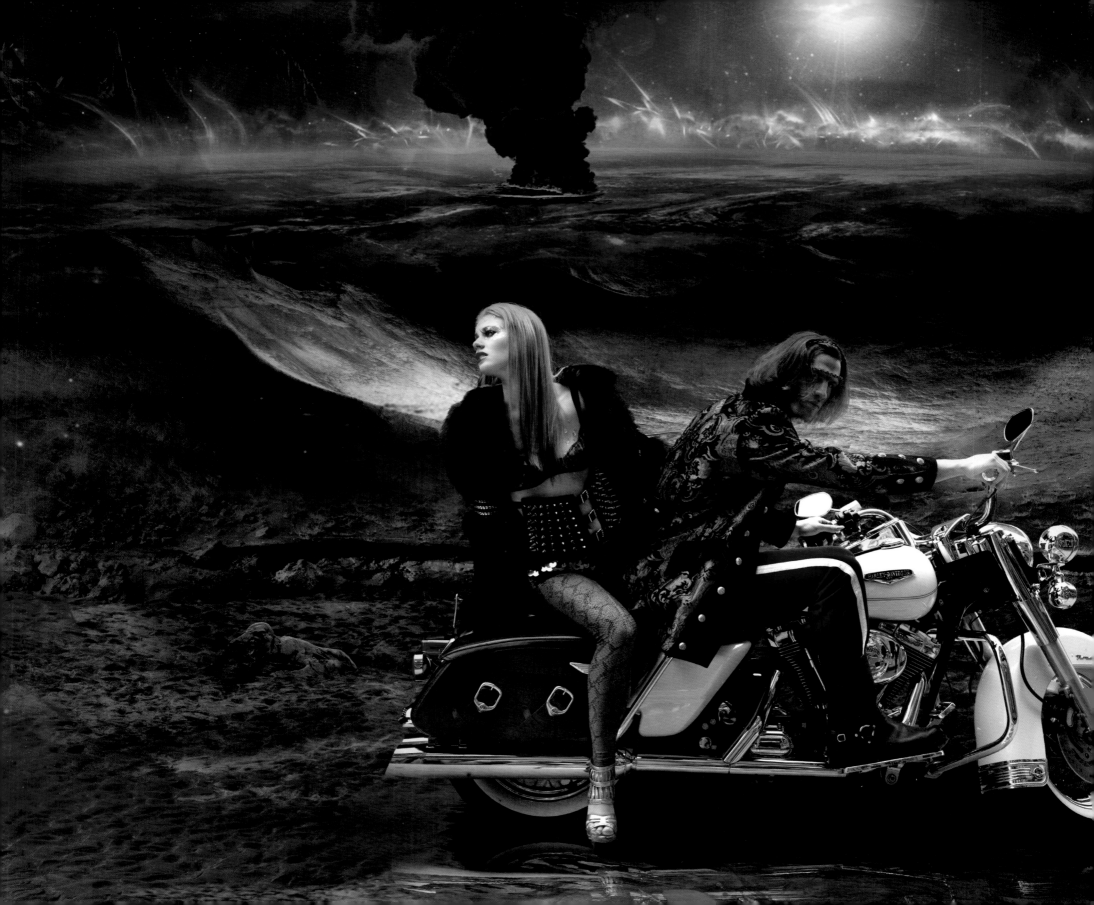

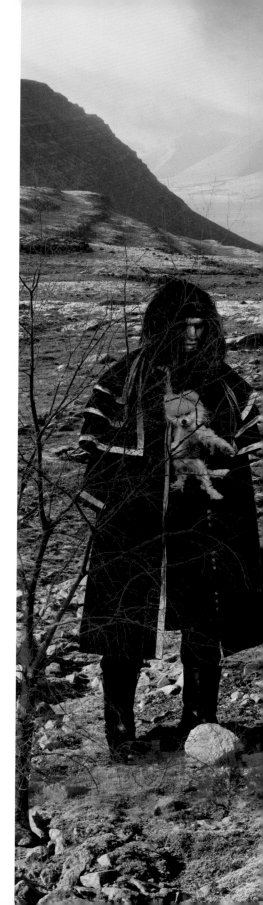

Black Orchid (The cruel marks of many a bloudy fielde), 2013

(previous) *Bandit (Of her delights she unto him betrayed)*, 2014

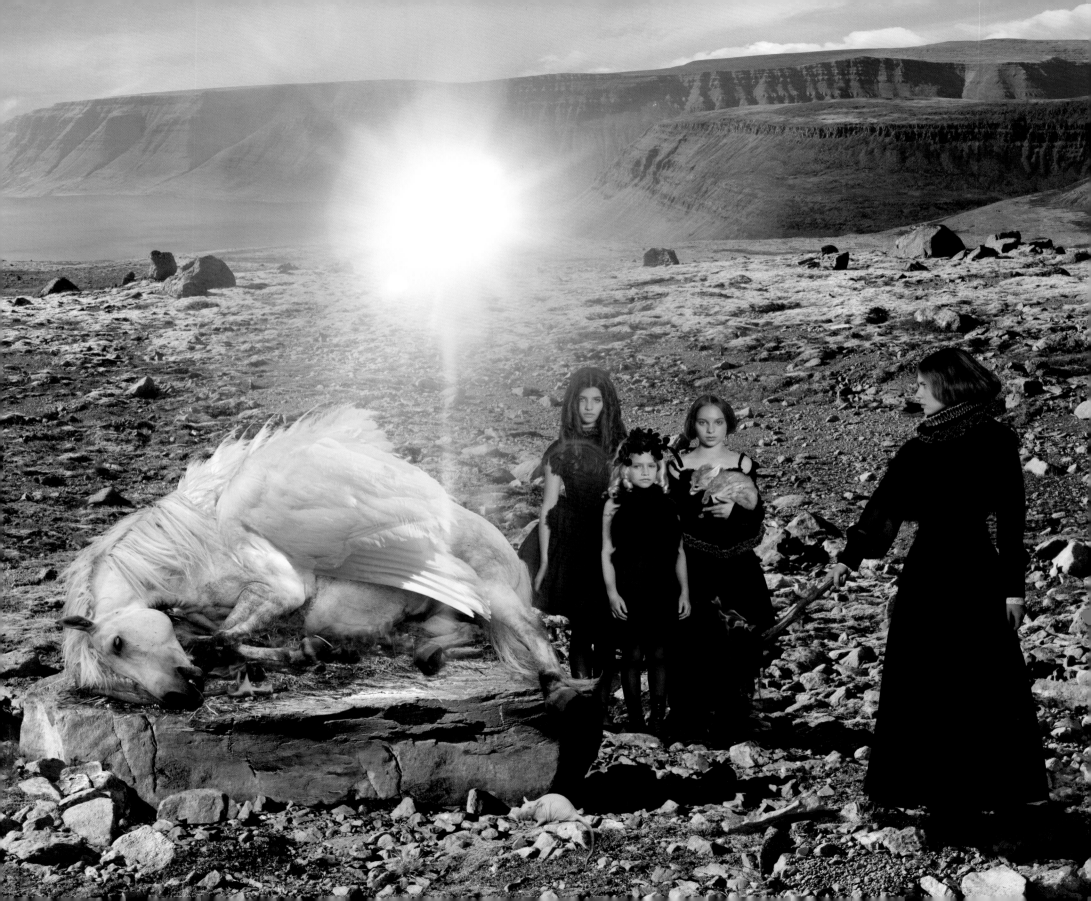

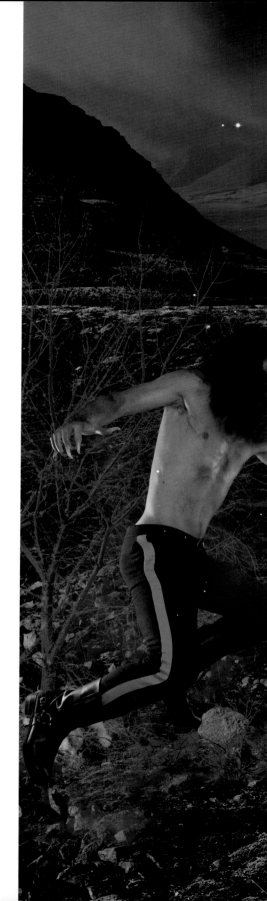

Unforgetable (Blind fortune's darksome way), 2014

(following) *Beyond Paradise (It was a chosen plot of fertile land)*, 2013

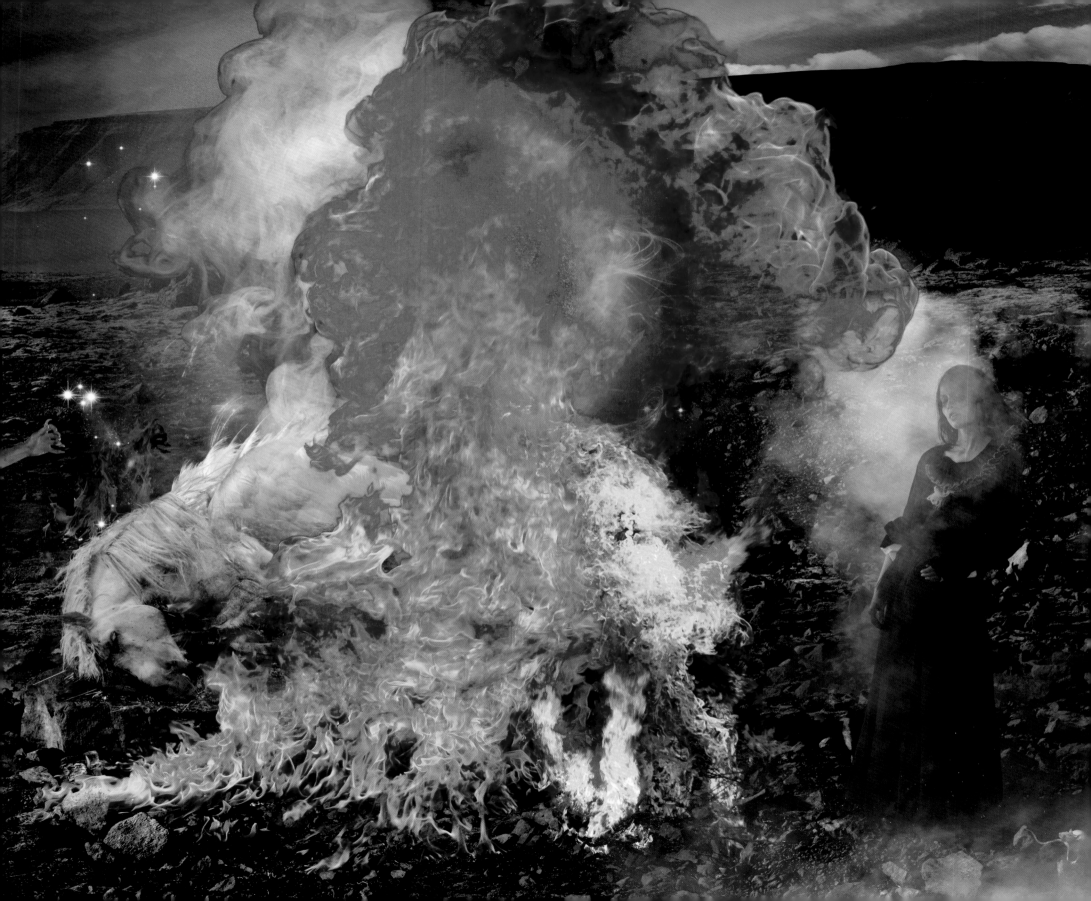

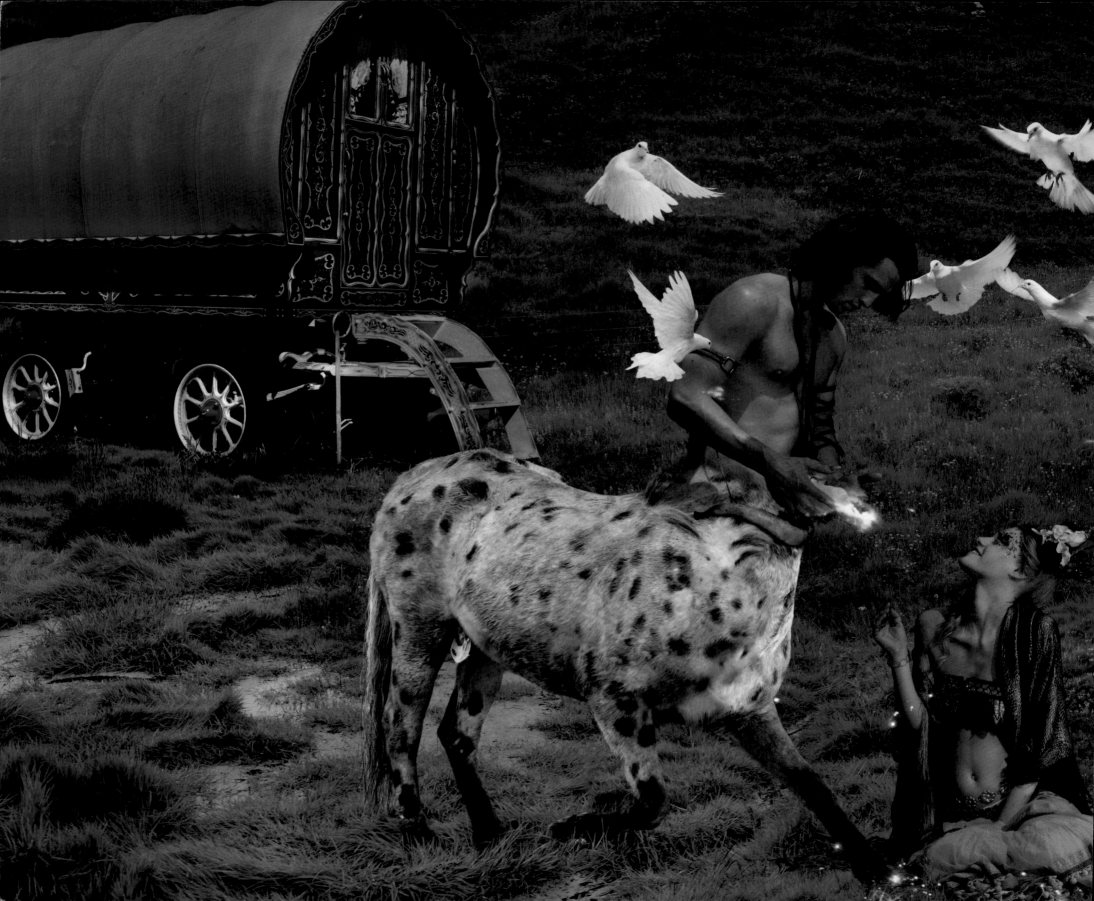

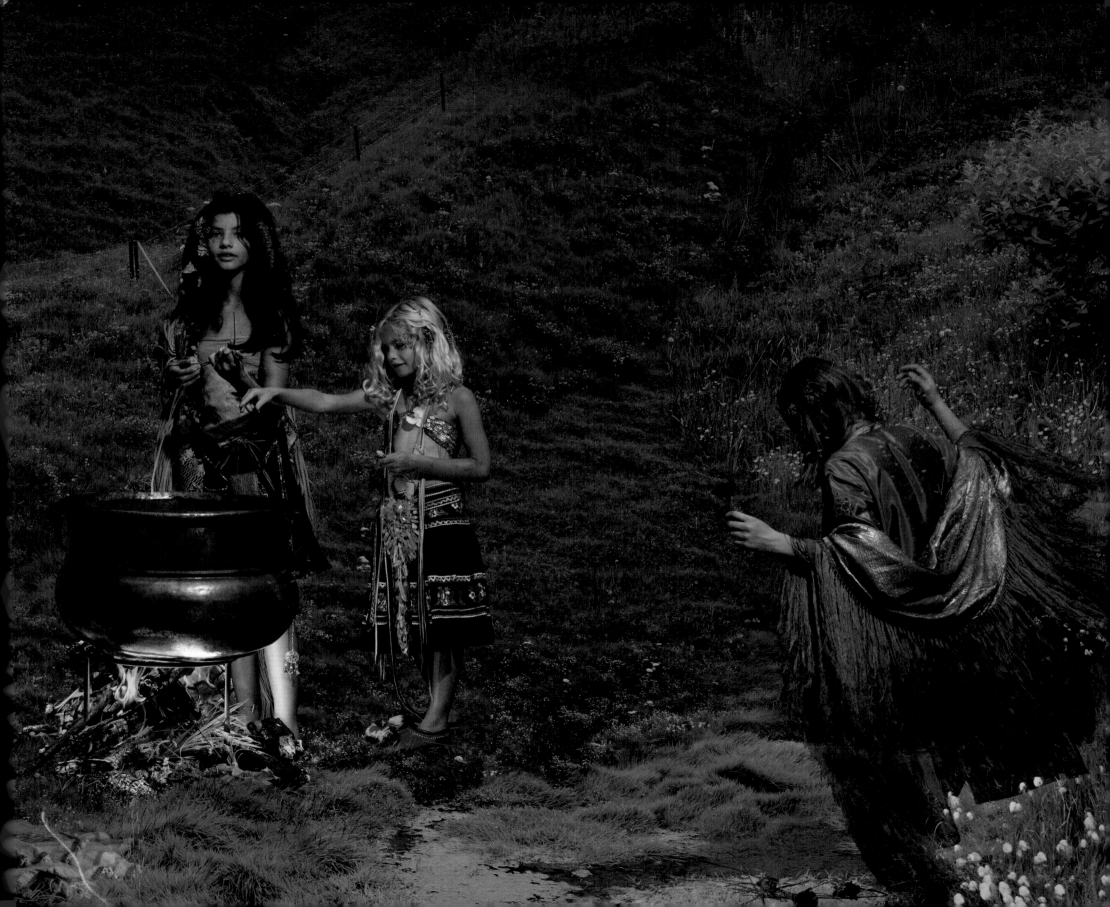

The Ingenue

PsycheSuperStar
ORACLE

BOODY IS INTERESTED IN SYMBOL SYSTEMS and how they affect the psyche. A student of divination, alchemy, and a reader of tarot cards, she has spent decades exploring universal archetypes and their role in marshaling the human spirit. With this knowledge, it was a natural step for her to create her own deck of cards. She designed the *PsycheSuperStar Oracle* as a tool for divination and personal growth while offering a peephole into her characters' interior lives.

Boody pares down the symbols in her oracles to their most simple and universal essence. Similar to Peter Greenaway's "100 Objects to Represent the World," Boody devised her deck as a basic catalogue of human experience and emotion. Non-initiates and tarot experts alike can draw insight into their own lives as they pick cards from this easily interpreted deck.

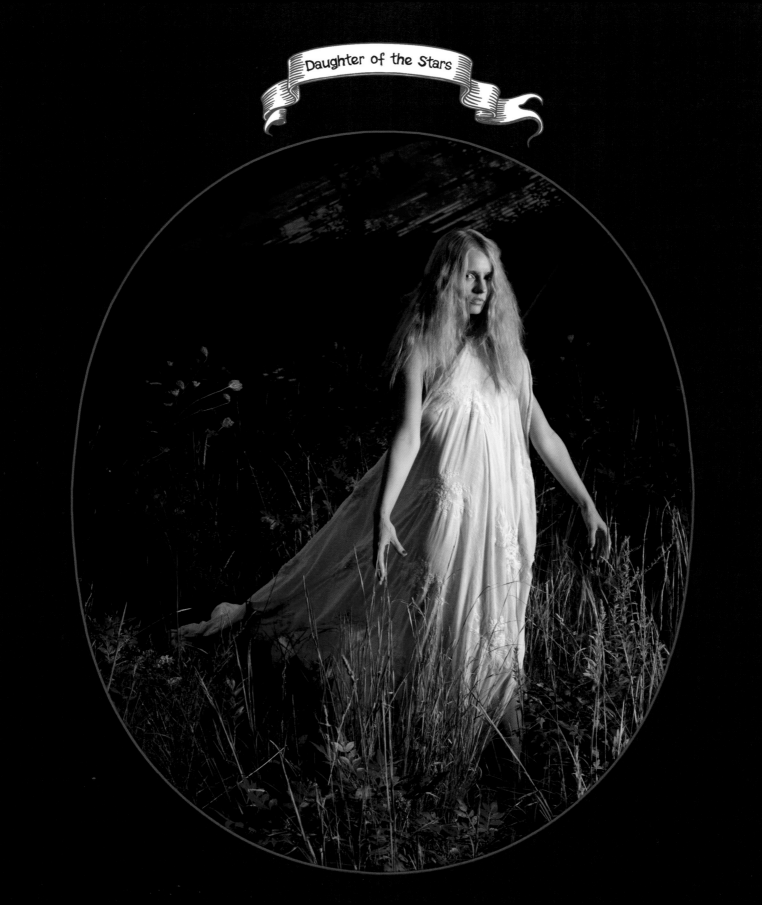

Daughter of the Stars

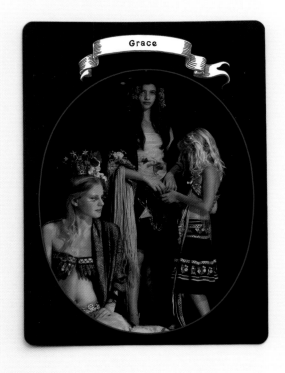

Grace

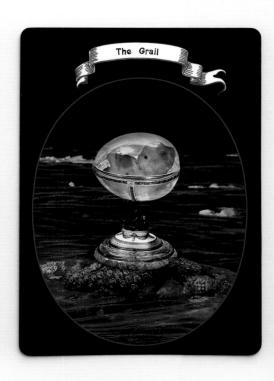

The Companion

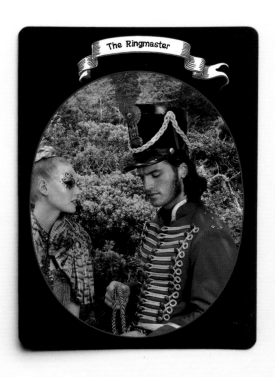

The Ringmaster

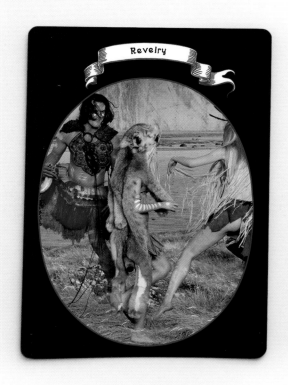

Revelry

The Grail

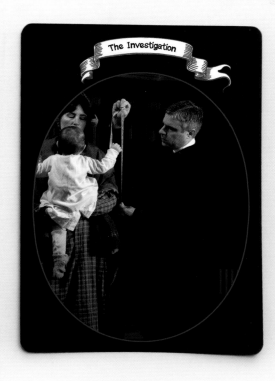

The Investigation

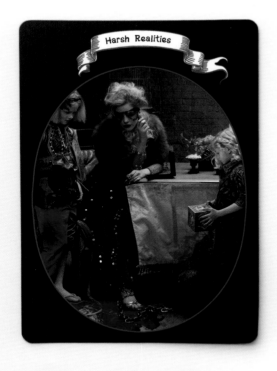

Harsh Realities

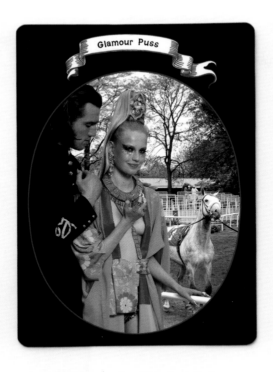

Glamour Puss

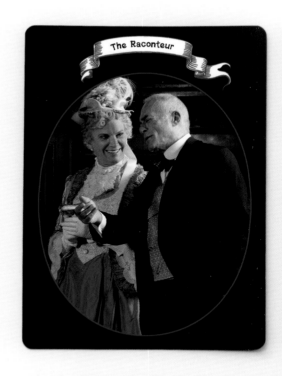

The Raconteur

Herald of Adventure

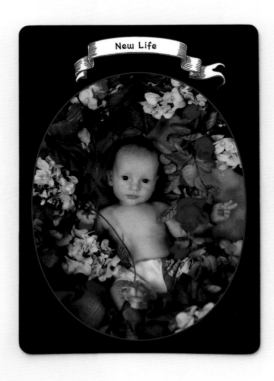

New Life

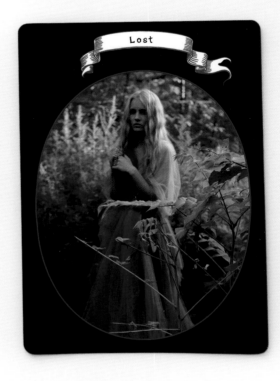

Lost

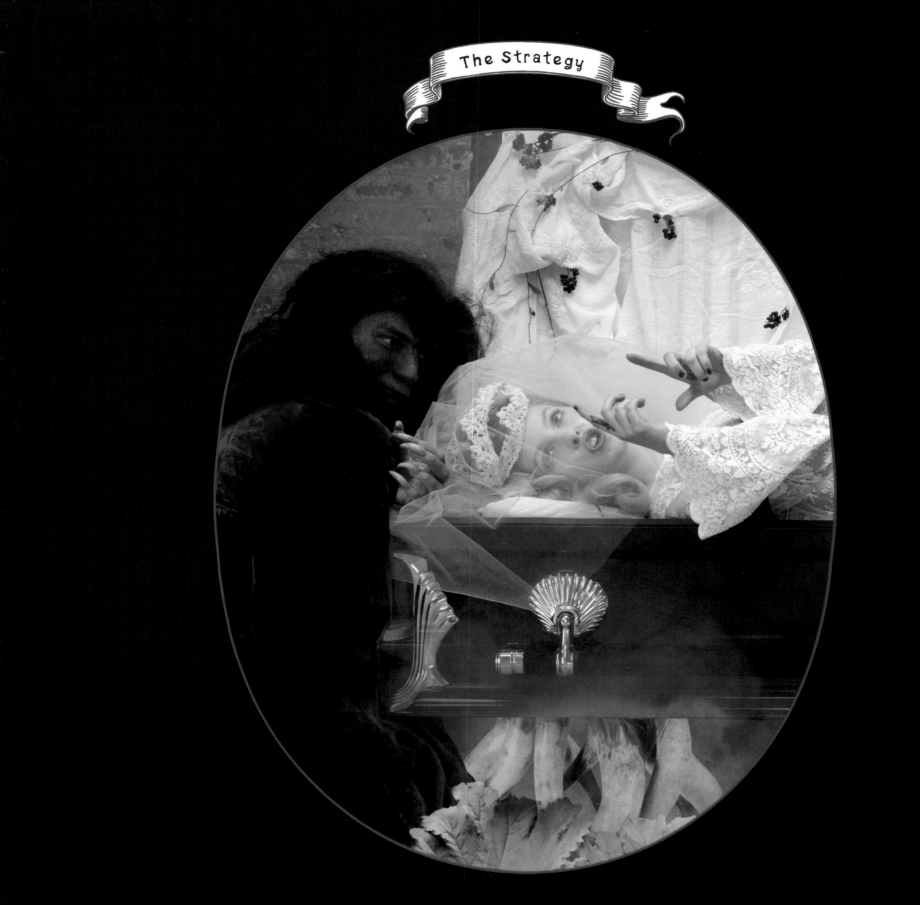

The Strategy

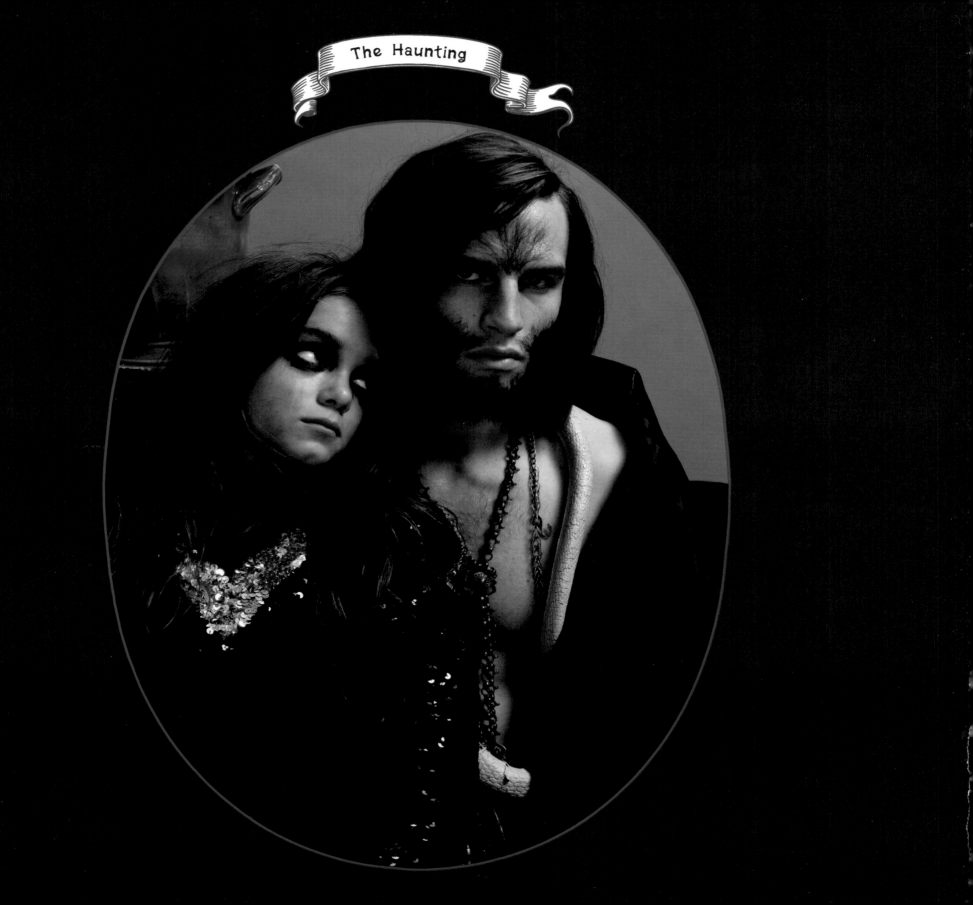

The Haunting

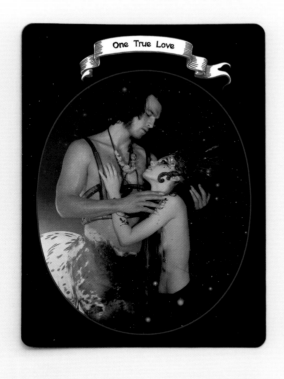

One True Love

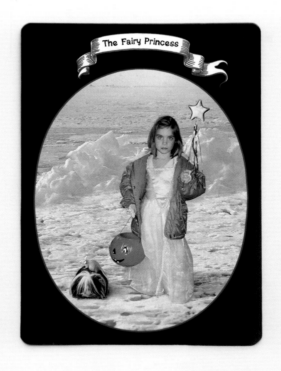

The Fairy Princess

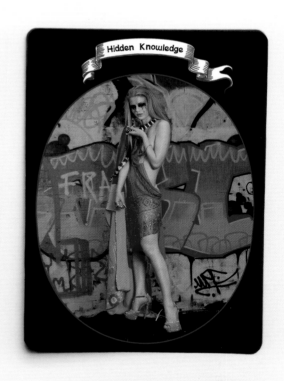

Hidden Knowledge

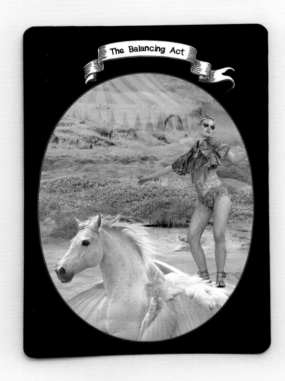

The Balancing Act

Off the Grid

Sacred Rites

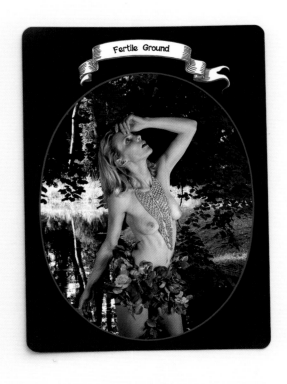

Fertile Ground

Sitting Pretty

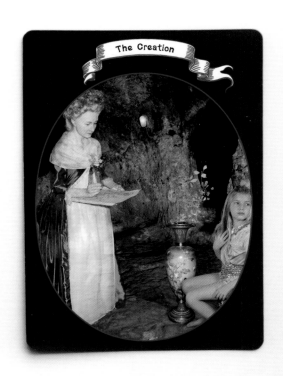

The Creation

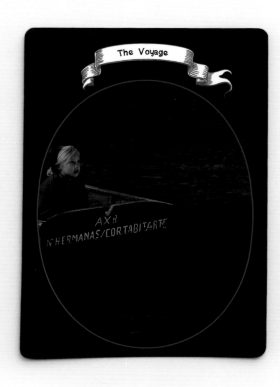

The Voyage

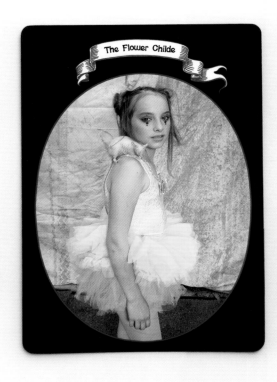

The Flower Childe

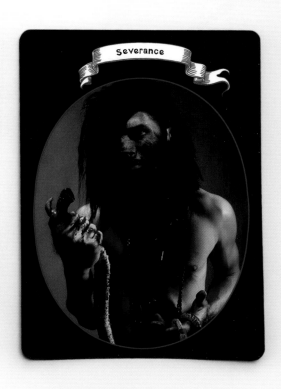

Severance

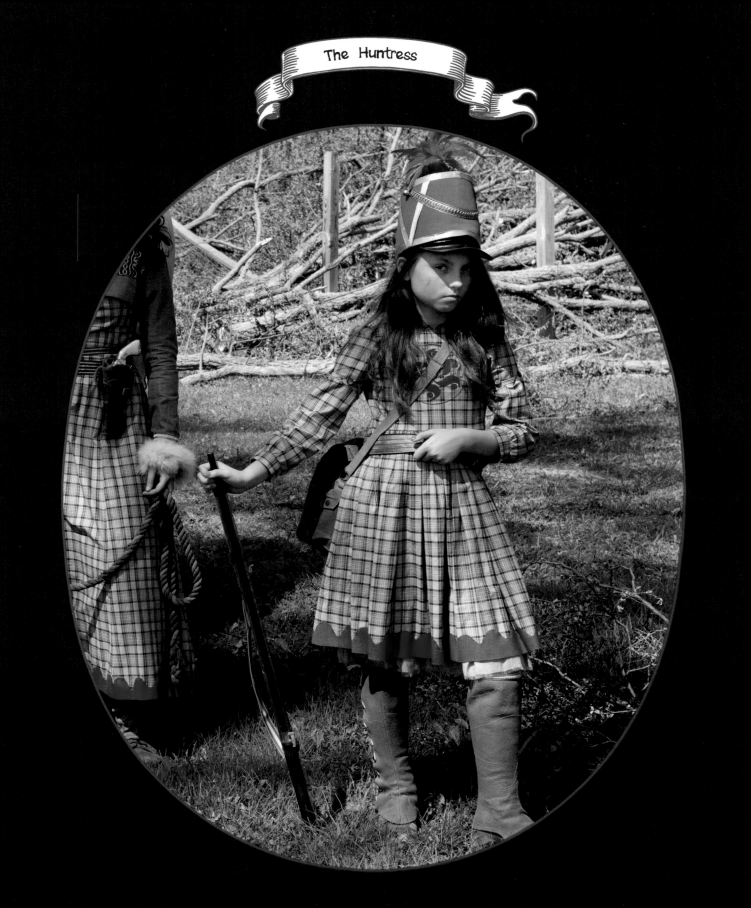

The Huntress

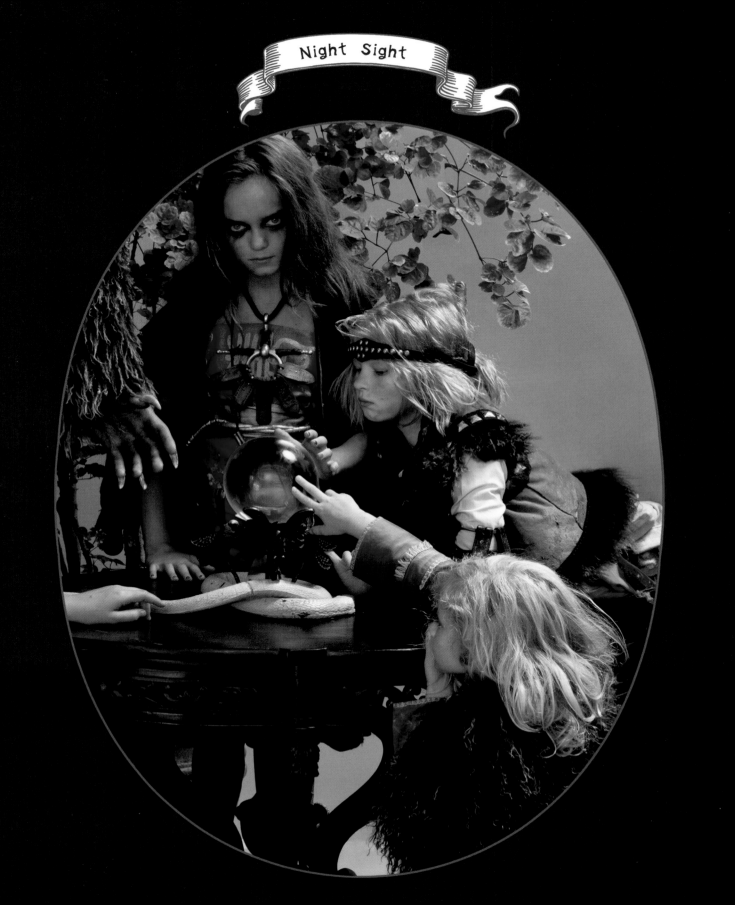

Night Sight

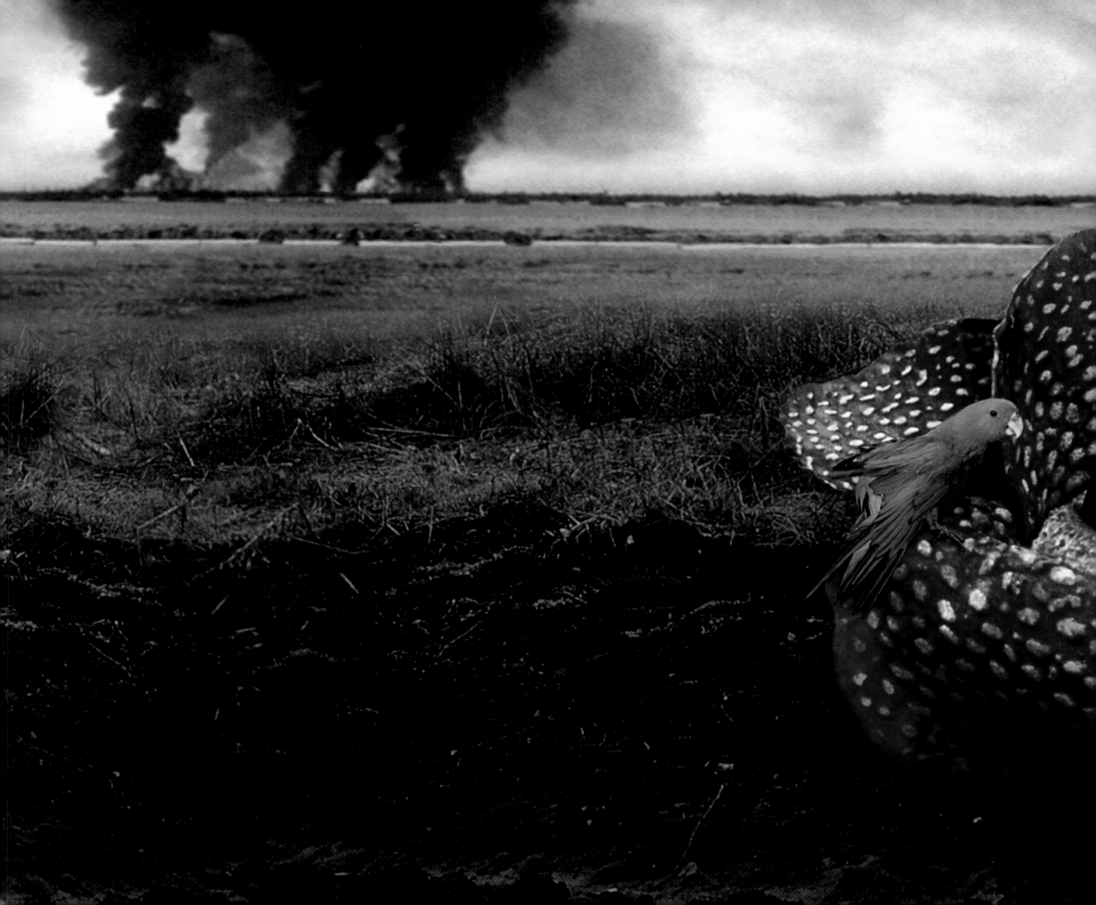

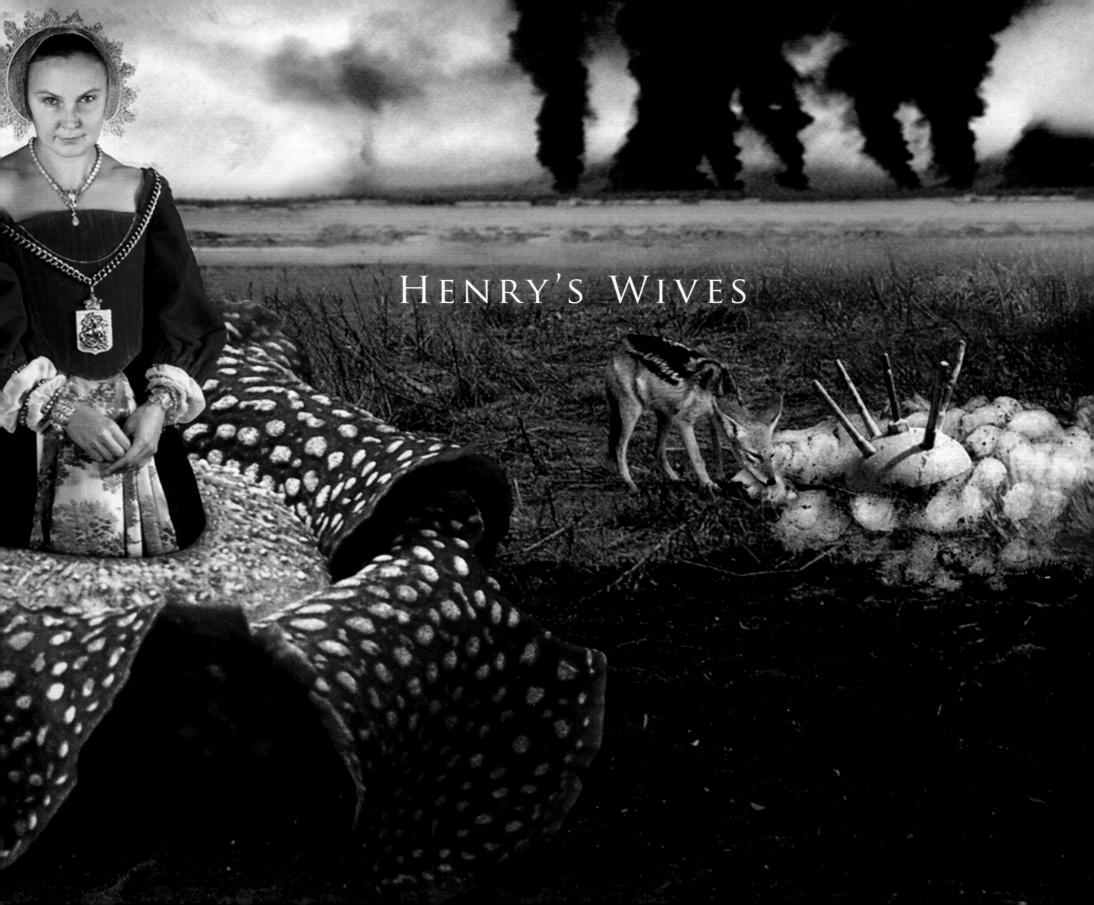

HENRY'S WIVES

BOODY'S SERIES ON THE WIVES OF HENRY VIII tackles the subject of love gone awry, mapping out an existential journey of blunders between the sexes. The fate of each queen is predicated on their ever-present wrong turn: Henry. He is the unlucky lodestar around which the queens orbit and the organizing principle of Boody's photographs.

Drawing inspiration from the histories of each queen's life, Boody drapes her fantasies on an armature of fact: Catherine of Aragon's domestic tendencies are recalled in Boody's depiction of the queen happily perched in her nest along with her daughter, the future Queen Mary I. Similarly, Anne Boleyn's habit of eating green apples during her pregnancies can be seen along with her miscarried children. More biographical information is packed into the titles, which are the mottos that each consort chose during her reign, offering a rare glimpse of queenly self-perception.

The six densely layered tableaux show Henry's gradual transformation from handsome prince to eventual blob of putrefying flesh, as he gorges on a steady appetite of queens. Over time, his many wives have come to represent six distinct female types and Boody portrays each in their storybook incarnation: the Betrayed Wife, the Temptress, the Saint, the Ugly Sister, the Bad Girl, and the Mother, all icons of marital strife. A final seventh tableau gives hope. In an unlikely family portrait, the resurrected queens gather around the decomposing serpent of King Henry. A young girl on a pedestal presides over this drama, an angelic phoenix rising from the ashes.

Catherine of Aragon: Humble and Loyal, 1997

(previous) *Katherine Parr: To be Useful in All I Do*, 1997

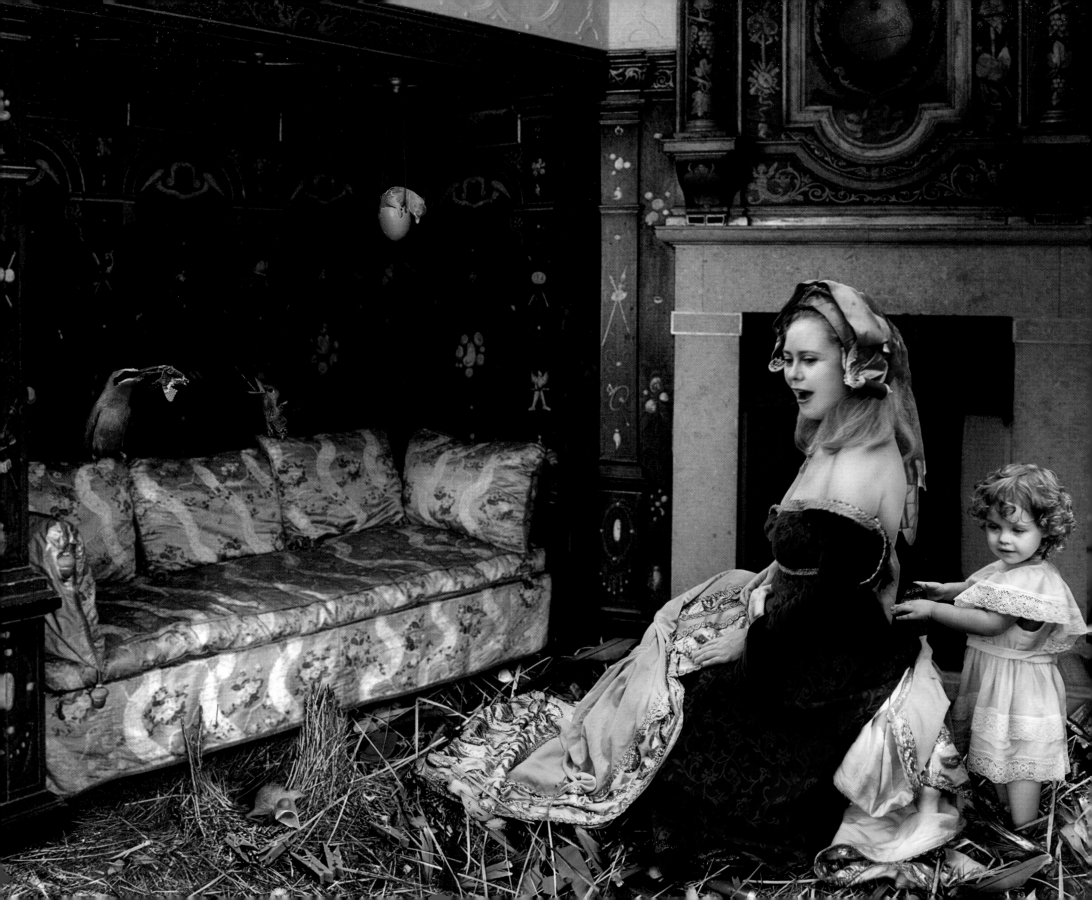

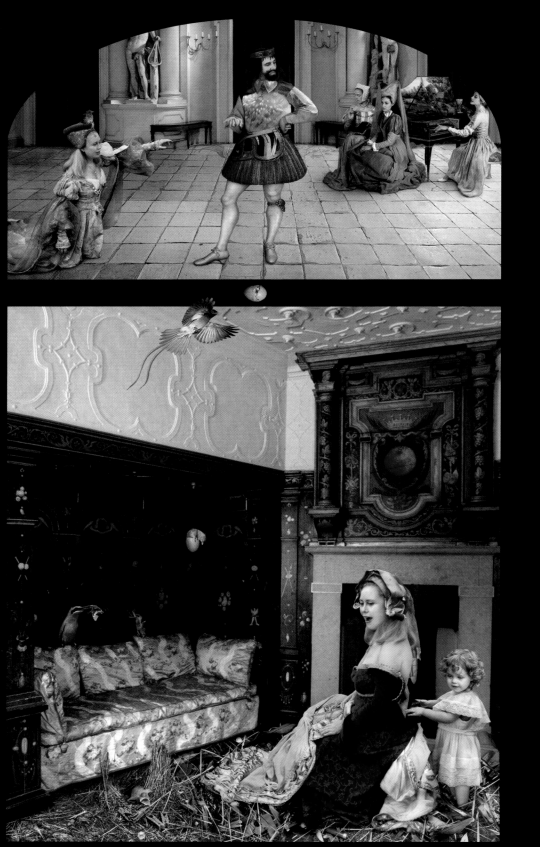
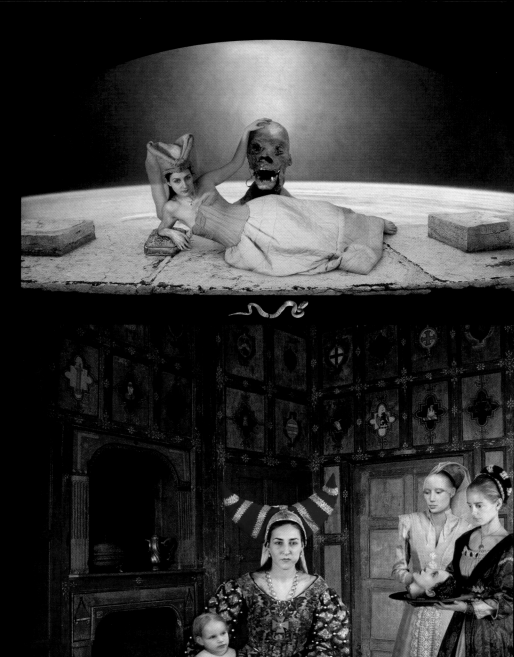

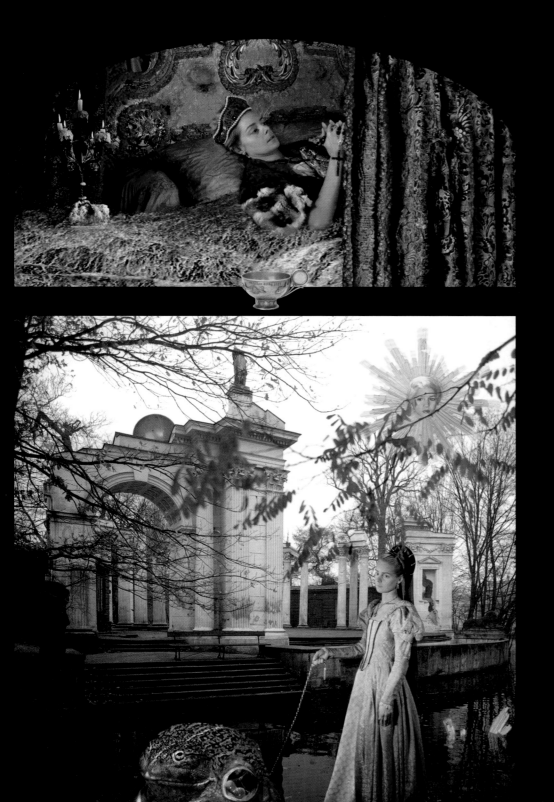
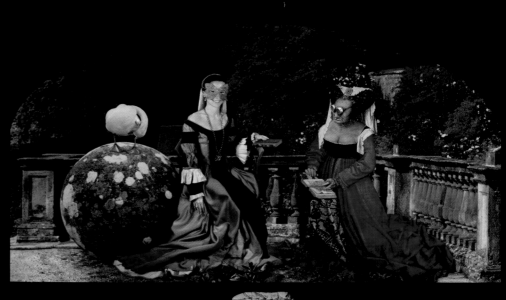
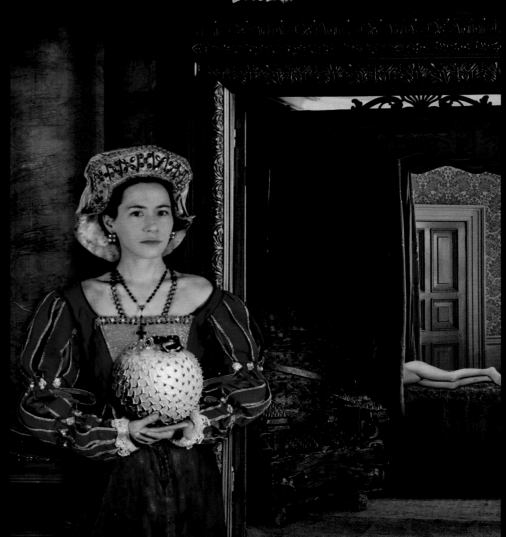

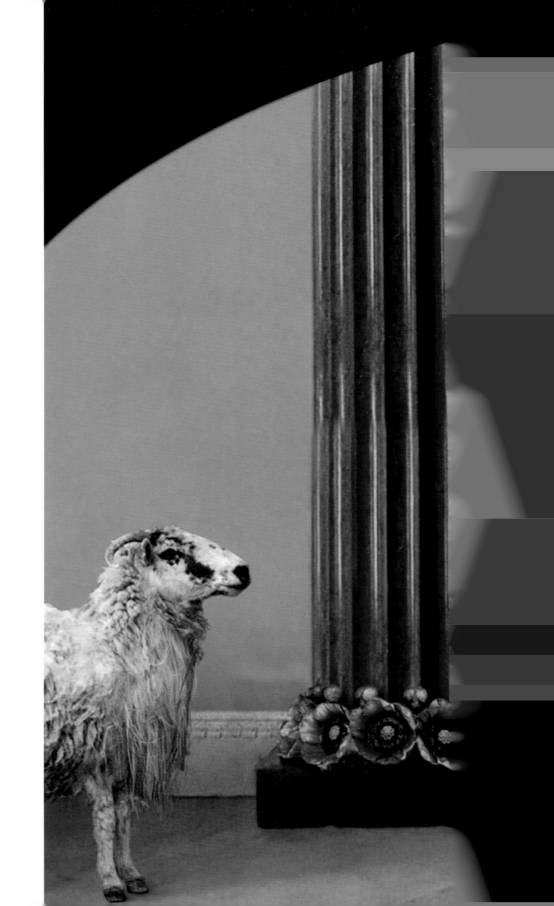

Katheryne Howard: No Other Wish But His, detail, 1997

(previous, from left) *Catherine of Aragon: Humble and Loyal*, 1997

(previous) *Anne Boleyn: The Most Happi*, 1997

(previous) *Jane Seymour: Bound to Obey and Serve*, 1997

94 (previous) *Anne of Cleves: Du Kennst Mich Nicht*, 1997

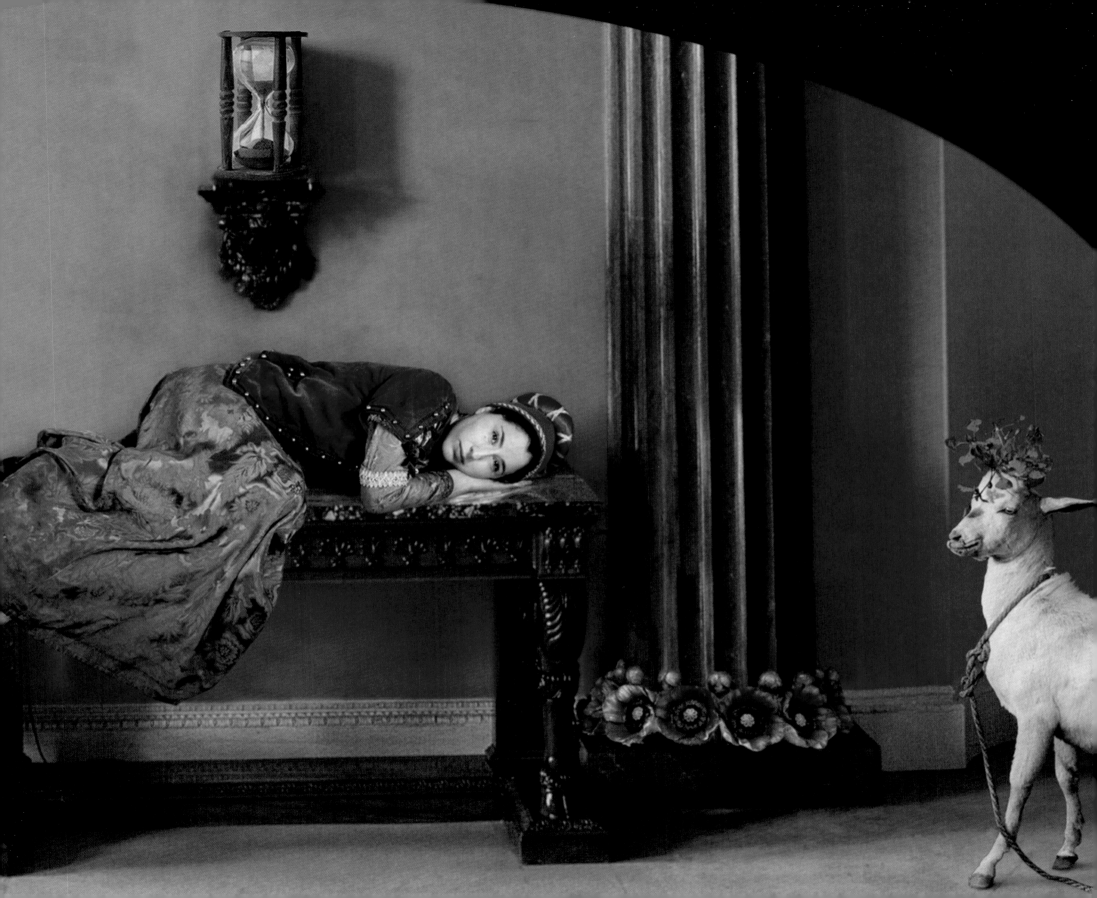

Katheryne Howard: No Other Wish But His, detail, 1997

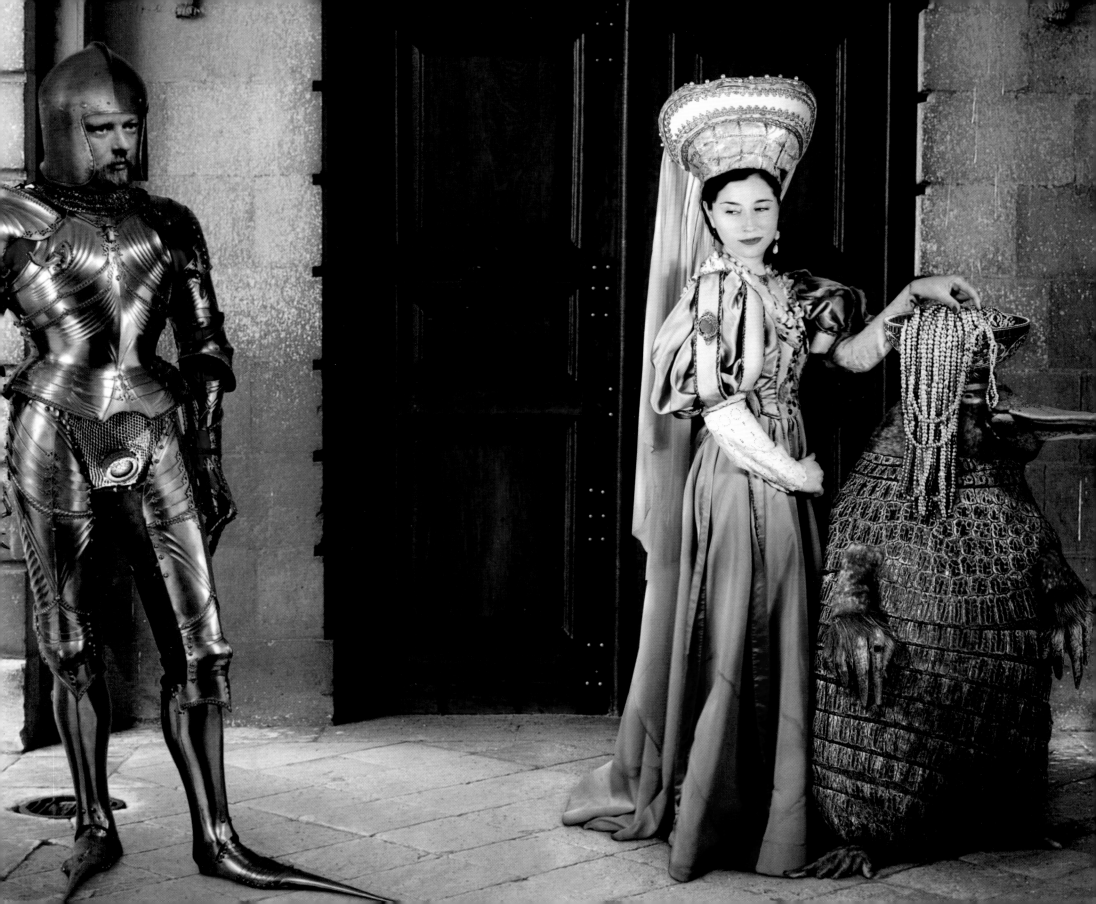

Katherine Parr: To Be Useful In All I Do, detail, 1997

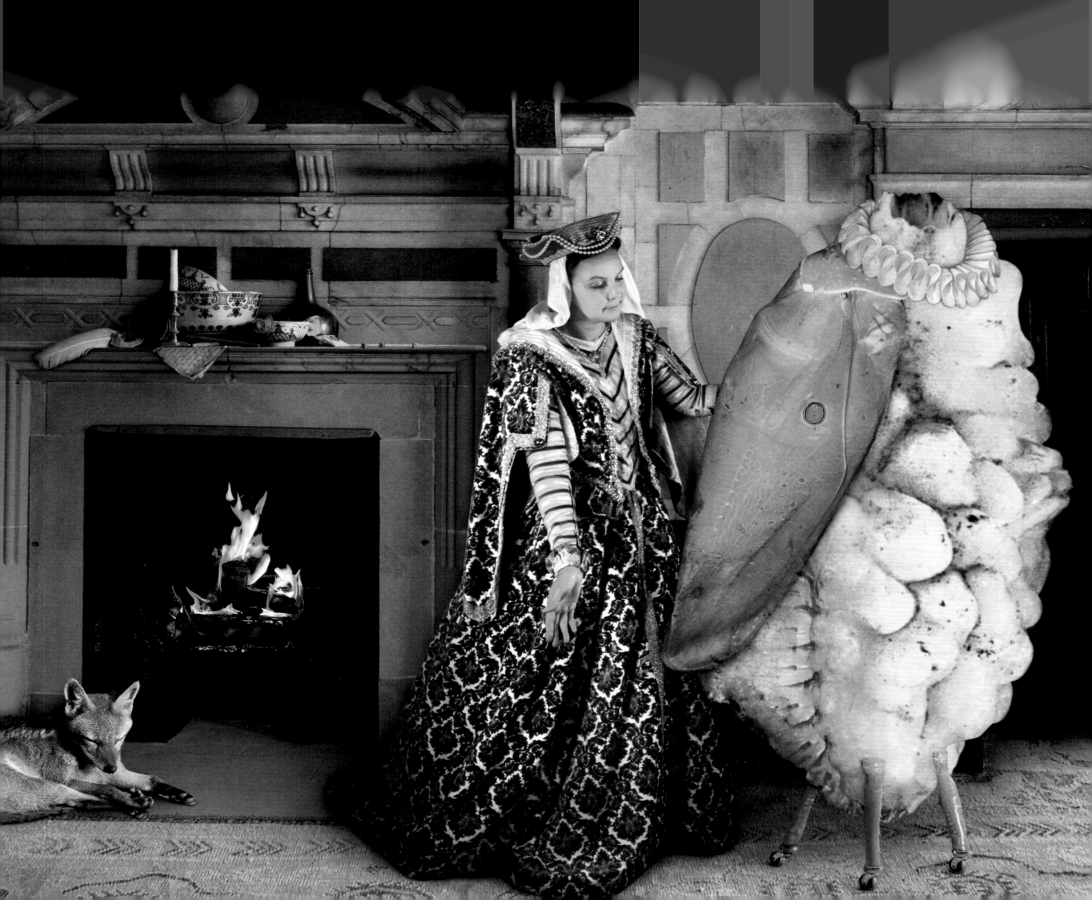

In a Garden So Greene, 1998

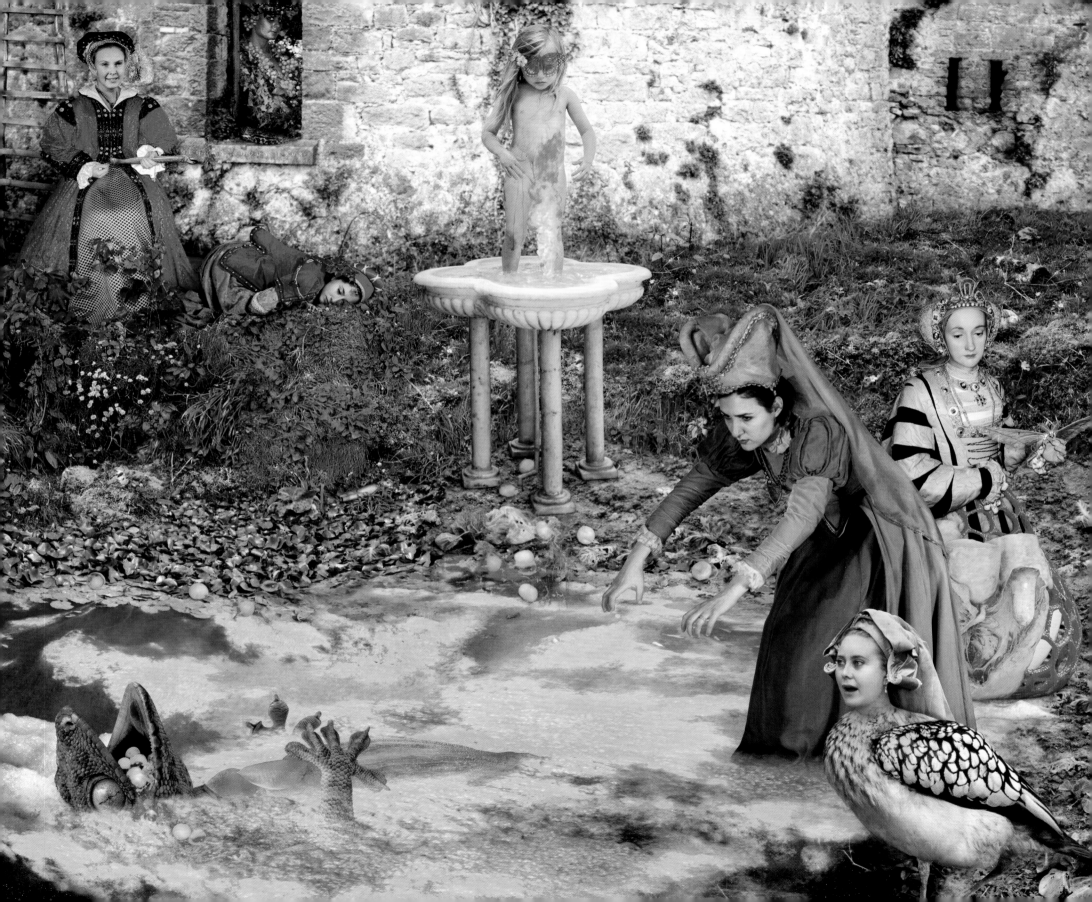

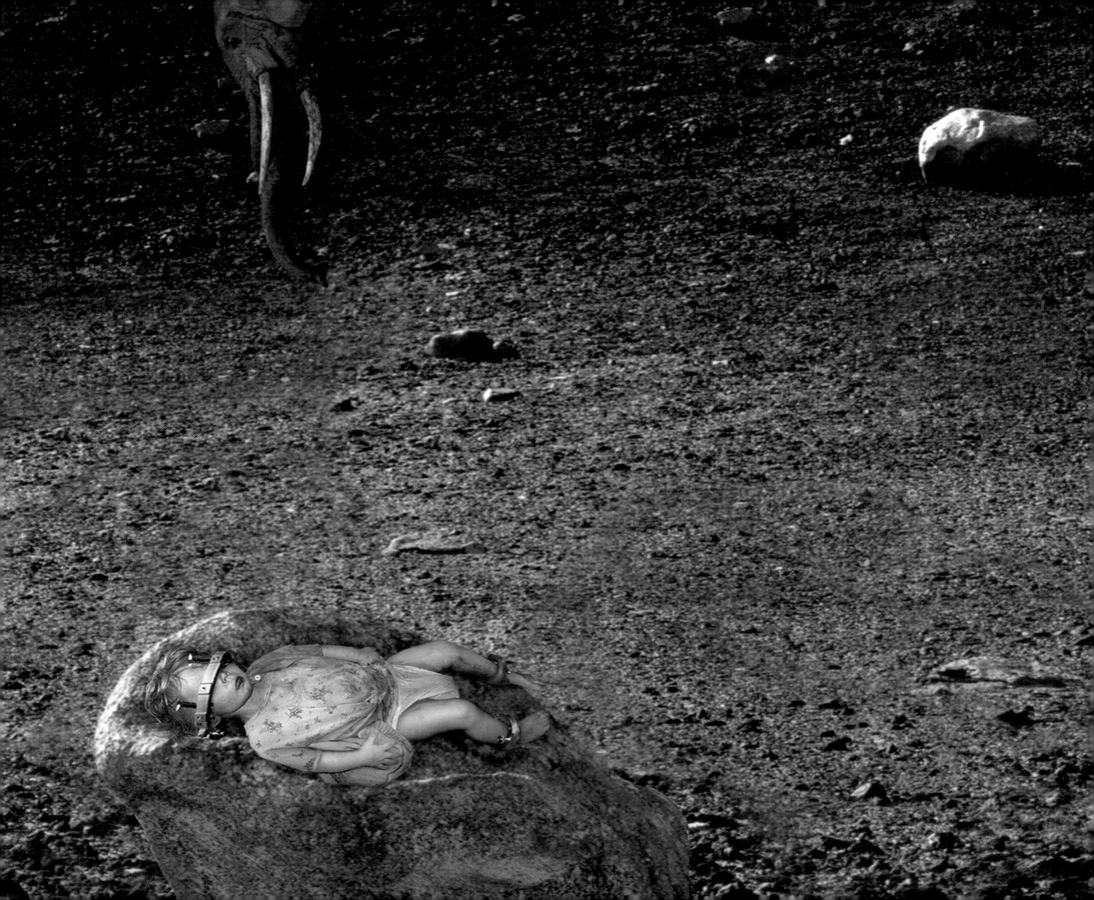

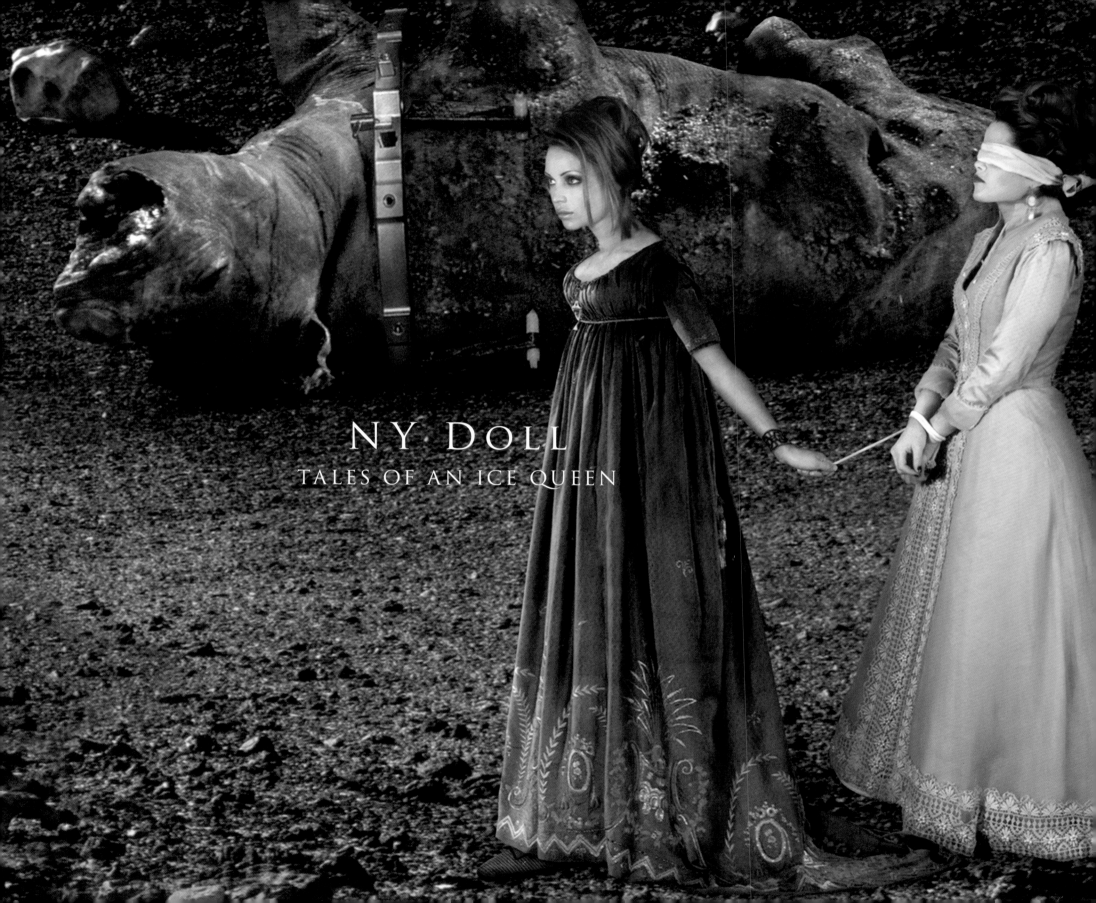

NY Doll
TALES OF AN ICE QUEEN

ONE DAY ON THE STREETS OF MANHATTAN, Boody caught sight of a striking woman entering a local strip joint called New York Dolls. The sheer beauty of the woman intrigued Boody and she followed her in. A working friendship evolved between Boody and the stripper as the young woman and her fellow dancers became models for *NY Doll: Tales of an Ice Queen*. In these multilayered images of polar icescapes, beautiful women sprout whole from cavities in the frozen ground and cavort with strange creatures. Doll-like, they lounge and display themselves, either bedecked in finery or nude. Like the images of a dream, allegorical snippets fuse together in disquieting ways. Maids walk blindfolded through a valley of frozen tundra. Beauty remains entangled with her Beast. Blue-lipped Goddesses sprawl across the Arctic terrain.

Boody's ethereal images gently probe the nether regions of female experience. Notions of the fleetingness of beauty and the desire to remain forever young surround her girl-child hybrids as they encamp in their frigid habitat. Boody writes in her lyrical statement for the series: " 'I'll never grow up' was her mantra as the pack ice reached its shiny tentacles inside her. Snow White, sewn tight, please grant the wish I wish tonight."

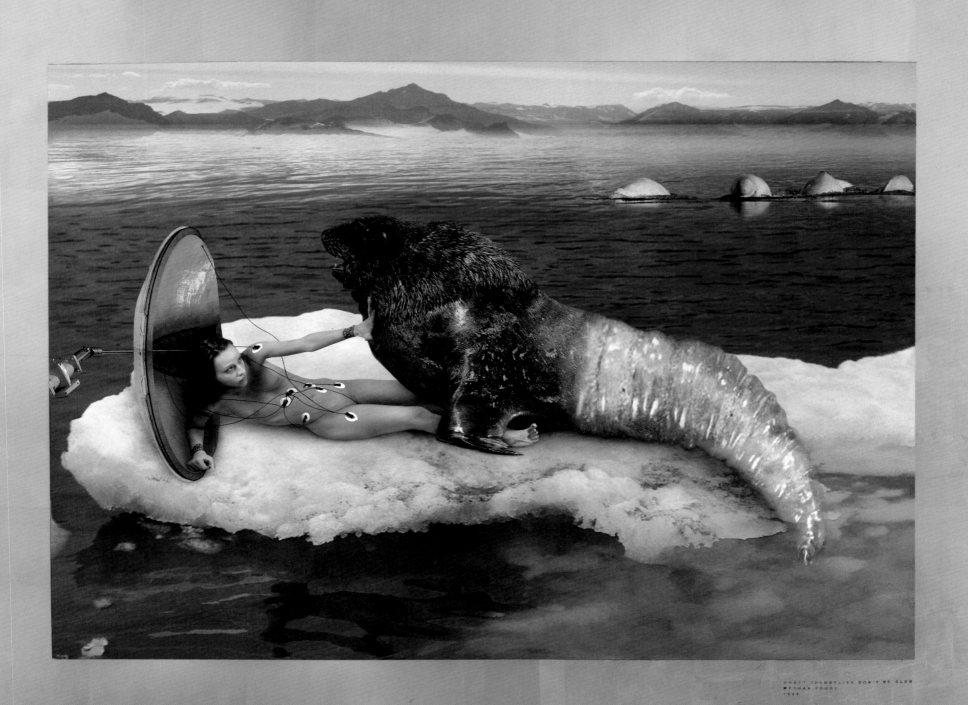

I Love Little Pussy, 1996

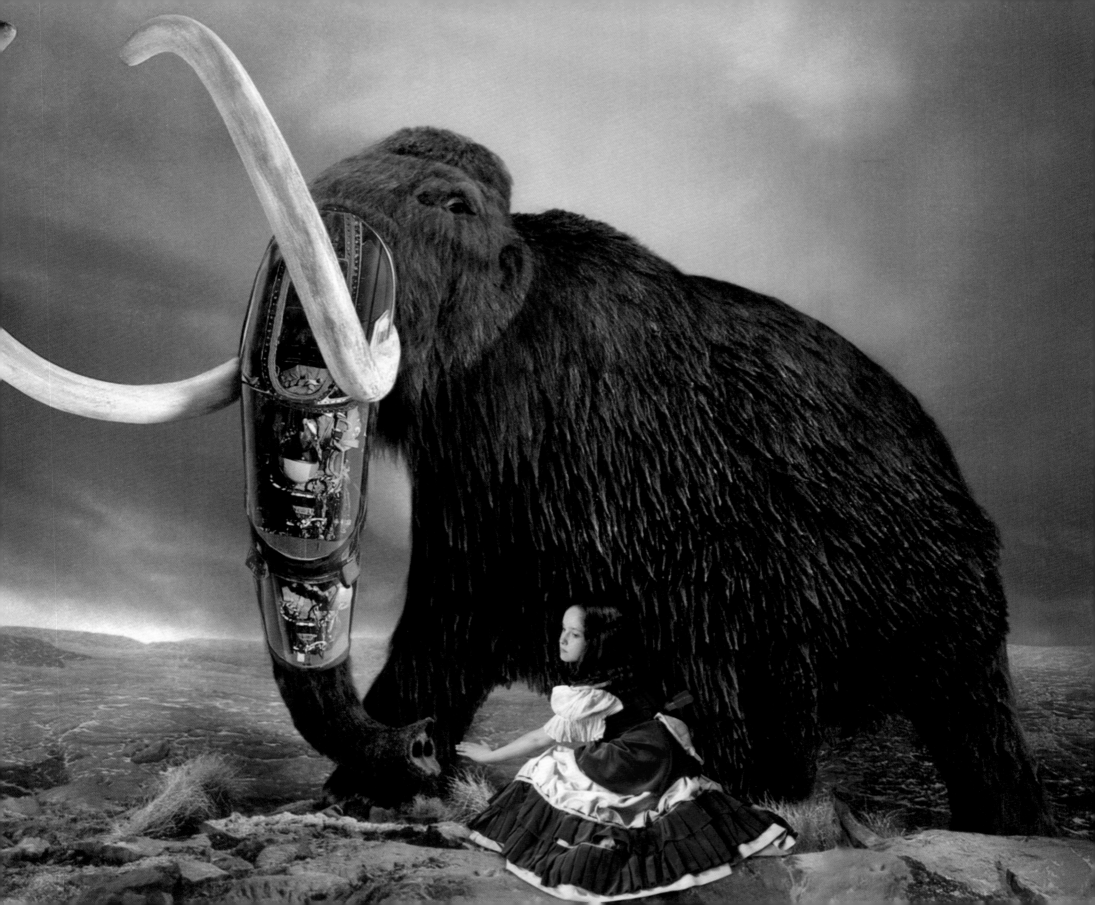

Hushabye Island, 1996

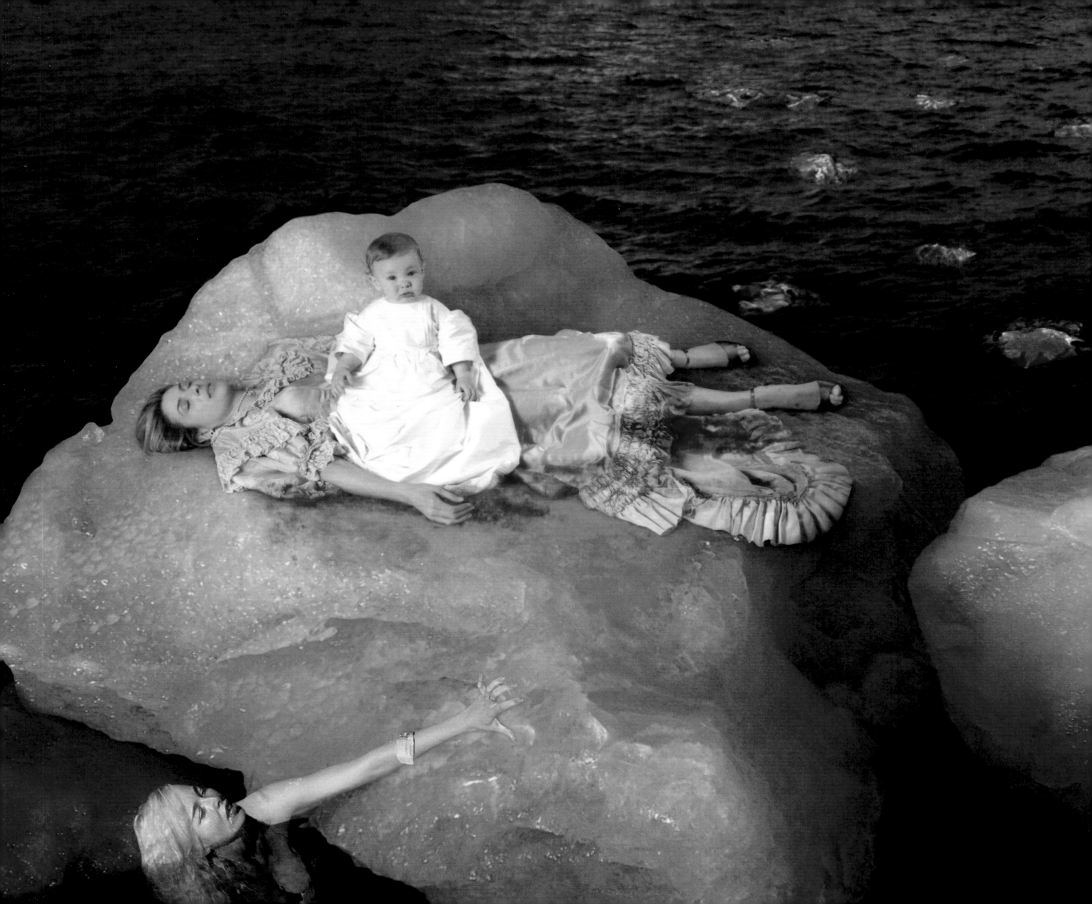

Lucky Girls, detail, 1996

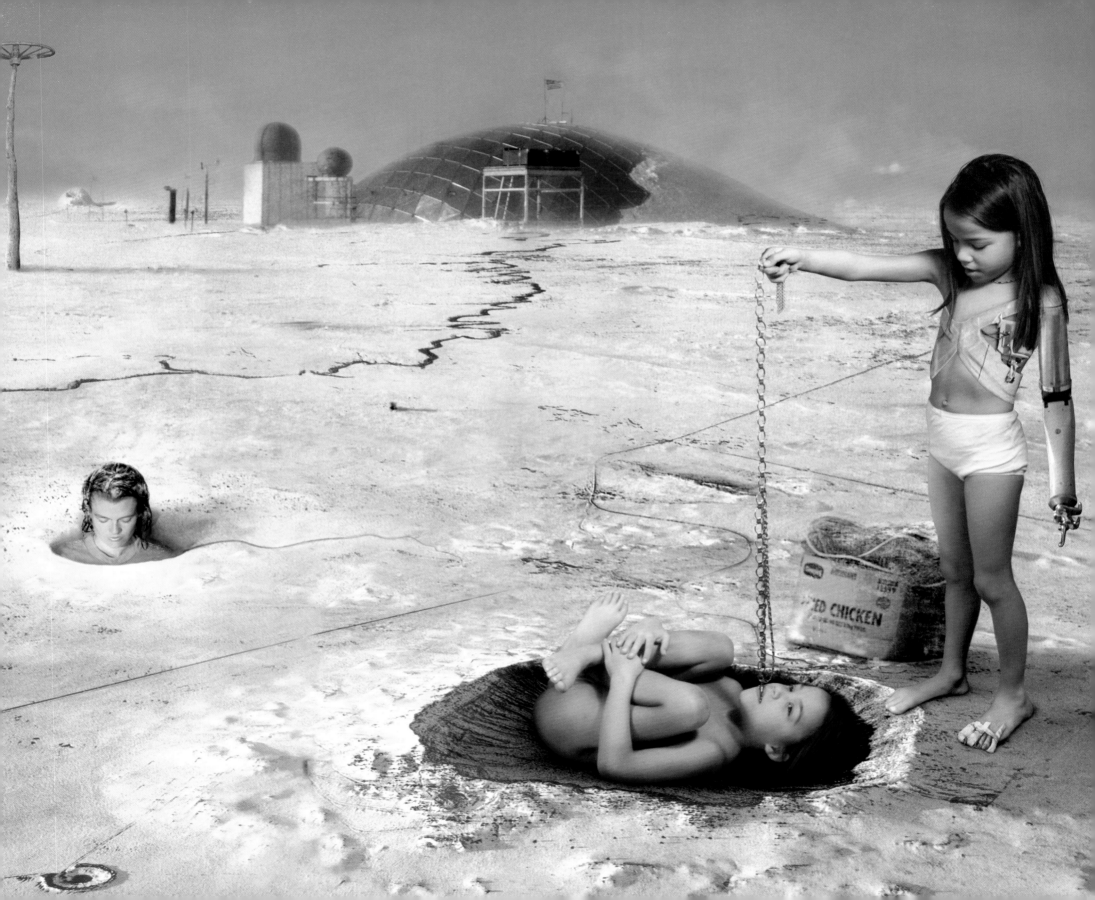

Just a spoonful of sugar, detail, 1996

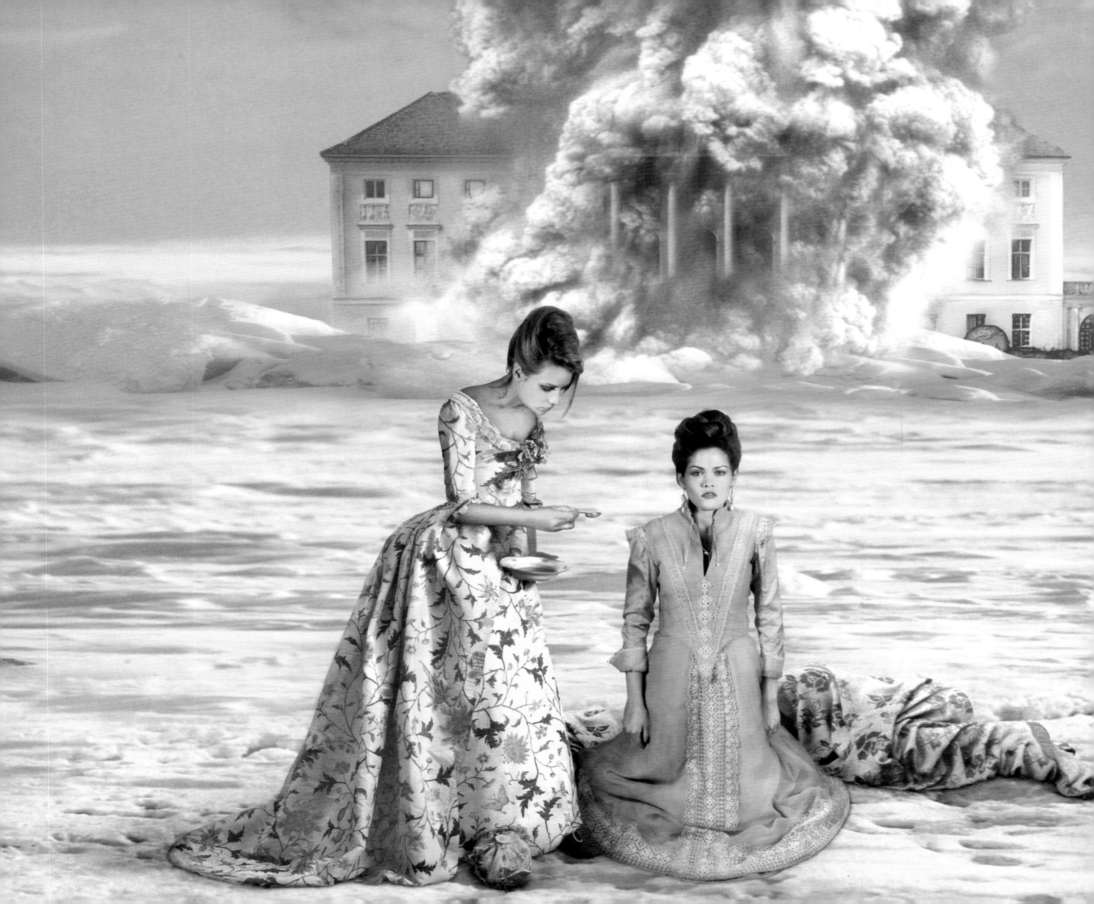

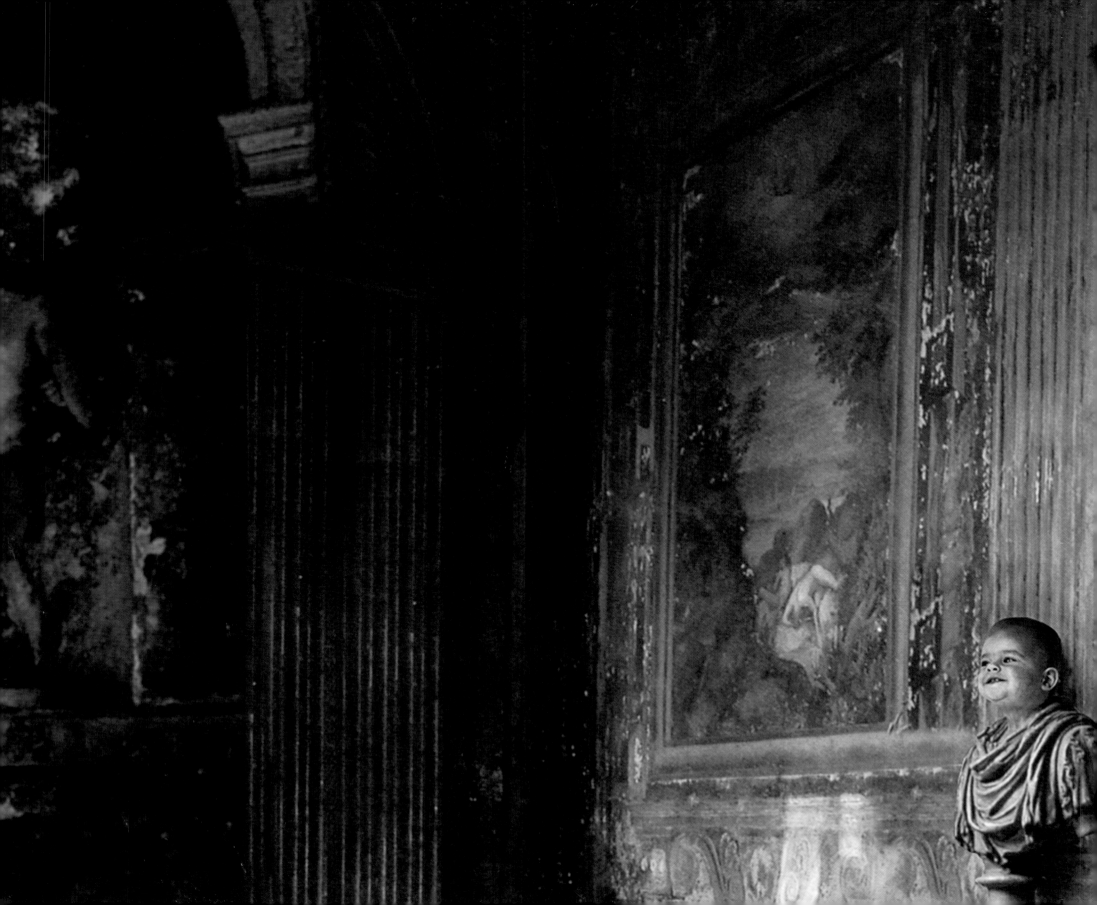

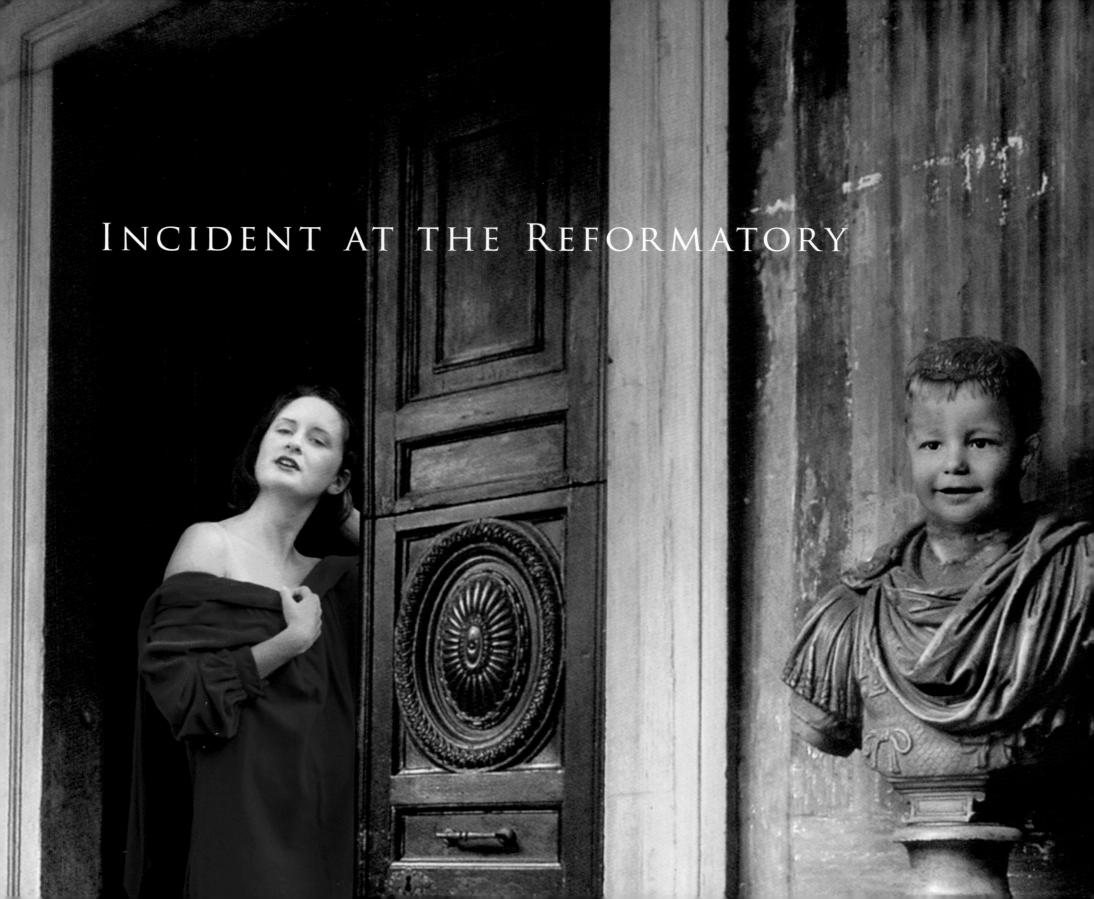

INCIDENT AT THE REFORMATORY

BOODY'S FIRST SERIES of large-scale composited photographs, *Incident at the Reformatory*, unfolds one room at a time. Whether the foyer, the attic, or the boudoir, each space seems part of a magnificent dwelling that is in turn part of a much larger feudalistic system. People engage in the routines and rituals of daily life, observant of a mysterious decorum. Only the narrative titles provide clues to these cryptic and phantasmal images and the world they portray.

A subtle foreboding emanates from the well-dressed inmates in their stately confines. Fetal rodents are plopped in corners and hang on strings like decorations, carcasses become ottomans, and creatures must submit to grooming. Yet there are also glimmers of the divine. Humans occupy pedestals and niches normally reserved for Gods, and there is a harmonious complicity between all inhabitants of this extravagant realm.

The traning procedure was frequently observed, 1995

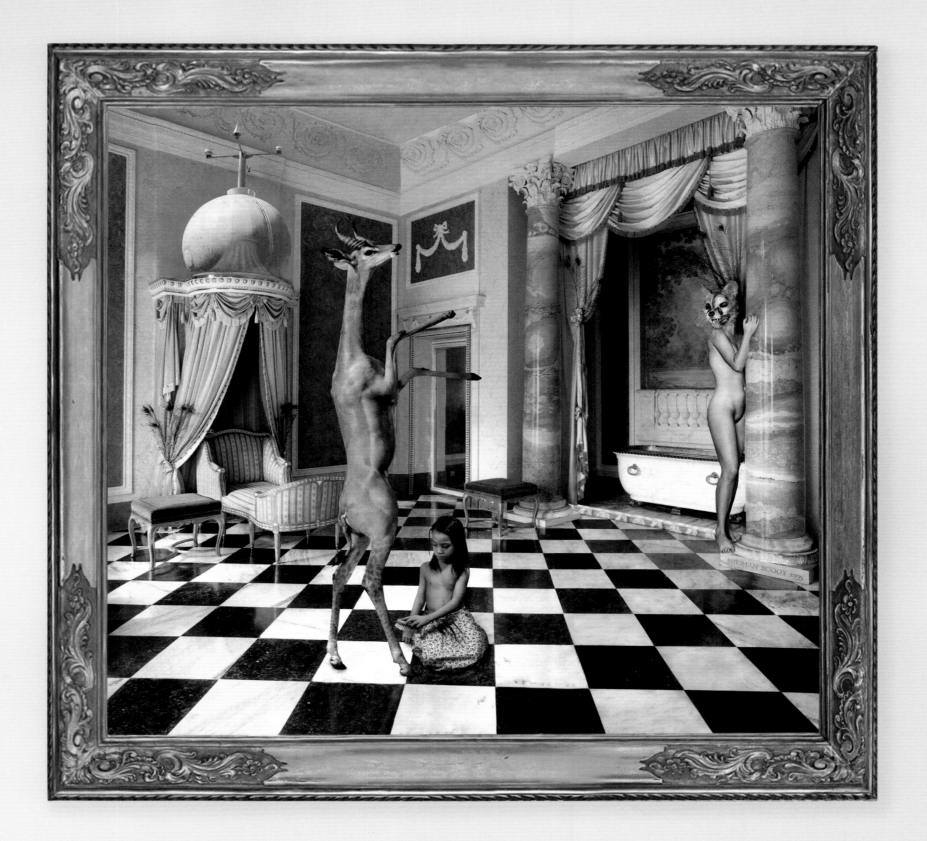

Justine and Juliette quickly resumed their game of hearts, 1995

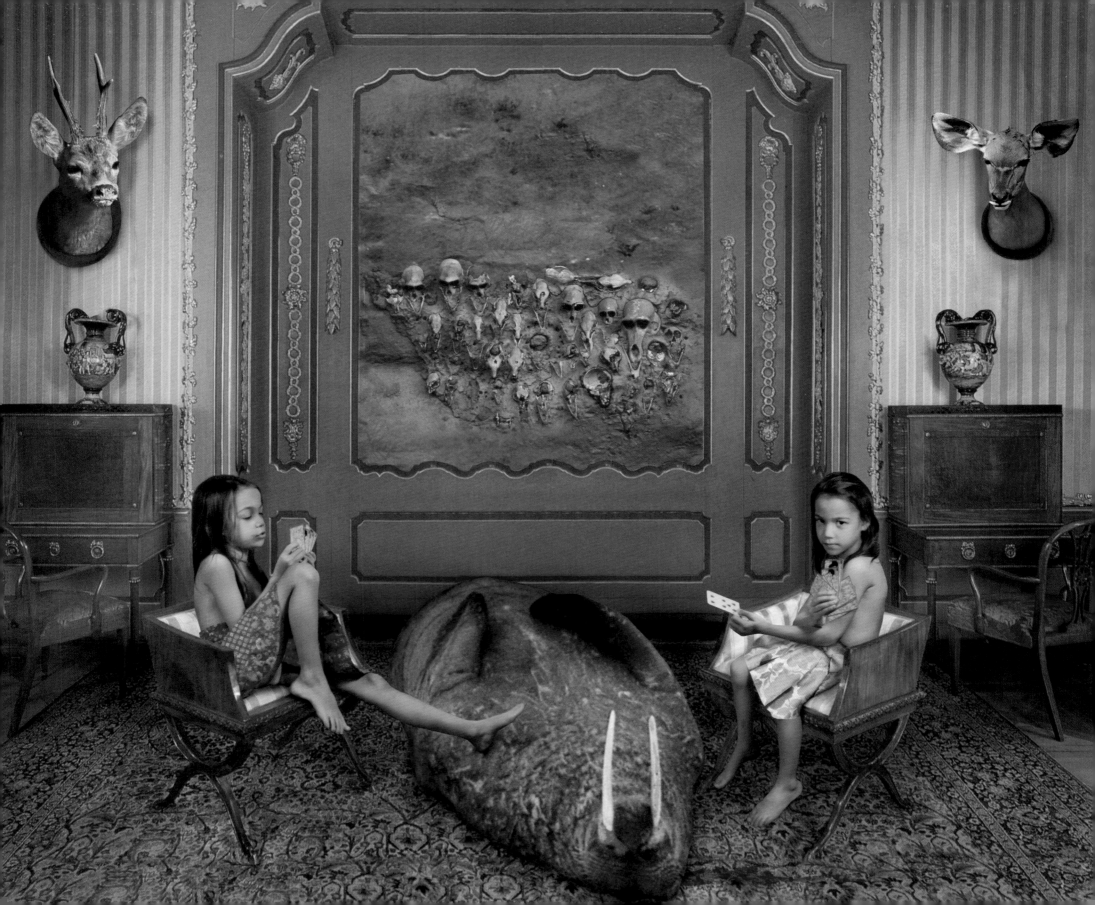

Margaret's innocence did not lessen the finality of the decision, 1995

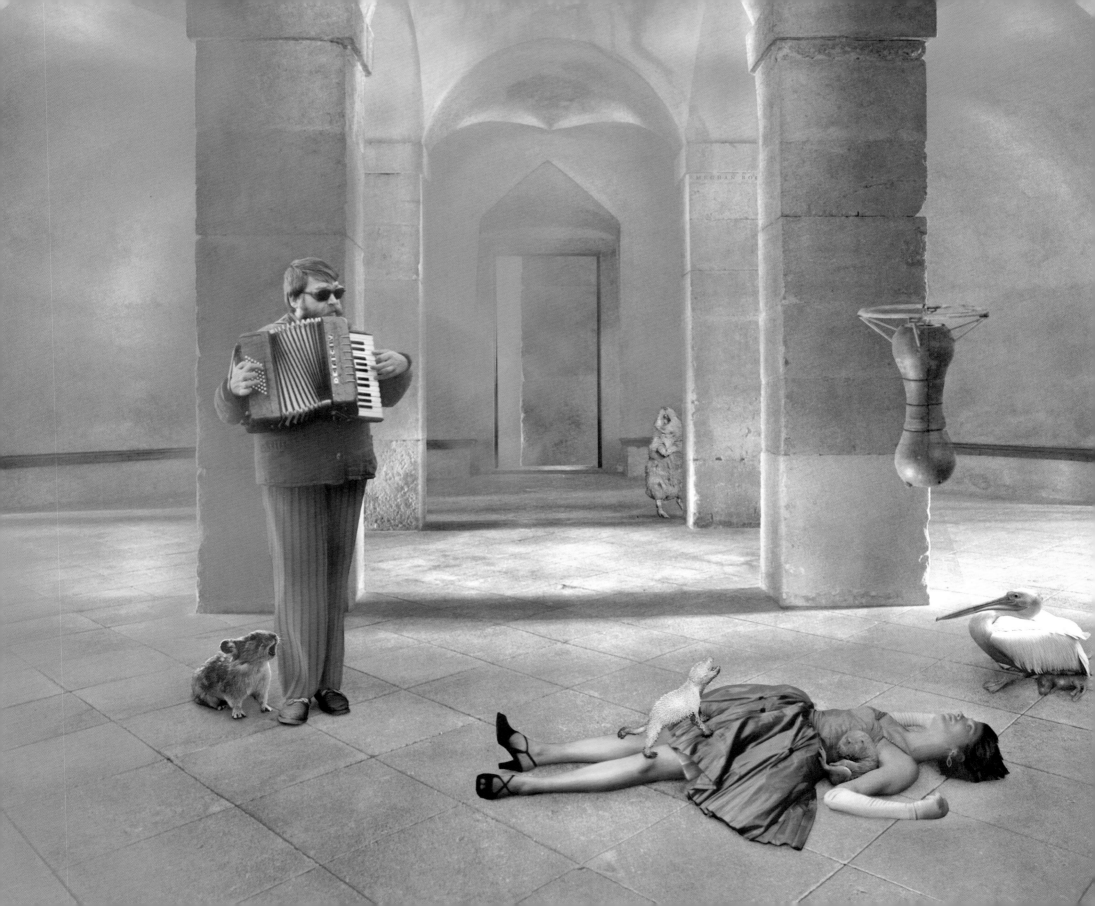

It was hoped the confinement would inspire cooperation, 1995

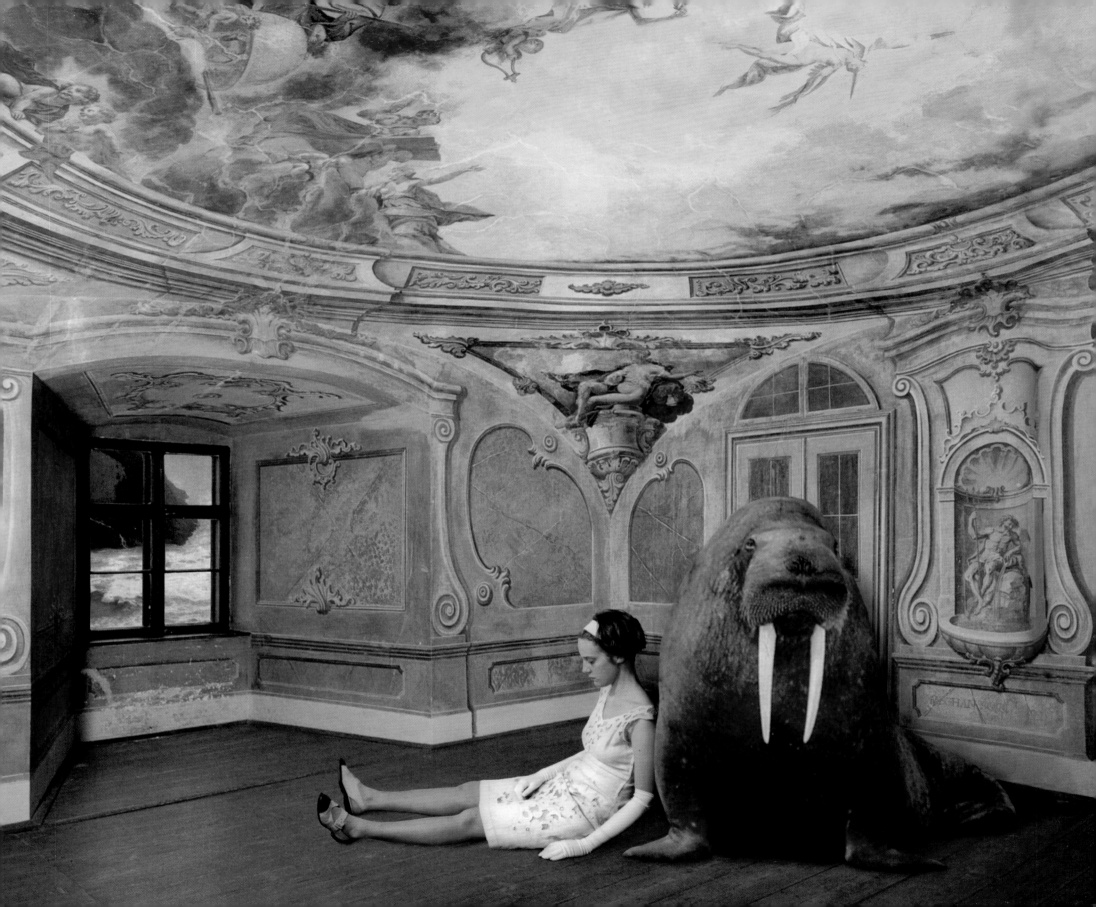

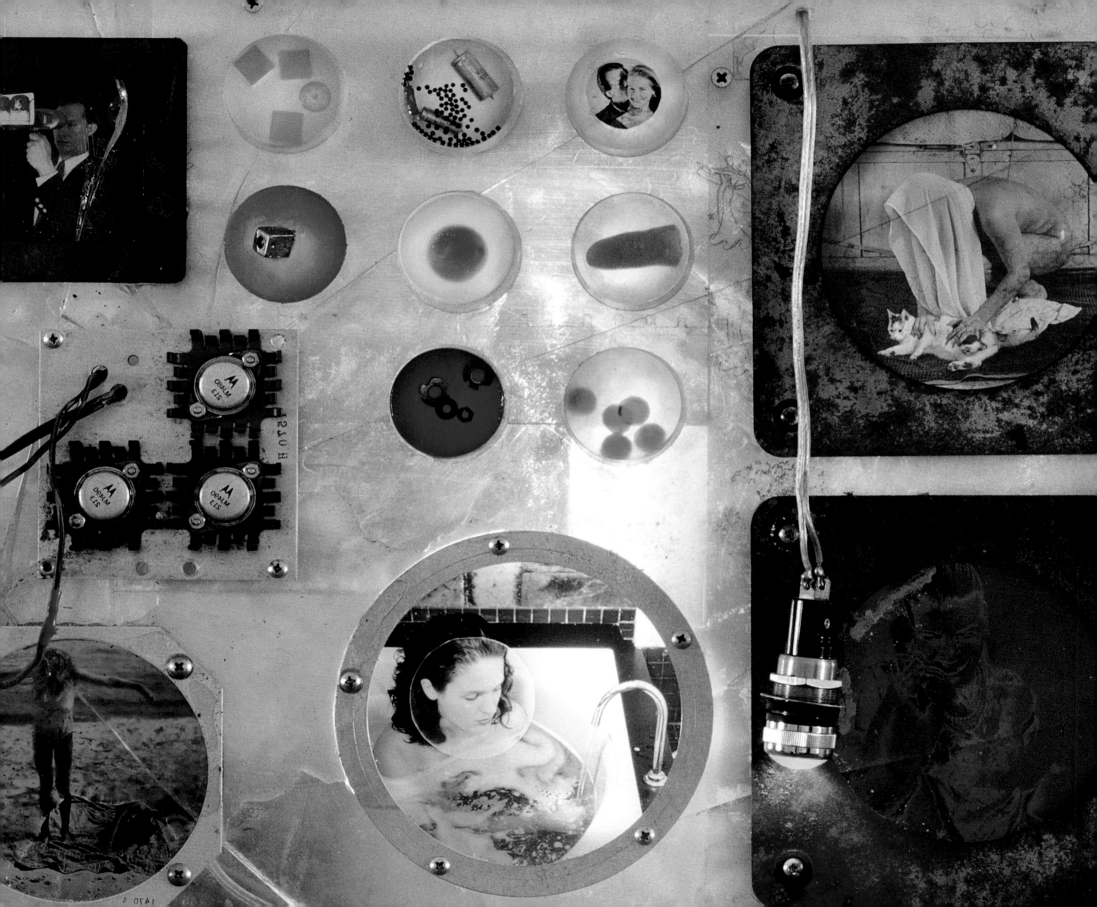

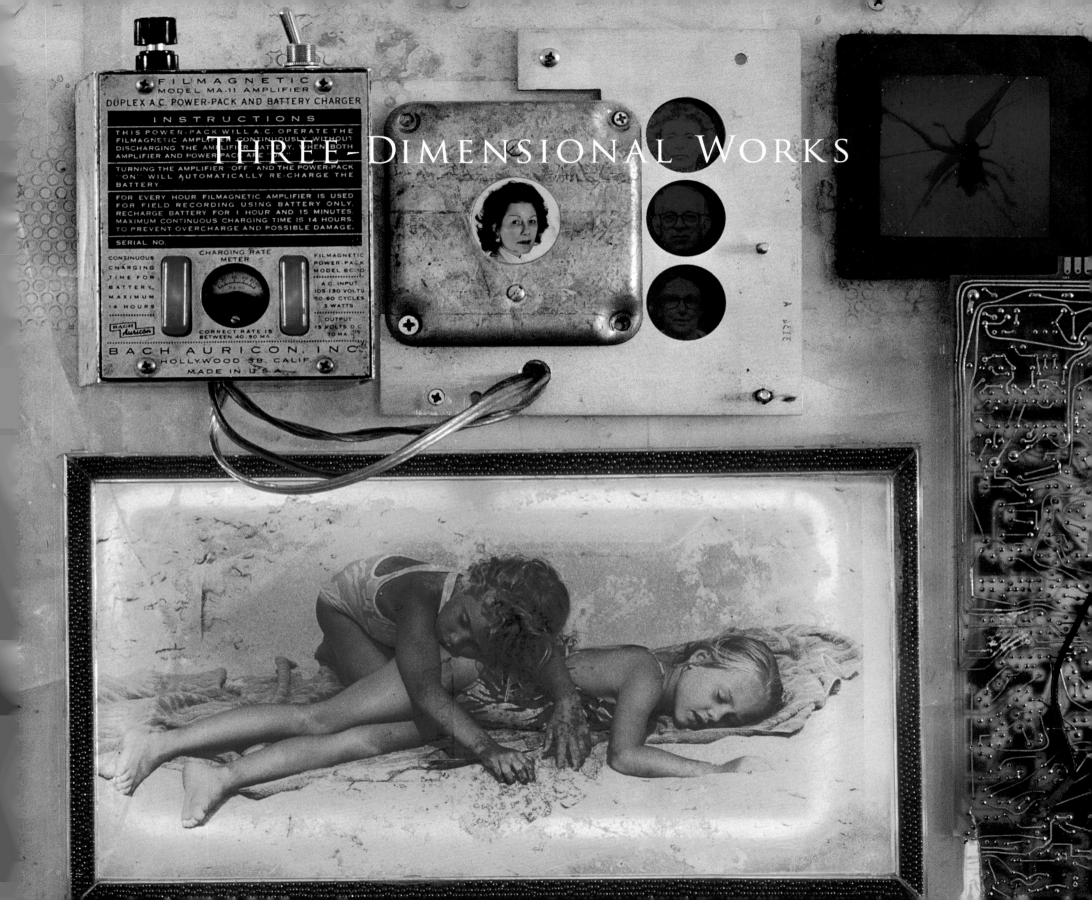

THREE-DIMENSIONAL WORKS

BOODY HAS LONG BEEN FASCINATED with hideouts and secret nooks where the magical imagination of a child can run wild. In her three-dimensional work, Boody offers the viewer privileged access into such private spaces. Like giant cocoons or tombs, the tough outer casings of the works house fragile inner worlds that light up, emit sound, and mechanically animate. Viewers are invited to peer inside these timeworn objects by lifting trap doors or levers that set into motion narratives of the past. A discarded secretary brims with the mementoes of a friendship with a beautiful addict, the translucent photographs permitting glimpses of once-living spiders now desiccated in their webs. A carousel of miniature animals revolves inside a lumpen Tower of Babel to the tune of Danny Kaye's "Thumbelina." In a coffin-like vitrine, a model of the artist as a child lies in a grassy knoll next to a small watering hole continually refreshed by droplets of her "saliva." A colony of live mice drink the water, feed on the seed from her hand, and nest in her hair, forming a self-sustaining ecosystem with their girl companion.

To create these haunted time capsules, Boody revamps architectural and industrial salvage. Victorian fire screens and clock domes, hospital gurneys and military control panels—all are retrofitted with wiring and electronics and filled in with photographs, dolls, and stories. Lost love, the distant but ever-present domain of childhood, and the complexity of being an adopted daughter are among Boody's raw materials. Trafficking in recovered memory, Boody stuffs her contraptions full. They lie in wait for the unsuspecting viewer, ready to release their vapor of bottled-up desire, loss, and transformation.

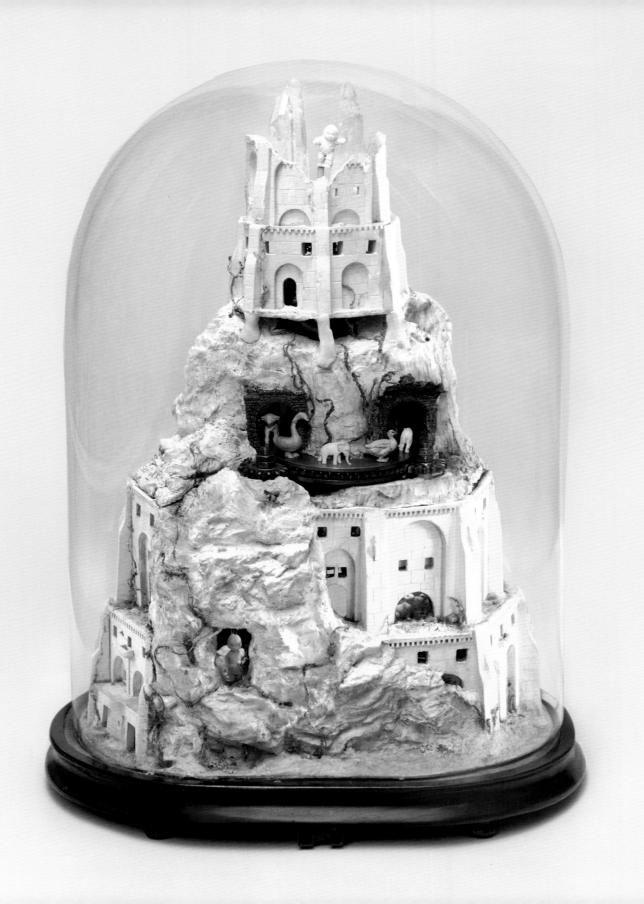

Magic Mountain, 2012

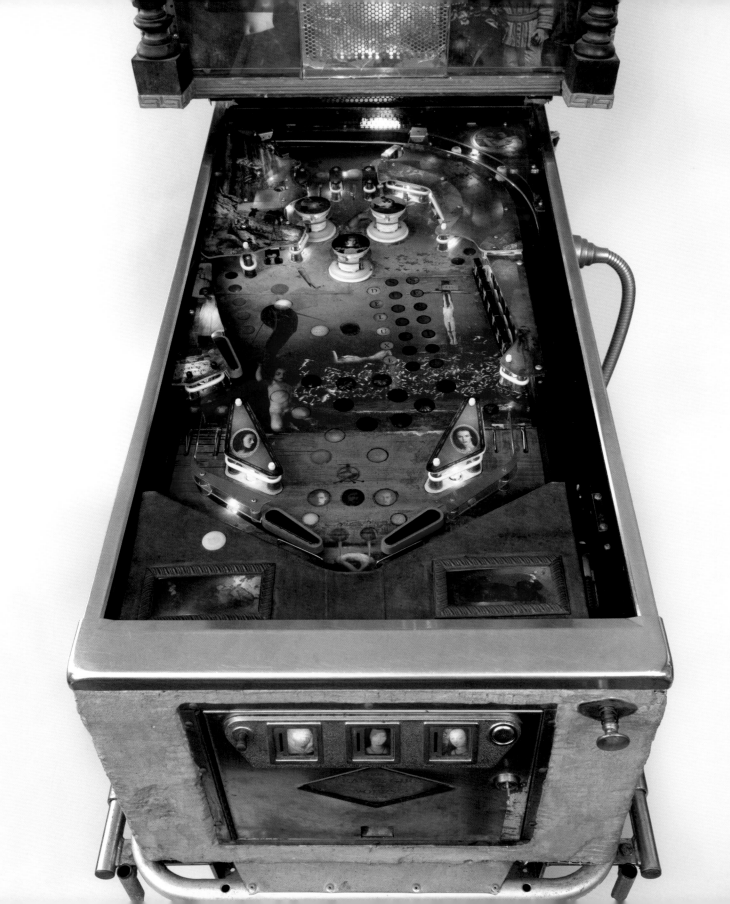

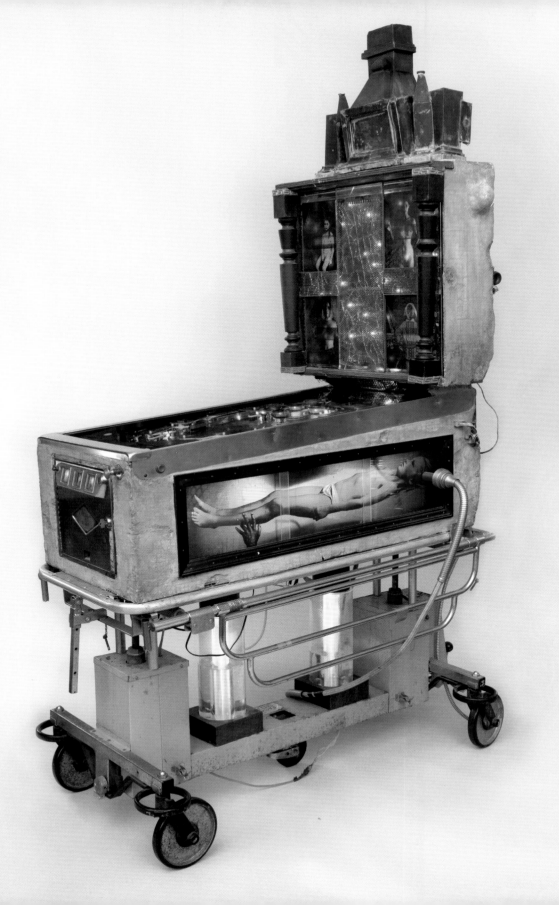

Deluxe Suicide Service, 1996

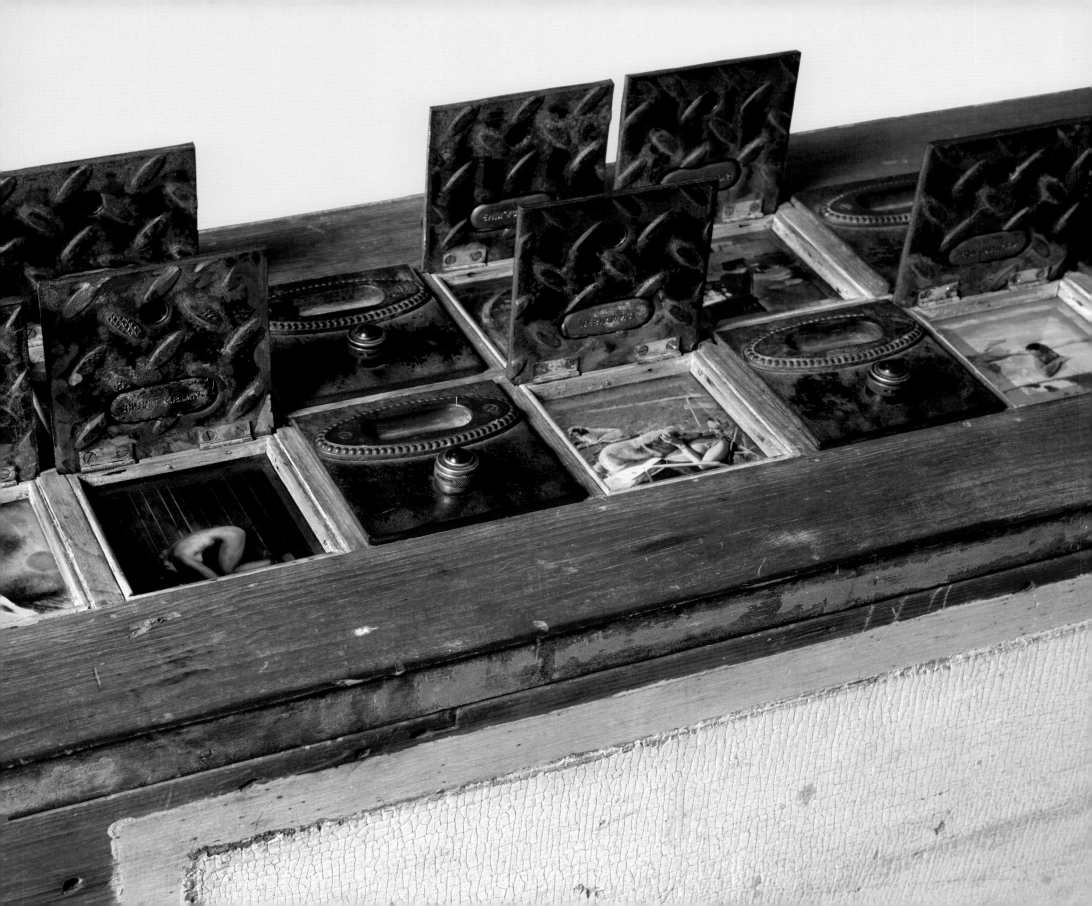

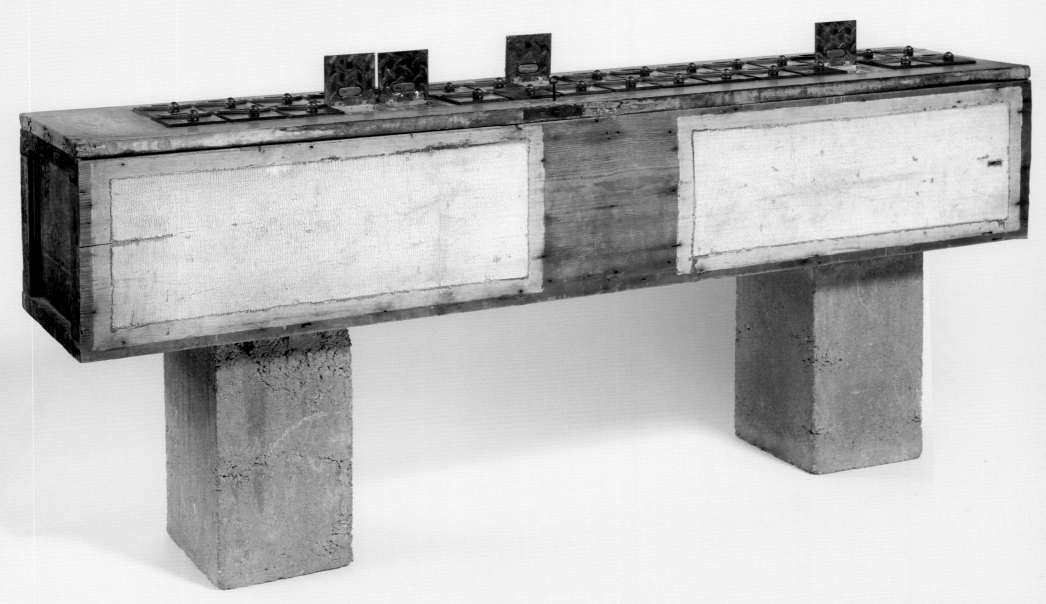

Electronic Warfare Suite, 1991

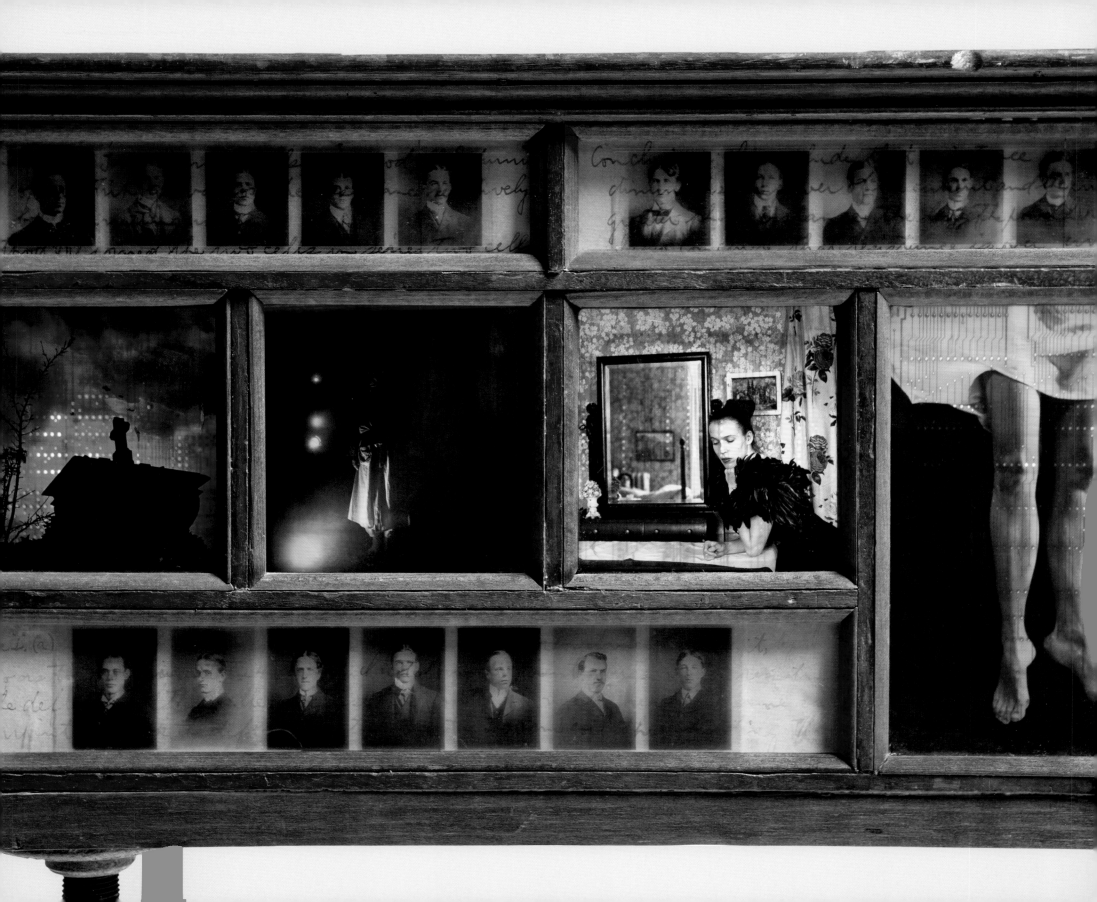

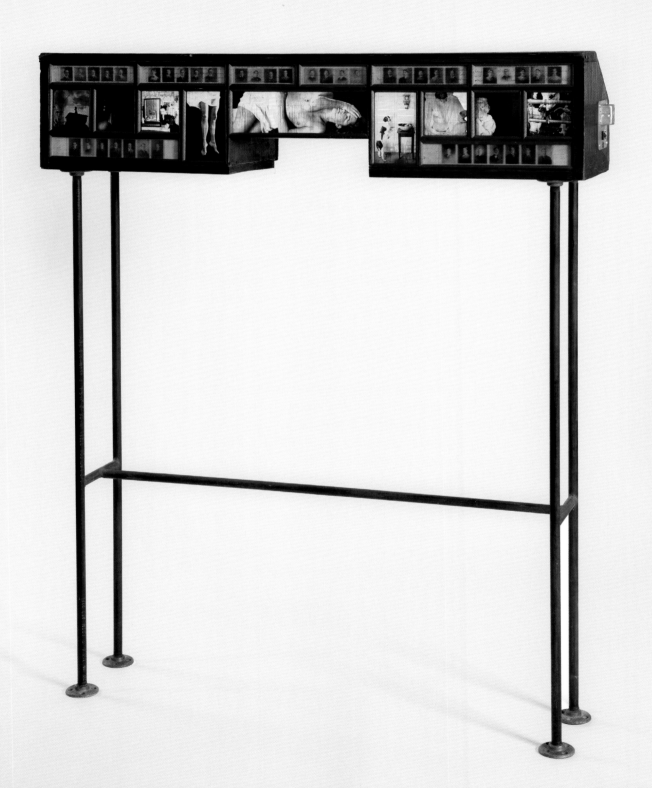

Death Row, 1992

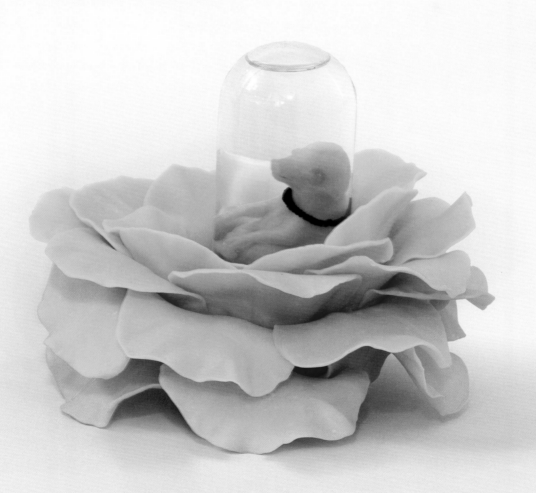

Mimosa, 2005

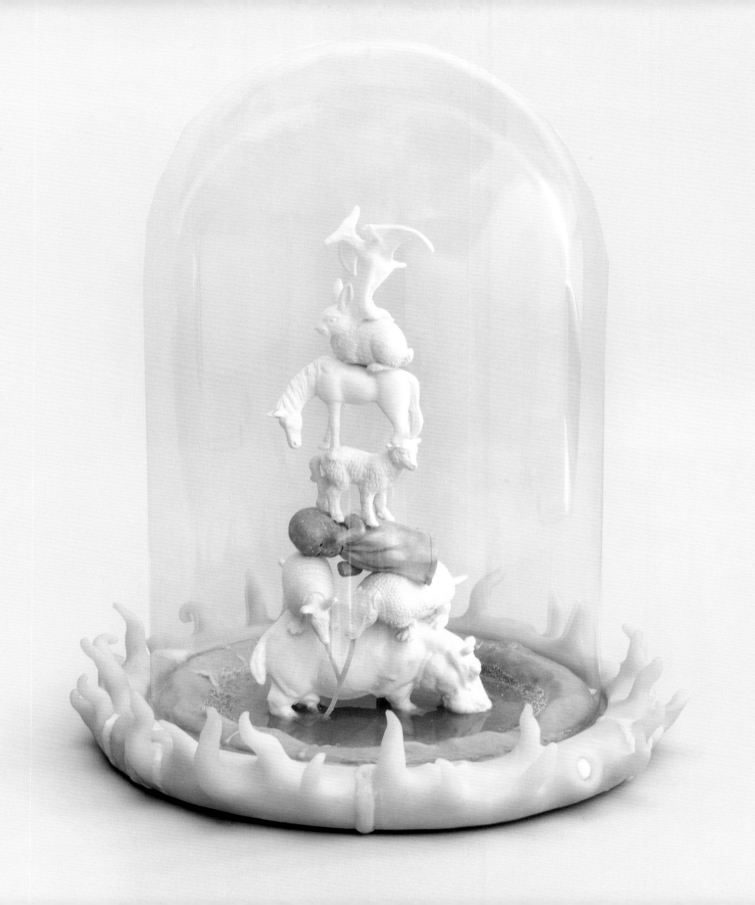

Castor, 2005

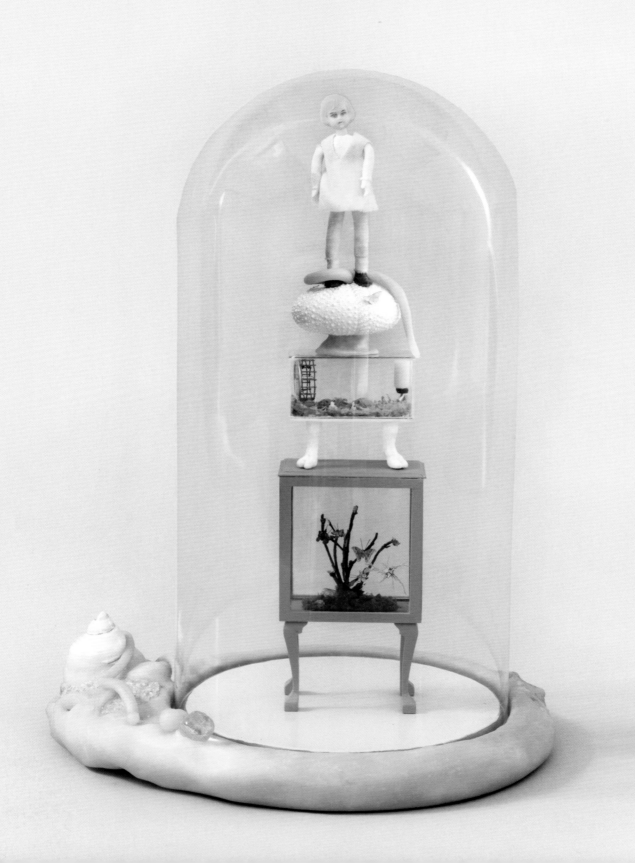

Mira, 2005

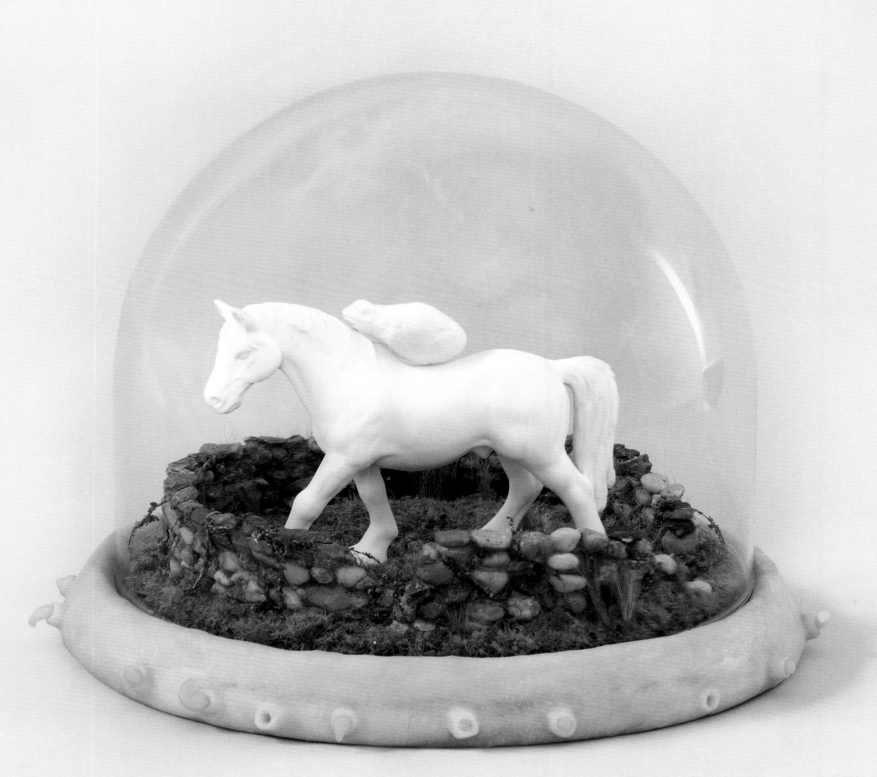

Pollux, 2005

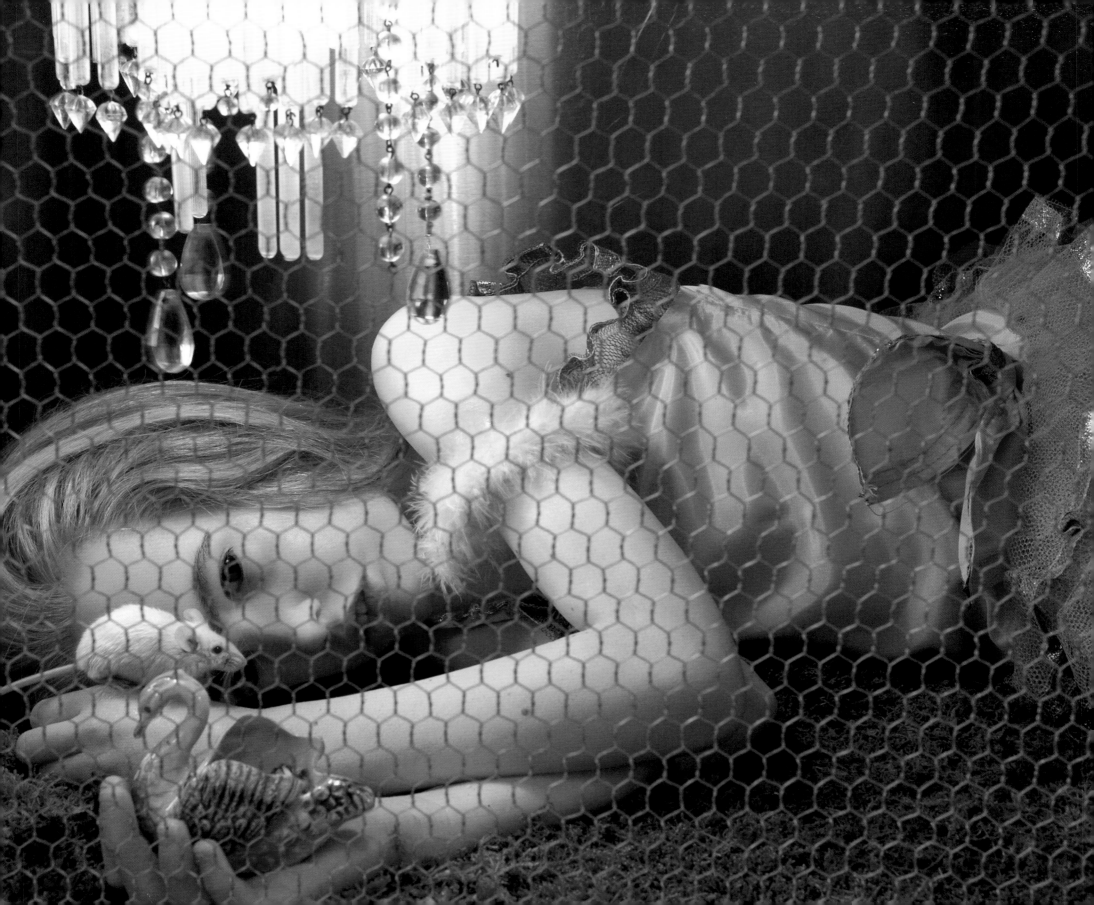

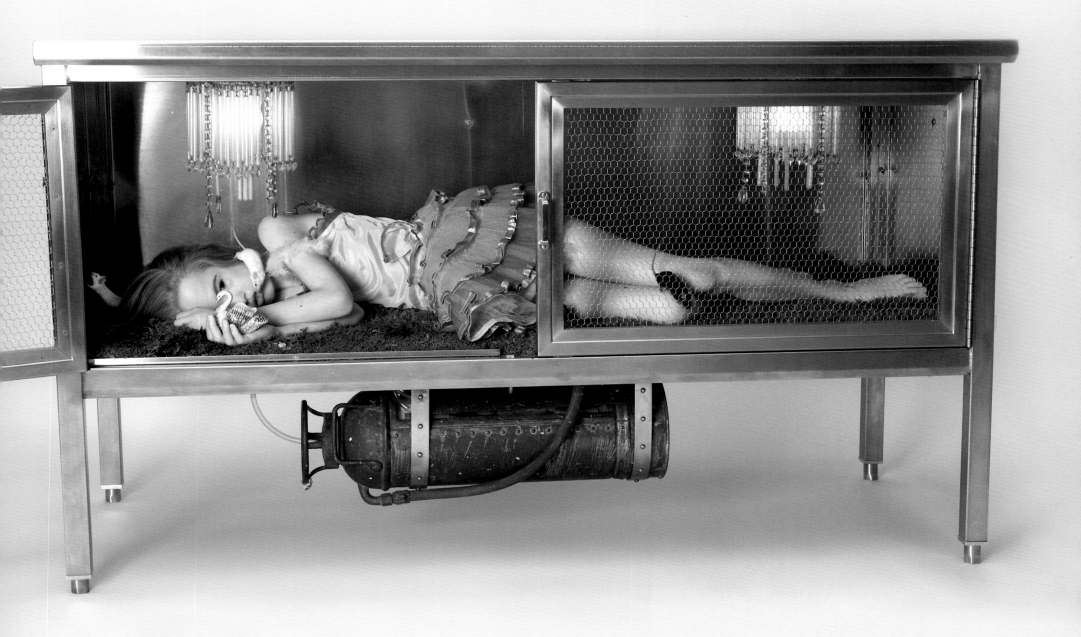

The Mice and Me, 2008

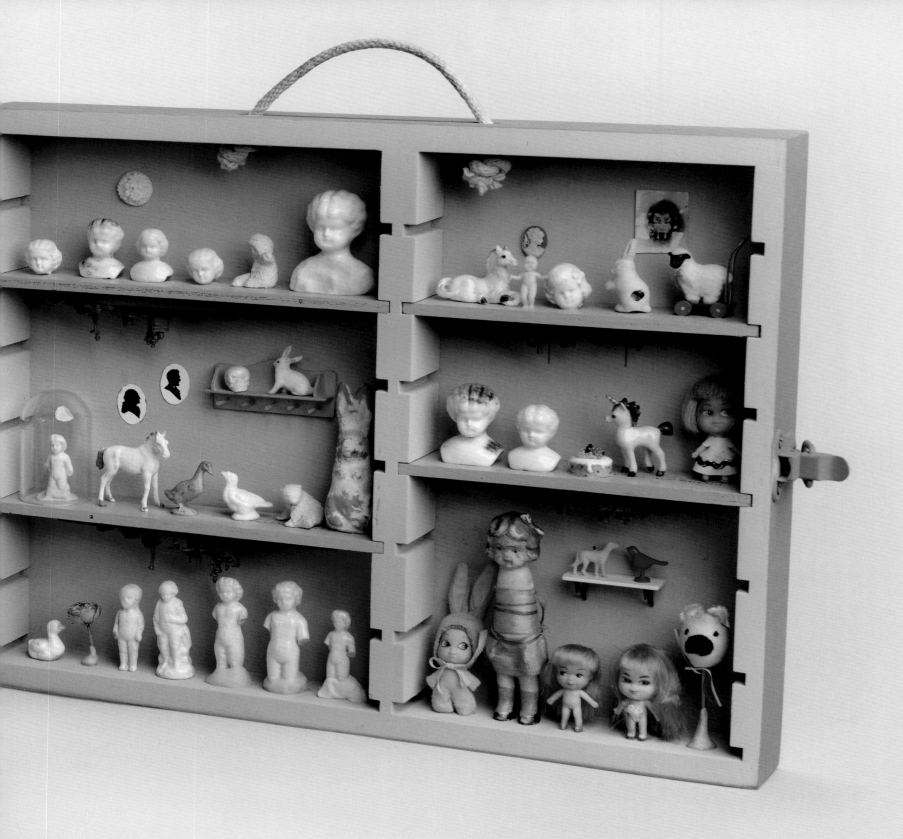

Premium Girl and Horse Starter Kit from the series *Army of Me*, 2015

ABOUT THE ARTIST

AFTER RECEIVING HER BA from Georgetown University in philosophy and French, Boody moved to Paris in 1986 to study fashion design at Parsons. There she took an introductory course in photography on a whim and immediately fell in love with the medium. Upon returning to New York, she apprenticed with photographer Hans Namuth for three years and began to combine photography with interactive sculpture. With the advent of Photoshop in the early 1990s, she went on to pioneer a new form of digital photography based on composited imagery. Boody has exhibited her work widely since the late 1980s. Recent exhibitions include "Radical Terrain" at the Rubin Museum of Art, New York; "Magical Realism" at the Houston Center for Photography; and "Fairy Tales, Monsters and the Genetic Imagination" at the Frist Center for Visual Art, Dallas. Her work is held in important collections including the Whitney Museum of American Art, New York; the Herbert F. Johnson Museum at Cornell University, Ithaca, NY; and the Museum of Old and New Art (MONA) in Tasmania. Boody's otherworldly art and homes have been featured in *Telegraph Magazine*, *Marie Claire*, *Homes & Gardens*, and *New York Magazine*. She is represented by Rick Wester Fine Art in New York, Imago Gallery in California, and by Thomas/Treuhaft for commercial commissions.

IN GRATITUDE

To Toby for making my world that much richer.

To Christof Kerber and Katrin Meder for sharing my vision and bringing *Chrysalis* to life and to the page. To Renate Aller for getting the ball rolling and for her wisdom in all things photographic. To Laurie Dolphin for her design expertise and infectious spirit. To Sue Scott for her uncluttered vision and for knowing what goes where. To Katie Roiphe for her temerity and ability to see in the dark. To Ryan Newbanks for his superior wordsmithery. To Bonnie Young for her style prowess and generosity with her collection of treasures from around the world. To Heloise Goodman and Tora Lopez for their production genius. To Jacob Gossett for his strong eye, perseverance, and excellent company in the studio. To my dear mother, Claire Boody, for her unfailing belief in what I do. And to Hans Namuth for showing me the ropes. I miss you.

To all the dedicated and talented assistants I have had over the years, especially Jennifer Mahlman, Stan Laflott, Stan Rachel, and Hang Xu. I couldn't have done it without you.

To Tsarina Merrin, Alyx Liberator, Lindsay Brown, Yasmine and Jade Liang, Tegan Casio, the Pepe McCann Family, the Berke sisters, Harper Parr, Michaela Bootz, Grant Mellon, Lisette Van Der Brandt, Natalia Uliasz, Skye Stracke and all my other talented models and muses, human and otherwise: thank you for going down the rabbit hole with me.

Looking Glass Labs